MODERN
1905-1945 **ART**

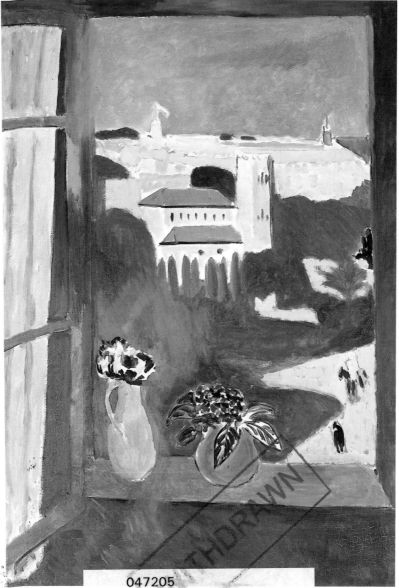

047205

THE HENLEY COLLEGE LIBRARY

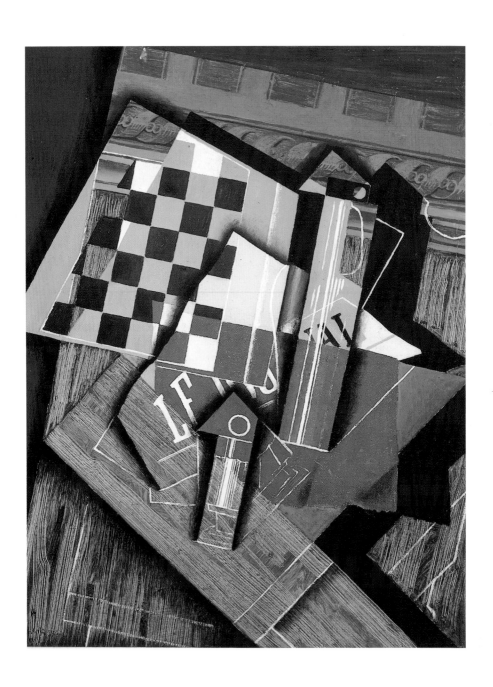

MODERN

1905-1945 ART

Edina BERNARD

CHAMBERS

For the English-language edition:

Translator
Richard Elliott

Art consultant
Dr Patricia Campbell, University of Edinburgh

Series editor
Patrick White

Proofreaders
Stuart Fortey
Camilla Westergaard

Prepress
Vienna Leigh

Originally published by Larousse as *L'Art Moderne, 1905-1945* by Edina Bernard

© Bordas S.A., Paris, 1988
© Larousse-Bordas, P, 1999

English-language edition
© Chambers Harrap Publishers Ltd 2004

ISBN 0550 101187

Cover image: Wassily Kandinsky, In the Bright Oval, 1925 (Thyssen-Bornemisza Collection, Madrid), Photo L Joubert © Larbor Archives © ADAGP, Paris 2003

Page 1: Henri Matisse, *Window at Tangiers*, 1912 (Pushkin Museum, Moscow). Photo © Artephot/Plassart/T © Matisse estate.

Page 2: Juan Gris, *Game of Chess*, 1915 (The Art Institute, Chicago). Photo © H Josse © Photeb/T © ADAGP, Paris, 1999.

Typeset by Chambers Harrap Publishers Ltd, Edinburgh
Printed in France by MAME

Contents

INTRODUCTION

The great artistic movements of the early 20th century originated mainly in Europe, and above all in France, a relatively prosperous creditor country whose strong currency served as a benchmark for international markets. In 1905, the Fauves caused an uproar at the Salon d'Automne in Paris, thereby freeing art from its academic conventions. The following year saw the death of Paul Cézanne, who left a legacy that would prove hugely important to the 20th century. An aesthetic revolution was about to take place that would break with the classicism of previous centuries. Anticipated by Symbolism and Impressionism in terms of its treatment of form, this revolution had its origins in the 18th century, when the individual sensibility of the artist first began to play a part in the genesis of a work of art.

These pictorial upheavals, in particular the challenging of the limits of a work of art, reflected social uncertainties, demographic expansion and scientific revolutions: Einstein's theory of relativity expounded in 1905, which restated man's position in the universe and changed our perception of time and space, and applied nuclear physics during the 1940s. Nietzschean philosophy, Bergsonian intuition and psychoanalysis were all exploring new spheres of consciousness.

The emergence of Marxist regimes, notably the Soviet Union, the confirmation of a form of collective atheism (which had existed on an individual level since the 17th century in representative art) and the growth of extreme right or extreme left ideologies, all broke down the traditional reserve of intellectuals and prompted them to commit to the cause. This was still the era of the bohemian and of *mal de vivre*, a time before the proliferation of museums and cultural institutions and the extreme commercialization of art that occurred during the second half of the 20th century.

The growth of industrial art, photography, cinema and television sounded the death knell for genres such as academic portraiture (whose last great exponent was Ingres), provoked a debate over science's victory over art, or their rivalry at least, and resulted in a widening of the various artistic disciplines to embrace other areas: painters wrote poetry and drama, created sculpture and even architecture, in the form of architectural drawings. Artists' imaginations were stimulated, too, by innovations in transport, particularly aviation, and the development of the telephone, new means of communication that expunged the traumatic and sordid associations of 19th-century mass industrialization.

An incessant and unprecedented splintering into schools of painting designated by their respective 'isms' reflected both the effervescence and rigour of differing intellectual movements. The struggle was against the blandness and platitudes of academic and decorative art, and was pursued either through the exaltation and restructuring of planes and colours, spurred on by a kind of survival instinct, or else through the blur-

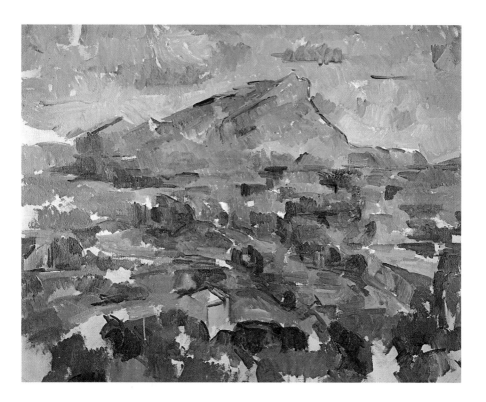

Paul Cézanne, *Mont Sainte-Victoire from Les Lauves*, 1902–6 (Kunsthaus, Zurich). After 1885, Cézanne returned repeatedly to Mont Sainte-Victoire, near Aix-en-Provence, using the subject as the basis for experiments with spatial illusion and the depiction of landscapes, which reached their climax in 1906. By means of a complex system of modulating touches of colour aimed at eliminating the outline, unity of tone and, therefore, the contour of objects, Cézanne laid the foundations for the whole of modern art.

ring or contraction of form, either in deliberate mockery or as a verdict of failure.

Art emphasized or hid signs of division by taking either a phenomeno-logical or an existential approach to the universe. The two World Wars, the first global conflicts in history, and the Spanish civil war, in which many artists lost their lives, caused irreparable trauma and a dichotomy in human sensibility. In parallel with the revolution in aesthetics, this period of emancipation and effervescence, which would be followed by a period of regression, also witnessed a change in mores. The upheavals provoked engagement or disengagement on the part of intellectuals and artists, but also increased the level of contact between Europe, the United States and South America, giving rise to a notion of collective conscience. Colonial expansionism brought about a shift of cultural interest towards the Middle East, Africa and the Far East, and African and Japanese art started to exert an enormous influence on that of the West.

The origins of the crisis in representation, a cliché of 20th-century art, lie in an attempt to resolve the contradictions between human drives and impulses, as revealed by psychoanalysis, and the rationality in which art had revelled hitherto. The Surrealists posited an individual no longer reliant upon principle alone, but on instinct, too. Like poetry, abstract art was based on a language of signs whose equivalent can only be found in

INTRODUCTION

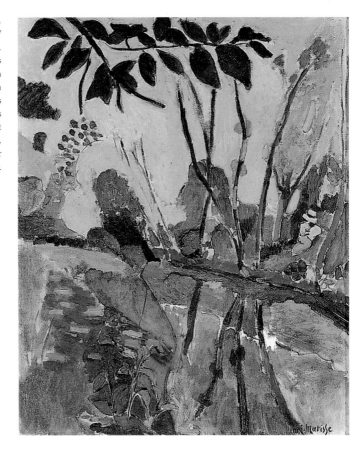

Henri Matisse, *The Bank*, 1907 (Kunstmuseum, Basel). This landscape displays an enduring link with Fauvism in its rejection of natural local colours in favour of vivid hues and in the movement of its diagonals, accentuated by their reflection in the water.

certain prehistoric periods or during periods when civilization, having reached the limit of its investigations and feeling itself threatened, sought to protect itself by turning to hermeticism. Such speculations on the irrational, on the necessity of returning to a primitive spirit, but also on the rigour of abstract art, proved that the debate that opposed idealism with naturalism, which was explicit during antiquity and had been latent since the 18th century, had not been entirely eliminated.

Although his dates place him in the 19th century (1839–1906), through his portraiture, still lifes and landscapes, Paul Cézanne was the initiator of one of the greatest aesthetic revolutions of the 20th century. He treated painting in a similar way to language or algebra: as a field for experimentation that was destined to produce a new vision of the universe – the very opposite of the fixed vision of the classical artists, and already resembling ideas later elaborated by Einstein.

Cézanne gradually distanced himself from outline and light and shade, becoming attracted to the idea of creating a 'space filled with colour'. During the time he spent working with Camille Pissarro at Auvers-sur-Oise in 1872 and 1873, he assimilated the techniques of Claude Monet, but rejected divisionism in favour of an analysis of mass, plane and per-

spective based on abstract reflection, not simply subordination to subject matter.

He preferred the stable light of the south to the changeable light of the north. The hieratic portraits of his wife – some of which required more than a hundred sittings – and the six fine portraits of the gardener Vallier, featuring a transparent, watercolour-like effect, display a modification of the spectator's vision by the dissolution of established forms into individual facets. Unlike in the work of the Cubists, however, these works were based on an underlying structure.

Reversing the principles of perspective inherited from the 15th century, Cézanne took up Maurice Denis's description of a painting as a 'flat surface covered with colours assembled in a certain order', but invested it with a fundamental coherence – using a complex system of colour modulation based on the elimination of outline and flat colour – that was closer to reality. Paul Gaugin admired Cézanne, who in turn was contemptuous of him. Cézanne declared that 'Gaugin was not a painter, simply a maker of Chinese images'. He criticized Gaugin for the lack of modulation in his canvases, which led him to juxtapose large areas of colour and give his figures a strong outline. To the problem of depth, Cézanne strove to find a solution based on the modulation of tones. Preparing the way for contemporary painters, he relied on the intrinsic qualities of colour as a tool. For him, line and form were closely linked, with colour determining the fullness of form through a fusion of the form-colour and outline functions, and to this the artist added his knowledge of simultaneous contrast. This allowed him to create a sense of depth through the highly skilful interplay of hard and soft outlines between his touches of colour. Rejecting both improvisation and empiricism, he replaced these with a thoughtful sensitivity.

At the end of his life, Cézanne stated that he was merely at the early stages of his investigations and expressed the hope that other painters would pursue the steps he had taken towards a system of representation in which the power and authenticity of reality would be conveyed through colour. Despite exhibiting at the premises of dealer Ambroise Vollard in 1895 and at the Salon d'Automne of 1904, his last years were largely solitary.

Posthumous tribute was paid to him, however, in the form of a retrospective at the Salon d'Automne of 1907, and the avant-garde artists of the time – the Fauves, the Cubists, Henri Matisse, Pierre Bonnard, Kasimir Malevich – soon came to regard him as a point of reference. In the second half of the 20th century, the majority of abstract painters, including Josef Albers, took the experimentation Cézanne had started even further, proving that his legacy still remains alive today.

REVOLUTIONS THROUGH COLOUR

A generation of painters and sculptors of great individuality working in France at the beginning of the 20th century absorbed the aesthetic discoveries of the previous century but went beyond these to produce works of great density that anticipated the experimental avantgarde that would follow. Their boldness, though not excessive, shocked visitors to the shows of the time – young girls were denied access by the authorities to Vallotton's 1910 exhibition in Zurich, for example – but their work soon came to be regarded as conventional in comparison with the huge changes in systems of representation that would later spring from it. Painters Édouard Vuillard (1868–1940), Félix Vallotton (1865–1925), Louis Valtat (1868–1952), Paul Ranson (1864–1909), Pierre Bonnard and sculptor Aristide Maillol met at the Académie Julian in Paris and were associated with the Nabis, a group formed in 1888 by Maurice Denis (1870–1943) and Paul Sérusier (1865–1927), although they rapidly began to evolve in their own individual ways.

Félix Vallotton, *House and Reeds*, 1921 (MNAM, Centre Pompidou, Paris). A realist painter at the outset of his career, Vallotton subsequently adopted the principles of the Nabis, before returning to realism after 1918. The strength of his paintings lies in their affirmation of the autonomy of representation, the reduction of his subjects to a few essential shapes and the use of a sober poetic palette. Vallotton was to have a major influence on the artists of the Brücke group.

Post-Impressionism

These painters were encouraged by brilliant art dealers, such as Ambroise Vollard, and the poets and intellectuals with which they associated: Gide, Mallarmé, Léon Blum, Clemenceau and, in Vallotton's case, Alfred Jarry, author of *Ubu Roi* ('King Ubu'). Despite the acuity of their views, the violence of the times and the constant splintering of the

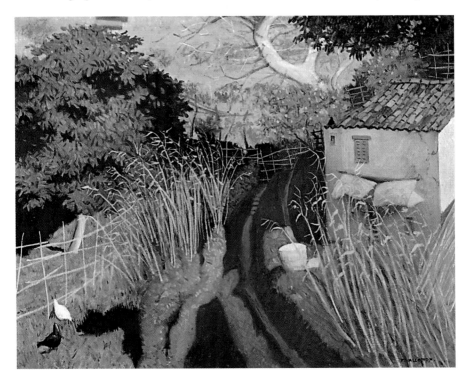

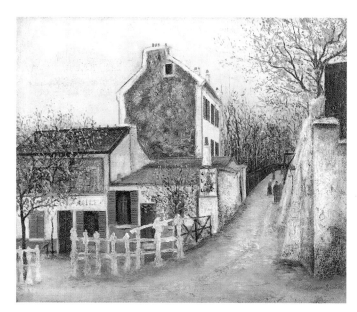

Maurice Utrillo, *Le Lapin Agile*, 1910 (MNAM, Centre Pompidou, Paris). This picture is from Utrillo's white period. As was his custom, he drew his inspiration for this work from one of his favourite haunts, a tavern in Montmartre previously known as the Cabaret des Assassins and punningly renamed in honour of the caricaturist André Gill: 'Là peint A. Gill' ('A. Gill paints here'). It displays the skill of the artist (who was affected throughout his life by alcoholism) in maintaining cohesion and equilibrium of composition, despite his bold decision to position the higher buildings in the background, thus inverting the classical ideal of decreasing height. It was at the Lapin Agile that writer Roland Dorgelès organized the greatest hoax in modern art when Aliboron, the donkey of tavern manager Frédé, painted with its tail a splendid abstract work entitled *Sunset over the Adriatic*, which was successfully exhibited at the Salon des Indépendants in 1910. The hoax can be attributed to the general derision with which modern art was regarded.

artistic movements of the day, they ensured a continuity of style based on a specific set of aesthetic values until after World War I.

The name Nabi, Hebrew for prophet, was invented by poet Henri Cazalis because by rejecting academism, naturalism and the flat verism of Impressionism and pointillism, the group revealed a truth that transcended a mere optical recreation of the real. They adopted some of the techniques and approach of Sérusier and Maurice Denis, who were in turn inspired by Van Gogh, the Pont-Aven School and Gauguin, namely the treatment of surface based on areas of pure colour, the abolition of perspective and a need to bring the emotions into play in the creation of art. They adhered to statements made by Maurice Denis (in an article of August 1890): 'Remember that a picture is essentially a flat surface covered with colours assembled in a certain order'; and Jan Verkade, a disciple of Gauguin: 'We say no to perspective. A wall should remain a surface, should not be pierced by the representation of infinite horizons.'

Vuillard, Vallotton and, above all, Bonnard undertook a stylistic reinterpretation of the paintings of Van Gogh and the painters of the Pont-Aven School, suppressing their mystical and hedonistic references and integrating into their formal system the problematics of traditional Japanese art, which rejects the visual illusion of reality.

World War I disrupted the momentum of their experiments. From 1918 onwards, Vuillard took refuge in a certain academism, whilst remaining inseparable from his loyal friend Bonnard. Following his Fauvist phase, Valtat devoted himself to painting still lifes in seclusion. Vallotton, bitter and disillusioned, experienced considerable difficulties and contributed a series of anarchistic illustrations to his friend Alfred Jarry's denunciation of political power games. He also continued to paint rigorous landscapes

that showed that he still adhered to certain values, such as equilibrium of feeling. Although the Post-Impressionists were more isolated and low-key than the avant-garde movements, the innovative character of their experiments would endure. Their frank and profound analyses of the most secret human drives would influence Edvard Munch, the Expressionists, painters of the Neue Sachlichkeit (New Objectivity) and Magic Realism movements and even the Surrealists. The Russian avant-garde and all the movements founded on abstraction would also later take up the rigorous construction of their works, and the Tachistes of the 1960s their decorative floral patterns.

Those painters who maintained a certain classicism of style include Albert Marquet (1875–1947), Raoul Dufy (1877–1953), André Dunoyer de Segonzac (1884–1974), Suzanne Valadon (1865–1938) and Maurice Utrillo (1883–1955).

Félix Vallotton, *The Harbour at Trégastel*, 1917 (Lausanne, Donald Paul Valotton, Galerie du Chêne). In this 'studied landscape' devoid of human or animal life, painted during the war, Vallotton, having freed himself from the Nabi style, rejected naturalist illusion in order to capture the poetry and power of the elements in this typical Breton scene. An admirer of the carefully constructed art of Poussin, he ceased working from life, painting instead from sketches. The rather oppressive shapes in this painting hint at the artist's bitterness. He was deeply affected by visits he made to the front and by seeing the misery of the population at large.

Pierre Bonnard: stylistic originality

The life and work of Pierre Bonnard (1867–1947) present an illusion of calm and transparency. In 1889 he became a member of the Nabis, but soon distanced himself from them. He also freed himself from the other main influences on him (Gauguin, the Impressionists and the Symbolists) and developed his own personal style. He would continue to read the Symbolist poetry of Mallarmé all his life, however.

Bonnard remained most influenced by the essential elements of traditional Japanese art, to which he was introduced at an exhibition at the

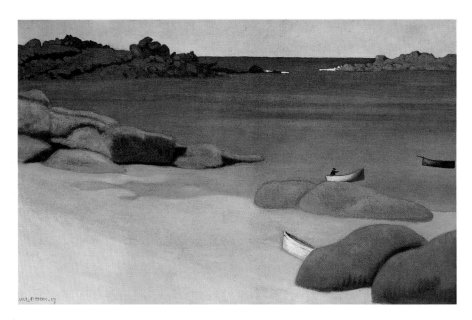

DER BLANE WEITER LONDON AQUARELLE KULI DINI DUCOLLO DELAUNAY KUPKA DIE VLAMINK RUSSIAN AVANT-HARDE MARDA ISM SCULPTURE SEVERINI NEU-IMPRESSIONISM PICASSO
CONSTRUCTIVISM ISSE KLEE DIE BRÜCKE ARCHIPE DUNCAN BONNARD SUCABIA DIE CHIRICO AVENT-GARDE COMPUTERS CUBRRISM DER BLAUE REITER SEURAT SANDUCK MUNCH BOCCIONI
SOBURG DER OTENRIIKE PRIZE SKI FURTURIISM GRIS SOUTINE DICKINE PARIS SEURAT ROUSSEAU KOKOSCIIKA MUNCH MAGIC REALISM PRESSIONISM STETYS VILLAIN BOCCIONI NEU-OBJECTIVITY
SBURG MONDRIAN NEO-PLASTICISM BAUHAUS BOCCIONI THE BLUE RIDER MARC KANDINSKY LARIONOV INTERNATIONAL MODERN EXPRESSIONISM DERAIN BOCCIONI THE BLUE RIDER

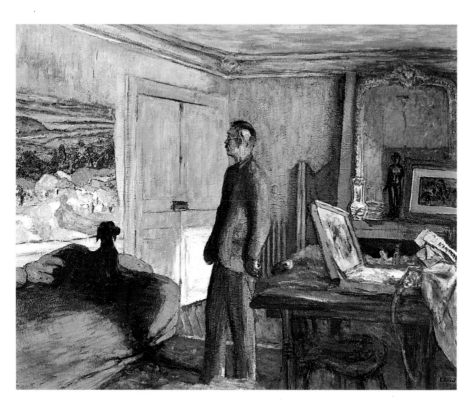

Édouard Vuillard, *Portrait of Bonnard*, c.1930–1935 (Musée du Petit Palais, Ville de Paris). This preparatory study for his portrait of Bonnard, also in the Petit Palais, reveals both Vuillard's taste for interiors and the deep friendship between the two painters. He has captured Bonnard subtly, in the process of examining one of his paintings with a critical eye. The painting is fixed to the wall, not resting on his easel as was Bonnard's custom (he reworked his pictures constantly). The humorous inclusion of his small and attentive dog is a reminder of his love of animals.

École des Beaux-Arts in Paris in 1890, earning him the nickname *Nabi très japonard* (very Japanese Nabi) from Maurice Denis. This influence can be seen in his choice of subjects – women, nature, flowers, fruit, anything fragile, evanescent and eternal – but above all in his treatment of perspective, which is based on the theory of 'dual viewpoint', ie alternating horizontal and vertical planes.

From 1895 onwards, Bonnard's style became more original as a result of his reflections on art theory. Despite the obvious seductive power of his colours and subjects, his painting had a cognitive and discursive aim. This is evident in *Reflection or the Tub*, 1909 (private collection, Winterthur) and in his series of self-portraits. Complex and rich in nuances and contradictions, beneath a deceptive surface of prettiness and bourgeois intimacy, his art elicits a permanent alertness of mind. Although they did not alter the quantity of his output, the two world wars, through which he lived in seclusion, had a deep effect on him.

Bonnard was to have a major influence on 20th-century art as a result of his re-examination of the traditional representation of space, and this would also influence the Russian avant-garde; Malevich himself (see page 57) took his inspiration for the composition of *The Flower-Girl* (1904–5, State Russian Museum, St Petersburg) from Bonnard.

Bonnard anticipated abstraction by defining pictorial space in terms of the laws that relate specifically to it and that are independent of the

Pierre Bonnard, *Signac and his Friends Sailing,* started 1914, finished 1921 (Kunsthaus, Zurich). During this time, Bonnard used to make frequent trips to Saint-Tropez with his friends the painters Henri Manguin and Paul Signac, and was seduced by the light – tinged blue by the sparkling sea. As was his custom, he returned to this painting a number of times. Bonnard experienced a crisis between 1911 and 1913: having been 'seduced' by colour, and fearing a return to the sketchy brushwork of the Impressionists, he decided to devote himself once more to line and composition. Here he masters space through the juxtaposition of different planes and dispenses with the vanishing point. The play of the diagonals and the outline of the boat, which is cut off by the edge of the picture, is reminiscent of Japanese art. The colour scheme (cold colours for the light, warm for the shadows) is all the more bold for its reversal of the norm.

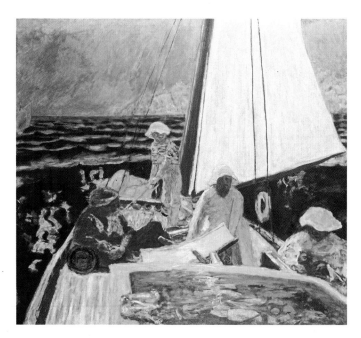

subjective and spontaneous vision of the individual, and by reasserting the value of the surface of the picture by means of what Mallarmé called 'artistic perspective' – something the painter admired in the work of Manet. He applied these new rules to the large-format interiors or lyrically coloured landscapes that he painted between 1926 and 1928, and also to nudes and portraits of those close to him, such as his companion Marthe, his friend Paul Signac and his animals, for which he had a special fondness. Between 1938 and 1945, during the dark days of World War II, which made him think the world was 'going mad', he completed five self-portraits lacking in any sense of complacency regarding his destiny.

Fauvism

Fauvism, generally considered the first artistic revolution of the 20th century, can be seen as a manifestation of the main impulses of the century: towards autonomy of colour and the intervention of the painter's emotions as a constituent part of the picture. Visiting the Salon d'Automne of 1905 – at which Matisse, Derain, Rouault, Marquet, Manguin, Vlaminck, Van Dongen, Puy, Valtat and also Kandinsky and Jawlensky exhibited – the art critic Louis Vauxcelles was heard to exclaim 'Donatello parmi les Fauves!' ('Donatello among the wild beasts!') in front of an Italianate sculpture by Albert Marquet. With this piece of remarkably sharp metonymy, Vauxcelles defined as a movement

HENRI ROUSSEAU KEVIS SCHOUTTE BORN NIKET HENRI-EDMOND CROSS ANNA MODERSOHN MORISSON KVACY CARLO A RANKUND POLLIVION THE BLUE RIDER MARC KANDINSKY LARIONOV SEVERINI BRIDGE KIRCHNER NOLDE ROSSO SIGNAC AMPT ROSE SURREALISM DERAIN BOCCIONI SEVERINI NOLDE MACKE CROSS THE SEVEN ANGELO BRAQUE MATISSE KANDT DIE BRUCKE KIRCHNER KANDT PARIS SCHOOL ROUSSENT LA MALEVICH DERAIN STAEL GRIS SEURAT BLAUE REITER FAUVISM MUNKEL PERCEPTION OF BURG MONDRIAN NEO-PLASTICISM BAUHAUS BOCCIONI THE BLUE RIDER MARC KANDINSKY LARIONOV INTERNATIONAL MODERN EXPRESSIONISM DERAIN BOCCIONI THE BLUE RIDER F

Raoul Dufy, *The Three Parasols*, 1906 (Museum of Fine Arts, Houston). Born in Le Havre, Dufy frequently took his inspiration from the Normandy coast. Having admired Matisse's painting *Luxe, Calme et Volupté* at the Salon d'Automne in Paris in 1905, he adopted the principles of Fauvism, evident here in the dynamism of the lines and in his use of brilliant, pure colour for the parasols. The strength of the drawing, however, also anticipates his brief Cubist period in 1908. Dufy did not develop his own personal style, characterized by a light graphic quality, fresh colours and a plunging perspective, until after 1918.

what since 1899 – when Matisse completed a number of landscapes of Corsica and Toulouse in particularly vivid colours – had been an experimental trend involving a dozen highly individual painters grouped around Matisse. Matisse, however, refused to see himself as their leader. The 'Cage aux Fauves' ('wild beasts' den'), as Vauxcelles dubbed the exhibition, caused an outrage, and Matisse's painting *The Woman with the Hat* (1905, private collection, San Francisco) in particular. These painters were also referred to as the 'incoherents' and the 'invertebrates'. All were French, with the exception of the Dutch Van Dongen, and all were self-taught but for Derain, whose erudition contrasted strongly with the libertarian roughness of Vlaminck. The 1905 Salon was a starting point for Dufy and Braque; that of 1906 witnessed an affirmation of their talent.

A number of retrospectives were held around this time that were revelatory for the Fauves: Van Gogh at the Galerie Bernheim-Jeune in 1901 and the Salon des Indépendants in 1905, and most importantly Cézanne at the Salons d'Automne of 1904, 1905 and 1907. Delacroix, Turner, Degas, Manet, Odilon Redon, Monet, Gaugin and the Expressionism tinged with pessimism and Symbolism of Norwegian Edvard Munch (1863–1944) also exerted a major influence on Fauvism and the Expressionism that was developing in Germany during the same period.

Matisse had studied the book *From Delacroix to Neo-Impressionism* (1899), written by Paul Signac, a master of pointillism. In 1904, he

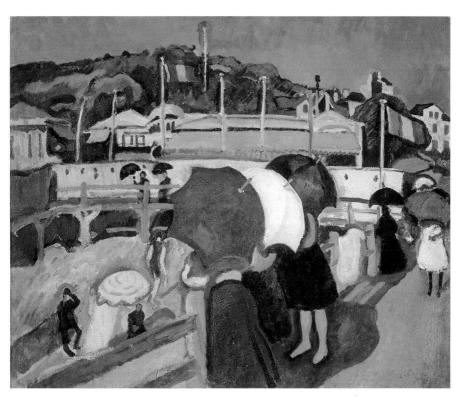

REVOLUTIONS THROUGH COLOUR

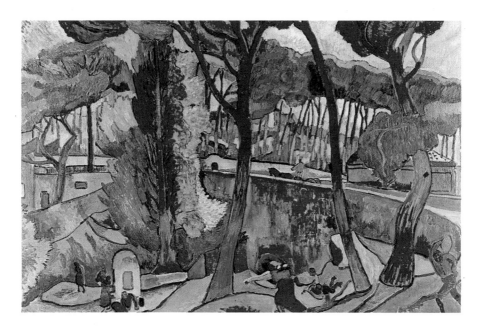

André Derain, *Turning Road at L'Estaque,* 1905 (John A and Audrey Jones Beck Collection, Museum of Fine Arts, Houston). Derain worked closely with Matisse in 1905, and shared his interest in the landscape around L'Estaque. Here he depicts it in a pure Fauvist style, with dominant reds set off by their complementary colour, green. Derain started to paint in a Cubist style in 1908.

exhibited 13 pointillist works, and although he later rejected divisionism, which he viewed as a superficial and fastidious technique, he did retain Signac's lessons on colour theory. Derain and Matisse were also fascinated by Negro art, which was fundamentally expressionist, and in 1906 Matisse became the first artist of the period to buy an African mask.

Although consisting exclusively of French painters, the Fauves had an international impact, thanks to Russian collectors Shchukin and Morozov, the painters Kandinsky and Jawlensky, and Matisse himself, who travelled a great deal, particularly in Russia. In 1908 he opened an academy attended by numerous foreigners, especially Germans and Scandinavians, at his studio in the Rue de Sèvres, moving later to the Hôtel Biron, in Paris.

In the words of Derain, Fauvism, which emerged while the crisis of representation was at its most intense, would be an 'ordeal by fire' for painting. The Fauves, rejecting neoclassicism and Symbolism, divisionism and Impressionism, asserted the autonomy of colour as a means of representing space. The relationships between artists were productive and helped this trend to develop. Matisse and Derain, who worked together closely, produced the first real Fauvist canvases at Collioure during the summer of 1905; and Friesz and Braque met up in 1907 at La Ciotat and L'Estaque, where the landscapes were a source of inspiration to them. Derain and Vlaminck founded the School of Chatou in a small village near Paris to which Courbet, Degas and Renoir had earlier come in search of inspiration.

Fauvism, described by French art critic Camille Mauclair as a 'paint pot hurled in the face of the public', is characterized by a distortion of

DER BLAUE REITER FAUVES M MAGRITTE BOCCIONI DI MILLO DE CHIRICO DI BRA DIE SPADING KIRKUSHA XVI CL GARDI M BRANCUSI BULLDOG M DER BLAUE REITER MARC KANDINSKY LARIO IONEXPRESSIONISM DE KNOCKE MIT DA TUSODO NEW ARCHITRUTY DIE ERLE PADAISS DWAN RARY MORELLA ART ARTHUR CO MERZ SMM CLARET SURREALISM ASCOTTON SSIONISM NEUE PROTECTION LES REVE REHDEO DEMIDIA PIAXSE SAMIT DIE BRUCKE KIRCHNER ZMUNCE PADES SCHLICK CIVACIEMPTO NACHRIXA MUNKHSSM CE GRIBSKER L DER BLAUE REITER FAUVES MAGNET QUEEB COCNI ISBURG MONDRIAN NEO-PLASTICISM BAUHAUS BOCCIONI THE BLUE RIDER MARC KANDINSKY LARIONOV INTERNATIONAL MODERN EXPRESSIONISM DERAIN BOCCIONI THE BLUE RIDER

volume, the rejection of natural colour (ie colours that reflect reality faithfully) and the division of the canvas into patches of pure, warm, strident colour positioned in powerful contrast with each other, a translation of the artist's emotions. The intensification of colour was aimed at increasing the impact sought and experienced during the contemplation of nature. Matisse declared: 'We must find arbitrary feelings capable of signifying the real world'. The Fauves' paintings are not lucky 'throws of a dice' and they only seem to be spontaneous. They achieved a synthesis or 'condensation' of feeling based on the manner of their construction. Without being linear, they retained perspective, 'the perspective of feeling', according to Matisse, by the juxtaposition of different planes, which allowed the presence of the artist to show through. Mastery of the laws of simultaneous contrast, used frequently in their works, produced effects of spatial recession and advancement, and the elimination of both outline and light and shade.

The Fauves' main subject matter was nature, but rather than portraying its ethereal, moving elements, such as air and water, as the Impressionists did, they chose to depict a nature with man's mark on it – although human beings figure only rarely – and with the exception of Derain, they even went as far as avoiding earth pigments. In contrast to the Expressionists, the Fauves, apart from Rouault, expressed a pagan *joie de vivre* through their work. The strength of their emotions was lived in the present and was devoid of any visionary dimension. Their openness to the century and the acuity of their reflections on the destiny and function of art are apparent in their writings – such as Matisse's *Les*

Maurice Vlaminck, *The Bridge at Chatou,* 1906 (Musée de L'Annonciade, Saint-Tropez). Of all the Fauves, Vlaminck was the only one who remained faithful to Fauvist principles all his life. This view of Chatou, near Paris, where he established the School of Chatou, has been intensified by touches of pure colour, which convey the emotions of the painter.

Henri Matisse, *Open Window*, Collioure, 1905 (collection of Mrs John Hay Whitney, New York). Following Fauvist principles, Matisse depicted not just the landscape, but also the window uprights in vivid, non-naturalistic colours. His style still retained traces of Neo-Impressionism, visible in the different planes achieved using short, strong touches of colour, and in the absence of lines of perspective. Throughout his life, Matisse returned repeatedly to the theme of the window, which reached its pinnacle in *French Window at Collioure*, started in 1914. According to the writer Louis Aragon in *Je N'ai Jamais Appris à Écrire* (1969, 'I Never Learned to Write'), this was 'the most mysterious picture ever painted, which seems to open onto this "space" of a novel just beginning, and about which the author as yet knows nothing, as in life'.

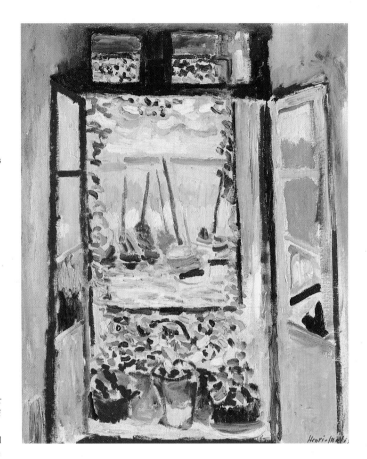

Notes d'un Peintre ('A Painter's Notes') of 1908, and the articles he and Derain published in *La Grande Revue* the same year – which were not, however, meant to be overly theoretical.

Its experimental character led the group to disintegrate in order to explore new avenues. Having been a meteoric force, the Fauvist movement finally fizzled out around 1908. Other than Vlaminck, who turned to Expressionism after a brief Cézanne-influenced phase, the Fauves all pursued different trends that were already present in their early work. Braque, whose Fauvist works consisted of subtle touches of colour against a white background, went back to the teachings of Cézanne and became a Cubist painter. Derain, like Friesz, worked in seclusion on a nostalgic rediscovery of the great masters. Van Dongen, Rouault and Marquet chose more individual paths.

Matisse – whose literary interests had already been clearly signalled by the title he gave to the painting *Luxe, Calme et Volupté* (1904, MNAM, Paris) (a quotation from Baudelaire's poem 'L'Invitation au Voyage'), which had been preceded by a series of studies – would continue his research into expression through colour and into harmony through the arabesque. By redefining the limits of representation, the Fauves

succeeded in liberating artists from the status that had become rigidly defined for them over the preceding centuries.

Expressionism

The Expressionist movement began in Germany in 1905, at the same time that Fauvism was emerging in France. The term appears to have been first used by the famous art dealer Paul Cassirer to describe the work of painter Max Pechstein in Berlin in 1910. Expressionism arose directly out of the three Secession movements formed by dissenting artists in Germany and Austria as a reaction to the academism, naturalism and nationalism prevalent at the time.

The first Secession, based around Franz von Stuck, Wilhelm Trubner and Wilhelm Uhde, took place in Munich in 1892 and leaned towards Impressionism. The second developed in Vienna in 1897 under the guidance of Gustav Klimt (1862–1918), who was its first president (1897–1905), and was closer to Art Nouveau. The 49th exhibition of this branch of the Secessionist movement, held in 1918, revealed the talent of Egon Schiele (1890–1918). The third and most important Secession followed in 1899 in Berlin, and brought to a wider audience the work of

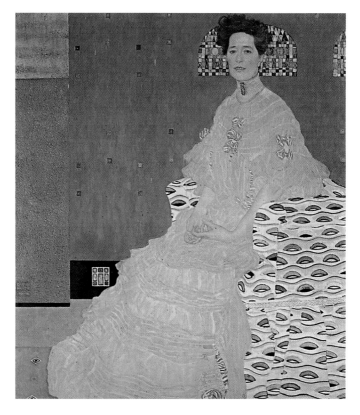

Gustav Klimt, *Portrait of Fritza Riedler*, 1906 (Österreichische Galerie, Vienna). Klimt painted numerous portraits of female members of the Viennese intelligentsia, among them Emilie Flöge, Sonja Knips and Elizabeth Wittgenstein. He sought to combine aspects of Japanese art – such as the asymmetrical composition – with decorative elements of medieval and Byzantine art. The foreground and background merge, and forms are dematerialized as a result of the repeated patterns and two-dimensionality of the surfaces. Unlike another great Viennese portrait painter of the period, Richard Gerstl, the hieratic quality of Klimt's human figures, though seen in grand isolation, lends his portraits a certain serenity.

the Nabis, the Fauves, Kandinsky and, above all, Edvard Munch (see page 21) through its exhibitions.

In the prominence given to the artist's emotions – his 'wild existential anger' (Nietzsche) – and tragic reflections on the universe, Expressionism reveals origins that go back further, however, to Romanticism and Symbolism, to Goya (1746–1828) in Spain, Blake (1757–1827) in England, and Caspar David Friedrich (1774–1840), Arnold Böcklin (1827–1901) and Hans von Marées (1837–87) in Germany. When Herwarth Walden, director of the review *Der Sturm*, wrote an account of the history of Expressionism, he described it as having influenced all the artistic revolutions between 1910 and 1920. Unlike Fauvism, the trend permeated a number of styles, both past and contemporary, including the Fauvist works of Matisse, Van Dongen, Rouault and Picasso's blue

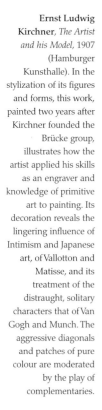

Ernst Ludwig Kirchner, *The Artist and his Model*, 1907 (Hamburger Kunsthalle). In the stylization of its figures and forms, this work, painted two years after Kirchner founded the Brücke group, illustrates how the artist applied his skills as an engraver and knowledge of primitive art to painting. Its decoration reveals the lingering influence of Intimism and Japanese art, of Vallotton and Matisse, and its treatment of the distraught, solitary characters that of Van Gogh and Munch. The aggressive diagonals and patches of pure colour are moderated by the play of complementaries.

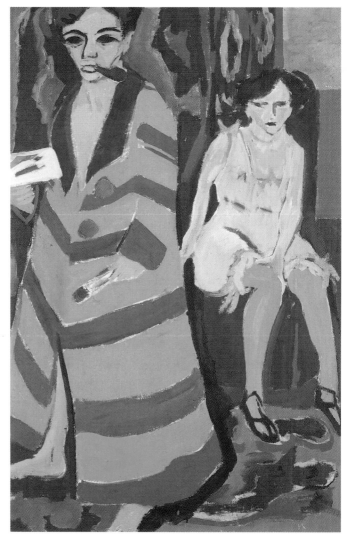

Edvard Munch

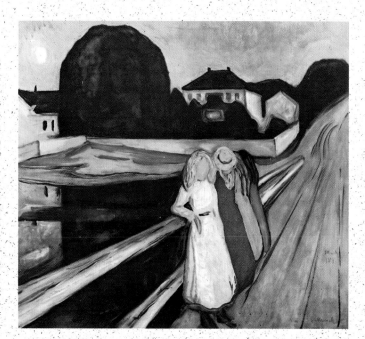

1863. Birth of Edvard Munch in Loten, Norway. Having shown precocious artistic talent, he produces pictures of considerable quality as early as 1877. Munch is deeply affected by the illnesses – tuberculosis and depression – that afflict members of his family, and death would later become one of his recurring themes.

1892. Munch is invited by the Association of Berlin Artists to exhibit works that are already Expressionist; these create an uproar that leads to a split within the association and gives rise to the Berlin Secession. Munch is badly affected by this failure.

1893. Munch's masterpiece *The Scream* is followed in 1894 by *Anxiety*.

1899. In Italy, Munch is fascinated by Raphael and the art of the Renaissance, which provide the inspiration for his decorative panels *Red Virginia Creeper* (1898–1900) and *Golgotha* (1900).

1901–13. Regular exhibitions of Munch's work in Vienna.

1902. *Frieze of Life* shown in Berlin. This work, begun in 1893, deals with the three ages of man through the themes of love, death and the demonic nature of woman. Munch is shot in the left hand by Tulla Larsen, whom he refused to marry, when he tries to break off their affair, and this tragedy provides the inspiration for a number of paintings including *Still*

Life (1906 and 1907) and *The Death of Marat* (1907).

1903. Munch becomes a member of the Société des Artistes Indépendants in Paris and exhibits in their Salon.

1904. Appointed a regular member of the Berlin Secession. The Vienna Secession devotes an entire room to him, as it does to Hodler, and he exhibits 20 paintings, which are a great success.

1906. Creation of scenery for Ibsen's plays *Ghosts* and *Hedda Gabler*.

1908. Munch has become an alcoholic and is involved in a number of violent brawls. This year also marks the onset of severe depression, for which he seeks treatment in Denmark.

1910. Munch returns to Christiana (Oslo) in Norway, where he paints bathing scenes, animals, and peaceful scenes of nature. He experiments with a more universal form of expression, overlaid with an element of social comment in works such as *Snow Shovellers* (1911) and *Workmen on their Way Home* (1912).

1922. Munch paints murals for an Oslo chocolate factory.

1937. The Nazis confiscate 82 of his works from German galleries as 'degenerate art'.

1944. Munch dies alone at home in Ekely, near Oslo. Munch refused all contact with both German occupiers and Norwegian Nazis.

REVOLUTIONS THROUGH COLOUR

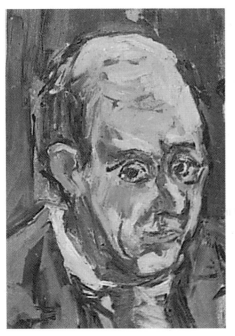

Oskar Kokoschka, *Portrait of Arnold Schoenberg*, c.1924 (private collection, New York). This portrait of composer Arnold Schoenberg, founder of the Second Viennese School, was painted by Kokoschka during one of his trips to Vienna while employed as a teacher at the Dresden Academy. Uncovering a certain disarray, the painter has exposed the deeper psychological make-up of his subject in a pose lacking in solemnity and which is very different to Richard Gerstl's portrait of Schoenberg. The artist has employed an Expressionist technique, previously used by El Greco and Goya, to produce a subtle deformation of the facial features.

period. It suits our purposes here, however, to confine our examination of it to Die Brücke (The Bridge). The group was founded in Dresden in 1905 by four architecture students – Fritz Bleyl (1880–1966), Erich Heckel, Karl Schmidt-Rottluff and Ernst Ludwig Kirchner, who became their leader – and its members included Emil Nolde, Max Pechstein, Otto Mueller, Georg Grosz and Otto Dix. Die Brücke, unlike the Fauves, was an experimental group inextricably linked to the social tensions of the day. Its name evokes something that unites artists against the forces of convention and leads them towards the future, and was a reference to Nietzsche's book *Thus Spake Zarathustra*, read with enthusiasm by Kirchner, and the passages in it on the symbolism of the bridge.

Unlike its art, which was stagnating in academism and Romanticism, German society was undergoing a period of major change as a result of a 'great leap forward' brought about by the unprecedented industrial growth of 1897–1914. German steel production was three times that of France, the workforce of the Ruhr rose by 90 percent and the harsh living conditions there spawned movements of socialist solidarity. Wilhelm II's pan-Germanist regime accentuated the divisions between agricultural Prussia – including Berlin – and the Ruhr and industrial south, and created a profound imbalance. Overproduction, one of the causes of the War, was already becoming a concern.

The artists of the Brücke experienced very intensely these tensions and threats, which already seemed to be reflected in the pessimistic and symbolist expressionism of Edvard Munch, whose work they would have been able to see at the Berlin Secession, the paintings of Van Gogh or Gaugin and African and Oceanian art, which Kirchner had researched at Dresden's Museum of Ethnography. They sought to differentiate themselves clearly from the Art Nouveau-derived Viennese Jugendstil, and in challenging bourgeois mores and values, as well as the academic conventions of art, claimed to be creating a new way of life. They rediscovered the formal and symbolic value of Gothic art, along with what they thought represented an ideal way of life for true artists: the community spirit built on modesty and anonymity of the builders and sculptors who created the cathedrals. The Brücke artists held everything in common and established their studios in working-class districts in order to disseminate art more widely among the populace.

LEVENS ANTI-ART WOOD NEW OBJECTIVITY DE STIJL DADAISM MUNCH AMEDEO CABLA DE CHIRICO SHRL ZSO MUTHERS SURREALISM VOLPI EXPRESSIONISM NEU IMPRESSIONISM FILE ONY MA
LES DERAIN DIE BRUCKE KUNST DIE BRUCKE KIRCHNER MUNCH MONDRIAN DUCHAMPS HEINCKEL ERICH SCHMIDT DEN SCHMIDT SURMIDTERS STRINDBERG DER STADT REPUBLICA NEO MUNCH CUBLOCLONY CLEA
RG MONDRIAN NEO PLASTICISM BAUHAUS BOCCIONI THE BLUE RIDER MARC KANDINSKY LARIONOV INTERNATIONAL MODERN EXPRESSIONISM DERAIN BOCCIONI THE BLUE RIDER M

Expressionism offers obvious similarities with Fauvism, with which it was exactly contemporaneous, in its fragmentation of perspective inherited from the Renaissance and in a manner of pictorial construction based on a palette of pure colours used in violent contrast with one another. But it also differs from Fauvism in certain fundamental respects, namely in its pessimistic psychological content and visionary conception of history, which led Munch to declare of the Brücke: 'God help us! A time of misfortune lies ahead.' Anxiety, that moment of consciousness defined by Kierkegaard as a fusion of the present moment with eternity, is omnipresent. So, too, is the human figure: solitary, at a loss, charged with the task of expressing the worries of this troubled pre-war period and the universal cares of the human condition through what the critics of the time called barbaric instincts – eroticism, screaming, laughter – in poses devoid of any sentimental prettiness.

As stated in the Brücke's manifesto, this group of artists 'think in terms of a wall being a wall, that is to say in colour'. As with Munch, Van Gogh and Gauguin, form is conveyed through rarely modulated areas of flat colour, without recourse to any theoretical system other than the interaction of complementary colours, the only reference point being the artist's sensitivity and perception. At its extreme, this involved the integration of objects and individuals into the artist's own identity through the senses and through Einfühlung (empathy). Graphic skills again played an important role, enabling them to capture the basic characteristics of

Oskar Kokoschka, *The Bride of the Wind*, 1914 (Kunstmuseum, Basel). This painting was inspired by a storm witnessed by Kokoschka in the company of Alma Mahler in Naples in 1913. He has imitated the subtle palette of Tintoretto and the Venetian painters in order to heighten the expression of human emotion. Kokoschka has depicted himself at the side of Alma Mahler, for whom he bore an overwhelming passion that was unrequited. This portrait of the two lovers carried away by the raging elements conveys a powerful sense of nostalgia.

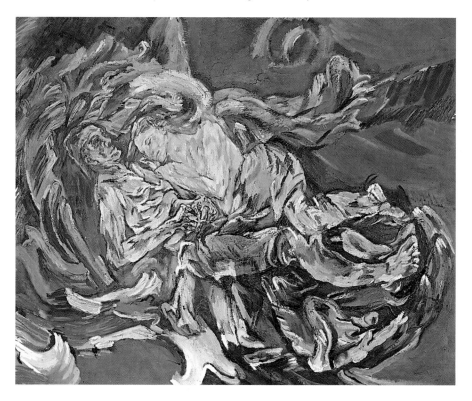

their subjects and essential lines of their landscapes, and thus translate their personal visions into paint more effectively. Initially, the Expressionists confined these influences to their prints – Kirchner produced more than 2000 – but from 1908 extended them to their paintings, still influenced by the style of Cézanne and Matisse c. 1905–6.

Expressionism, which regarded itself as universal in its approach to humanity's inner problems, was founded upon the subjectivism of artists who laid bare their own existence in order to help advance our knowledge of the human mind – in parallel with the psychoanalytical research being conducted as yet independently at the time – and in order to place art at the very heart of the prevailing social realities. This was a time when Sigmund Freud, who published his *Three Contributions to the Sexual Theory* in 1905, was quite separately developing methods for the analysis of neuroses that he – like Kokoschka and Schiele, as evinced in their paintings – observed in a decadent and introverted Vienna. It is the supreme irony that in this period that foreshadowed the most extreme violence, he was highlighting the role of instinct, and particularly that of the death instinct, in human behaviour. Like the art of the German Expressionists, the revolution based on his discoveries would only be felt much later.

The Brücke's final exhibition was held in Dresden in 1910, after which the group moved to Berlin and broke up. Its influence, however, spread, continuing to grow steadily. Prior to experiencing the horrors of war – that 'bloody carnival' as Kirchner described it – which was to take its toll of the members of the group, these artists became politically active on the left. Max Beckmann, Grosz, Otto Dix and Nolde remained Expressionists even after the War, and went on to found the New Objectivity (Neue Sachlichkeit) group in 1925. By asserting the autonomy of painting from the subject being depicted, and by endowing nature itself with meaning, this movement heralded the development of abstraction. Through *Einfühlung*, they opened up a more universal line of inquiry that conferred legitimacy on the emotions of the artist and allowed Expressionism to survive in the later years of the 20th century in the form of lyrical abstraction and the Action Painting of Jackson Pollock in the United States, the Cobra movement (1948–51) and the work of Pierre Alechinsky, Asger Jorn and Karel Appel in northern Europe, and Francis Bacon in Great Britain. The artists of the Brücke suffered persecution at the hands of the Nazis because they exposed their individuality, because they had such a strong, bold vision that was openly critical of the period they lived in and because they recognised the need for artistic expression to adapt in response to social upheavals. In the long term, however, they demonstrated that only those values that are constantly questioned can save civilization from decline.

BOCCIONI NEO-PLASTICISM NAIVE ART MONDRIAN NEW ART BEL GIOVANNI SEZESNA HUNKORAMI PARIS SCHOOL MONDRIAN BLAUE REITER NAIVE ART MARGUERITE AND RAM LA KINDE DE SANNALA KLEAT OF CHAIRO MONDRIAN NOVA L'EGART MARGUERITE BOCCIONI THE VENICE ART EXPRESSIONISM CEZANNE EXPRESSIONISM NEW ART DIE BRUCKE MAGRITTE MINER MANET BORN ART ITALIA GIACOMETTI TO SINO MORTIMA LE CORBUSIER DER BLUE REITER MUNCH MAGRITTE DUCHO REUBEN ART MONDRIAN NEO-PLASTICISM BAUHAUS BOCCIONI THE BLUE RIDER MARC KANDINSKY LARIONOV INTERNATIONAL MODERN EXPRESSIONISM DERAIN BOCCIONI THE BLUE RIDER M

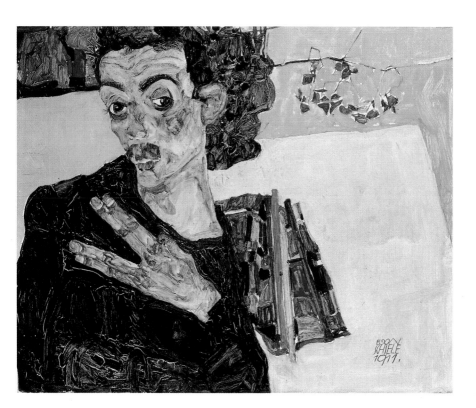

Egon Schiele,
*Self-portrait with Spread
Fingers*, 1911
(Historisches Museum
der Stadt Wien, Vienna).
Linked closely to Art
Nouveau before
becoming a central
figure of Viennese
Expressionism, Schiele
painted deserted,
visionary landscapes
and tormented portraits
and self-portraits that
reveal an obsessive
quest for identity,
offering an agonized
commentary on human
existence, life and death.
Inspired by
psychoanalysis, he also
painted nudes whose
blatant eroticism led
to the artist's arrest
in 1912.

Naïve art

Although almost non-existent in northern Europe, naïve art was certainly not restricted to France. It developed in the Mediterranean countries: in Yugoslavia with Ivan Generalic, in Greece with Theophilos, who was discovered by Le Corbusier, in Hungary with Csontvary, in Georgia with Pirosmani, in Central and South America, and in the United States with Grandma Moses (Anna Mary Robertson Moses). In Britain its main exponent was Alfred Wallis (1855-1942), a fisherman and scrap merchant who turned to painting during his retirement in St Ives. His informal painted objects and richly worked constructions reflected his seafaring experience, and were admired for their immediacy by local avant-garde painters Christopher Wood and Ben Nicholson.

France, however, did produce a number of highly talented individuals. Unlike Art Brut (the garden of postman Cheval, at Hauterives in the Drôme, is one of the best examples), which so fascinated the Surrealists and Jean Dubuffet, naïve art was characterized by a desire to produce finished work, meticulous in its level of imitation, which even parodies academic techniques.

The main exponents of this art were all from humble backgrounds: Louis Vivin (1861-1936) was a postal worker; André Bauchant

Séraphine Louis, known as **Séraphine de Senlis**, *Pomegranates*, 1930 (MNAM, Centre Pompidou, Paris). The repetitive density of the pictures of flowers and leaves meticulously painted by Séraphine is highly revealing of her confused state of mind during a period of crisis. Her employer and dealer, Wilhelm Uhde, abandoned her, driving her eventually into a psychiatric hospital. But her 'animist' approach to the plant world, glossy technique and refined use of colour testify to her talent as a painter, and earn her a place among the very greatest, despite the simplicity of her subject matter.

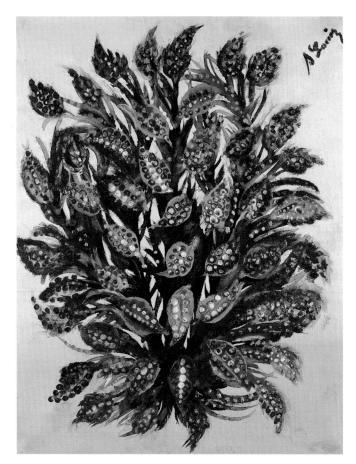

(1873–1958) was a nurseryman before serving as a rangefinder in Greece during World War I, returning with his head filled with images of antiquity; Camille Bombois (1883–1970) was a farm hand and subsequently a fairground athlete; Dominique Peyronnet (1872–1943) was a lithographic assistant; Henri Rousseau, 'Le Douanier', (1844–1910) was a customs officer in Paris; and most notably, Séraphine Louis, known as Séraphine de Senlis (1864–1942), was the housekeeper of German critic Wilhelm Uhde, who discovered her but exploited her talent.

Although they were from humble backgrounds and were self-taught, these naïve artists were committed to their art. They preferred to take up the classical and realist figurative tradition that was on display in the museums rather than the art of the ex-voto or sign, which they perceived as inferior genres.

Their art – characterized either by honesty and spontaneity, like that of children or the mentally disturbed, or by a candid and monumental interpretation of allegorical and historical themes – attracted the attention of many of the most important and rigorous artists of the time: Alfred

Jarry, Apollinaire, Robert Delaunay, Le Corbusier, Amédée Ozenfant, Picasso, Signac, Brancusi and even Serge Diaghilev, who commissioned the set and costumes for the Stravinsky ballet *Apollon Musagète* from Bauchant in 1928.

At at time when the art world was discovering Negro and primitive art, the work of the naïve artists seduced Giorgio de Chirico, the Surrealists and the Expressionists, who saw in it a new artistic sincerity, the translation of secret, and therefore true, impulses, even though their paintings were meticulous descriptions of reality, of the fixed and the finished, which earned them the tag 'popular masters of reality' at their first exhibition in 1937. They painted idyllic views marred, with apparent regret, by the errors of human tragedy.

Their smooth, meticulous and brilliant technique, identical to that of the classical painters, accentuates the weight and drabness of flesh tones, erases any sense of spirit, describes plant and animal species with precision and offers a simplified vision through the frontal depiction of both setting and figures, whose heads are excessively large relative to the rest of their bodies. But this realism goes hand in hand with a sense of unreality in the work of Séraphine – whose fantastic visions of flowers and leaves are nourished by a religious fervour – and in that of Louis Vivin or Le Douanier Rousseau, who believed in ghosts. The imagery of all these artists conveys a personally felt sympathy for the weak and victimized. Wilhelm Uhde said of Vivin's landscapes that they 'seem like the façades of another landscape'.

Their pictures offer a deceptively reassuring escapism and revenge on

Henri Rousseau, known as **Le Douanier**, *Negro Attacked by a Jaguar*, 1907 (Kunstmuseum, Basel). The naïve character of this exotic, motionless landscape, in which the paradisiacal vegetation is meticulously painted, is metamorphosed by Rousseau's imagination and visionary spirit into an oppressive and terrifying scene through the depiction of a man being viciously attacked by a beast.

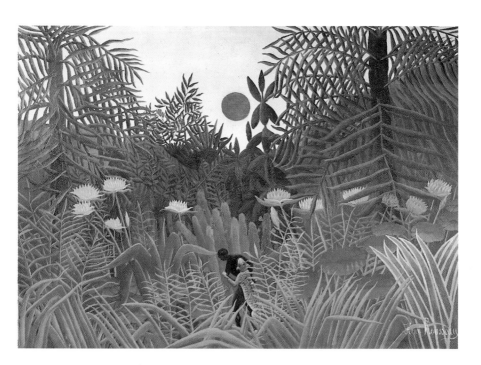

the aridity of everyday life. They evoke a golden age, a time of plenty or luxuriance, exotic dreams or jungle scenes, such as *The Snake Charmer* (1907, Musée d'Orsay, Paris) which was commissioned from Rousseau by Robert Delaunay's mother. But they are also traversed by serious and tragic themes such as war, cruel themes such as the death of animals or more trivial themes such as scenes of the humble lives they have led. Indeed, because Rousseau handled his disturbing or enigmatic jungle scenes with such sophistication, it was long suspected that it was actually Picasso who had painted *The Sleeping Gypsy* (1897, MOMA, New York).

The megalomania and repartee of the naïve painters provided material for countless anecdotes. Peyronnet compiled the catalogue for his own (and only) exhibition, guaranteeing that it was as flattering as possible. In 1907, having convicted Rousseau of theft, the presiding judge promptly released him upon seeing one of his paintings. The same year, Rousseau told Picasso: 'We are the greatest painters of the day, you in the Egyptian genre and I in the modern genre.' And in order to justify to Marie Laurencin the poor resemblance to her in his painting *The Muse Inspiring the Poet* (1909, Basel Museum), where she was depicted alongside Apollinaire, he declared that 'Guillaume is a great poet, he needs a large muse.' But oscillating between poverty and fame, artistic recognition and the skilful exploitation of the art dealers, a number of these artists later died in misery or madness. The richness and depth of the work of the naïve artists lie in its very defects and paradoxes.

The School of Paris

The School of Paris grew up relatively spontaneously between 1910 and 1920, and is sometimes extended to include all artists, both French and foreign, who were working in the city in a figurative style at the time. Paradoxically, the name should really be reserved for the émigré painters of strong artistic personality who arrived in Paris between 1905 and 1913, attracted by the atmosphere of freedom and intellectual effervescence that prevailed. Its main figures were Amedeo Modigliani (1884–1920), Chaïm Soutine (1894–1943), Moïse Kisling (1891–1953), Marc Chagall (1887–1985), Jules Pascin (1885–1930) and Tsuguharu Foujita (1886–1968). This legendary generation of ill-fated painters, grouped together in the Montmartre and Montparnasse areas of the city, achieved their artistic creation amid conditions of great excess, and perhaps because of them. Only Kisling and Chagall maintained a relatively conventional way of life. These artists had a great deal in common. Most of them were of Jewish origin and attached great importance to this, but they also shared a taste for wandering, a sophisticated and bohemian

IN SEVERINI NEO-IMPRESSIONISM PICASSO NAIVE ART MODIGLIANI VORTICISM ART DECO GAUDIER-BRZESKA FUTURISM GRIS SOUTINE ZADKINE PARIS SCHOOL ROUSSEAU KOKOSCHKA BLUE RIDER MARC KANDINSKY LARIONOV DE LA ORIVERA OROZCO SIQUEIROS RIVERA DUESBURG MONDRIAN NEO-PLASTICISM BAUHAUS BOCCIONI THE BLUE RIDER MARC KANDINSKY LARIONOV ISM EXPRESSIONISM DIERAN SACHLICHKEIT KIRCHNER MACKE PECHSTEIN NOLDE MUNCH KUPKA ACADIA ART DECO MERZ SCHWITTERS SURREALISM POST-IMPRESSIONISM NAIVE ART MODIGLIANI DE LA ORIVERA OROZCO SIQUEIROS RIVERA DUESBURG KOKOSCHKA SOUTINE ZADKINE PARIS SCHOOL ROUSSEAU KOKOSCHKA VORTICISM ART MERZ KANDINSKY DECO GAUDIER-BRZESKA FUTURISM GRIS SOUTINE ZADKINE PARIS SCHOOL ROUSSEAU KOKOSCHKA BLUE RIDER M

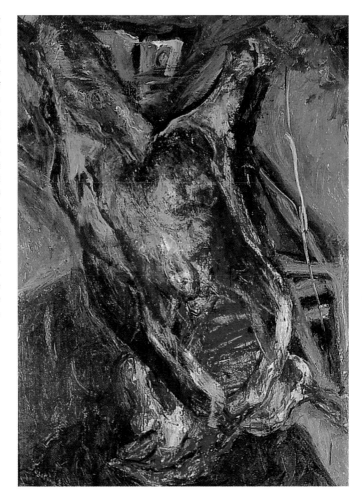

Chaïm Soutine, *The Carcass of Beef*, 1925 (private collection, New York). Soutine was heavily influenced by the prohibitions of traditional Jewish culture and the theme of death. He favoured saturated colours, in particular red, which he accentuated by using it against cold backgrounds. In this frontal composition, the strongly Expressionist dislocation of form produces a powerful emotional response, reinforced by the absence of perspective elements.

lifestyle (in some cases impoverished, as in the case of Modigliani, in others luxurious, as in the case of Kisling), a loyalty to figurative art – a closer link with real life – and their independence from avant-garde movements such as Cubism and Futurism, whose exponents were nevertheless their friends.

Their portraits, often commissions, transcend the insipidness and complacency of the academic tradition through their lucid, disenchanted, ironic and tragic take on the mysteries of individual and community life, which they strove to decipher. In their desire to go beyond the superficiality of the life that scarred them, they were consumed by their art. But their style remained deeply personal and marked by the tragedy of their lives.

The premature death of Modigliani, who was of Italian origin, followed by the suicide of his companion Jeanne Hébuterne, saw his work – devoted mainly to the nude and to stylized portraiture but little appreciated during his lifetime – raised to legendary status.

Marc Chagall, *The Blue House*, 1920 (MAMAC, Liège). Chagall painted many landscapes inspired by his hometown Vitebsk (Belorus), which he left in 1920. The contrasting unreal colours, and the way in which the houses, monastery and cathedral in the background, reflected in the Dvina River, all seem to move, evoke the dreamlike world of his tragic childhood. Chagall freed himself from the influence of the Cubists and Expressionists and formed his own style, not connected with any of the major movements.

Chagall retained his independence at all times, with respect to both the Russian avant-garde, of which he was one of the earliest members, and his School of Paris friends. Having arrived in Paris in 1910, he returned to Moscow when war broke out in 1914. As a result of the 1917 October Revolution, Russian Jews were finally granted official status as free citizens, inspiring him to paint a number of works on Jewish themes, including *Cemetery Gates* (1917, MNAM, Paris). He was appointed first director of the so-called 'free' Academy of Fine Arts in Vitebsk in 1919, but left in 1920 following a disagreement with Malevich and the Suprematists and returned to France for good in 1923. In their ambivalence, the works he painted in Paris, *To Russia, Donkeys and Others* (1911–12, MNAM, Paris) being one of the first, express the joys of intimacy and sensuality, pain, the disorientation of exile and his historical and individual destiny as an artist. Mystical and biblical metaphors mingle with his own world of memories of his Russian childhood. He introduced a tragic and magical dimension into his dreamlike paintings through the weightlessness of his figures, animals and objects. His style remained personal as a result of both his palette of unreal, acid colours and his psychological treatment of perspective, but also evoked the art of great masters such as El Greco, Giotto and Titian and even the Cubism of Gleizes, Metzinger and Léger.

The subtle colour, nacreous effect and delicate, precise drawing of Jules Pascin, born in Vidin in Bulgaria, resemble Foujita's Japanese technique and stem primarily from his talent as a draughtsman, which his mistress, a Bucharest brothel-keeper, had been the first to encourage. Following

several aimless years spent between Vienna, Munich and Berlin, where he
worked as a caricaturist, Pascin moved to Paris in 1906 before emigrat-
ing to the United States in 1914. There his work influenced painters he
met in New York such as Ganso, Brook, Dehn, Biddle (who admired his
'tolerant scepticism'), and above all the Japanese Yasuo Kuniyoshi, who
copied his linear style. But the freedom of the Parisian world that he had
frequented continued to exert its pull, and Pascin recrossed the Atlantic
in 1920. His artistic activity was conducted at an intense rhythm and
was punctuated by wild revelry. His life became a permanent spectacle
but he maintained an almost secretive relationship with his painting,
which he destroyed when he gave in, temporarily, to the temptation of
Cubism. He retained the same exquisite style throughout his life. This
was visible in portraits featuring modulated grey, beige and ochre half-
tones, with a lightly ironic touch in the treatment of the themes of love
and death. Weary of his own excesses and hurt by a negative critical

Amedeo Modigliani,
Woman with the Collar
(portrait of Anna
Zborowska), 1917
(Galleria Nazionale
d'Arte Moderna,
Rome). Modigliani's
work, little appreciated
during his lifetime,
concentrated on nudes
and stylized portraits.
This face, full of
refined, melancholy
grace, evokes Etruscan
art and that of Gothic
Sienna, studied at
length by Modigliani in
Italian museums. He
was also heavily
influenced by
Cézanne's portraits and
the African masks of
the Baoulé and
Yaoundé peoples.

response to his exhibition at New York's Knoedler Gallery, Pascin committed suicide in 1930.

Along with Yasuo Kuniyoshi (1893–1953), who went to live in the United States, Foujita was one of the very few Japanese artists throughout the long history of cultural exchange between the West and Japan to have emigrated permanently to the West. In 1913, after studying at the Imperial Academy of Art in Tokyo, he travelled to Paris, where he became one of the most prominent members of the School of Paris and befriended poet Robert Desnos and his wife. In 1940 he returned to Japan for the duration of the war, serving as a war artist with the rank of colonel. After repudiating the propaganda work he was forced to produce during this time, during the post-war 'purges' he decided to return to France for good, converting to Catholicism and adopting the name Léonard in 1959. Despite a veneer of modernist Expressionism, his portraits, self-portraits, still lifes and even the desolate landscapes he painted during his bohemian period in the 1920s reveal the enduring influence of Japanese art in their precious draughtsmanship, palette of subtle halftones, sensitive portrayal of plants and animals – above all cats – and treatment of perspective, which is almost always blocked by a close vertical plane.

Moïse Kisling, *La Naufragée*, 1927 (Kleinmann Collection, Paris). The portraits and landscapes of Kisling, who was born in Cracow in Poland, and who welcomed the sick and destitute Modigliani into his studio, are characterized by a cold, restrained density, and hinted from the outset at the influence of Cézanne and Derain. This influence became even stronger after the end of the War, during which he served in the French Foreign Legion. The artist combined his taste for brightly coloured decorative motifs with a sober compositional style of great lyricism.

Towards an evolution of form

During the early years of the 20th century, France was able to boast a wealth of major sculptors who exerted immense international influence.

DER BLAUE REITER MARC KANDINSKY LARIONOV INTERNATIONAL MODERN EXPRESSIONISM DERAIN BOCCIONI THE BLUE RIDER MARC KANDINSKY LARIO... DER BLAUE REITER MARC KANDINSKY LARIONOV INTERNATIONAL MODERN EXPRESSIONISM DERAIN BOCCIONI THE BLUE RIDER MARC KANDINSKY LARIONOV INTERNATIONAL MODERN EXPRESSIONISM DERAIN BOCCIONI THE BLUE RIDER

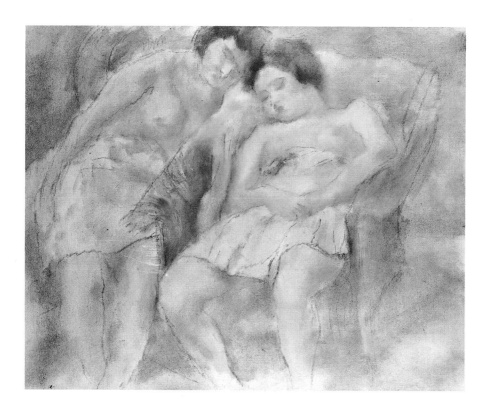

Jules Pascin, *Two Women Asleep*, 1928 (MNAM, Centre Pompidou, Paris). The slightly raised viewpoint accentuates the unreal and sensual character of this scene. Pascin devoted his work to portraits of women and his friends, executed in harmonious, modulated and transparent half-tones and invested with a light irony by themes of love and death.

Their work had a close link with the great classical trends in terms of its choice of subjects and preoccupation with ideal beauty.

Auguste Rodin (1840–1917), who like Cézanne belonged more in spirit to the 20th than to the 19th century, is still today the dominant figure in sculpture. The modernity of his art led to him being invited to show works such as *The Age of Bronze* (1877) and *The Gates of Hell* (on which he worked from 1880 right up to the end of his life without fully completing it), which had provoked storms of protest in France, at the exhibitions of the Vienna Secession. Rodin was an admirer of Gothic art – the inspiration behind his book *Les Cathédrales* (1914) – and of Donatello and Michelangelo. He also possessed a vast knowledge of literature and the poetry of Dante in particular, who provided another source of inspiration. It is possible to detect the realism of Courbet and the lyricism and pathos of French Romantic sculptor François Rude (1784–1855) in Rodin's prolific output.

Like the Impressionists, Rodin sought to portray life's moments of emotion in his portraits. He worked the clay in order to create multiple facets on the surface of his sculptures – for him simply the 'extremities of a volume' – which would catch the light and have the effect of expressing the emotions and anxieties of his subjects.

His portraits in sculpture of *Victor Hugo* (1890), *Balzac* (1897) and the

Auguste Rodin, *The Burghers of Calais*, 1884–95 (Musée Rodin, Paris). This sculpture commemorates the self-sacrifice of the six burghers of Calais who saved the town from destruction during the Hundred Years War by giving themselves up to the English invaders. In this *marche funèbre*, Eustache de Saint-Pierre, Jean d'Aire, Jean de Fiennes, André d'Andrieux and Pierre and Jacques de Wessant express in a very human manner and with a great range of emotion – conveyed predominantly through their hands – their solitude in the face of the death they have chosen. The absence of uniformity in the way their heroic gesture has been rendered and the originality of the sculpture's composition, which is cube-shaped rather than pyramid-shaped and anchored to the ground, attracted fierce criticism from a number of quarters, including the Calais town council, which claimed that 'their defeated bearing offends against our religion'. Rodin refused to submit to Jacques Louis David's rule of pyramidal composition: 'In Paris I am the antagonist of this theatrical and academic art which would have me follow those whose conventional art I despise.' Although he received support from the authorities, and despite being obsessed with failure, Rodin continued to defend his non-conformist stance. His work, described by Edmond de Goncourt as Impressionist, was exhibited in Paris alongside that of Monet in a retrospective of 1889. But Rodin distanced himself from Impressionism and defended the distinctiveness of his sculpture: its autonomy, its three-dimensionality, the working of its surfaces into facets to create an impression of movement and real emotions, always verging on ins-tability. Through his anti-academic, Symbolist sculpture, Rodin created a new language, whch sprang from an ever-present desire to 'go beyond'.

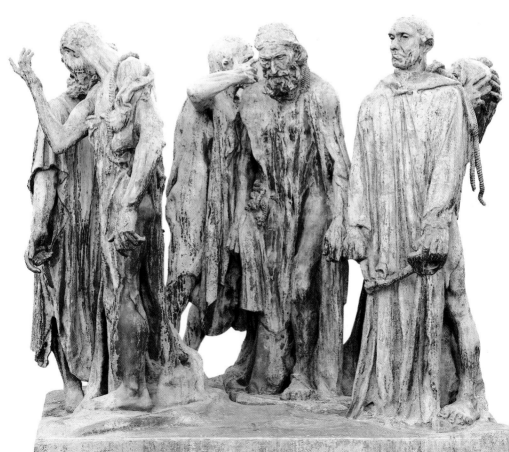

Burghers of Calais (1884–95) series suggest creative inspiration that is wrought in the painful struggle to render the soul in solid form. His drawings, equally remarkable, reveal his talent for the arabesque, which allowed him to capture the truth of his models' movements. Rodin was also a brilliant spotter of talent, welcoming into his studio – despite the difficulties with which he was beset – François Pompon (1874–1946), Aristide Maillol (1861–1944), Camille Claudel (1864–1943) and Charles Despiau (1874–1946). Pompon, considered one of the best sculptors from Rodin's studio, where he worked for 15 years, made his name primarily as a sculptor of stylized animals such as *Polar Bear* (1921). Constantin Brancusi (1876–1957) also benefited from Rodin's support from the earliest days of his career in France. Born in Romania, emigrated to France in 1904 and acquired French nationality in 1952, leaving his adopted country only for short visits to the United States, Romania and Egypt, where he admired the pyramids. Encouraged by Rodin, who noticed him in 1907, he nevertheless retained his independence from the older sculptor, while adopting his technique of direct modelling using blocks of material. Brancusi befriended Matisse, Modigliani and Rousseau, for whose tomb he sculpted a cippus inscribed with the poem that Apollinaire had dedicated to the artist. In 1913, Brancusi exhibited five works at the Armory Show in New York. This exhibition was a focus for the avant-garde, to which the sculptor never properly belonged despite his interest in Cubism. In its exploration of the essential and its elimination of detail, his work was closer to Neolithic art – evident in *Wisdom of the Earth* (1907) – and archaic or pre-classical antiquity, whose principles are clearly visible in the choice of motif for *The Kiss* (1923), which depicts a man and a woman locked in an embrace, than to the primitive art dear to the Cubists. He combined this heritage with modern, premonitory reflections on flight and space, returning repeatedly to one of his favourite creatures, the bird, whose polished surfaces, worked to such an extent that they are almost unbalanced, generate energy. Brancusi transposed life's themes to the realm of the absolute, and polished to perfection his marble, steel and bronze sculptures, whose surfaces are reflected in their mirrored bases, with a contrast provided by the roughness of the stone or plaster. Brancusi's meditation on spirituality, sometimes seen as crude, led to the original oviform model for the *Sleeping Muse Newborn Prometheus* and *The Beginning of the World* series that inspired the Surrealists.

Completed in 1938, the *Gate of the Kiss*, commissioned by Romania for the Tirgu Jiu memorial, marked the climax of his monumental work, which also included the *Endless Column* series, whose principle of modular repetition was one of the inspirations behind the Minimal art of the 1960s.

Brancusi gave his sculptures' solid pedestals an architectural impor-

REVOLUTIONS THROUGH COLOUR

Constantin Brancusi, *Maiastra,* 1912 (Tate Modern, London). Brancusi pondered the essence of flight throughout his life and the seven versions of *Maiastra* – the name of the bird that in Romanian folklore leads Prince Charming to his princess – were the first in a long sequence of birds. Seeking to 'reveal the beauty of the world', Brancusi polished the bronze to perfection, a 'necessity imposed by the relatively absolute forms of certain materials' in order to achieve a better stylization of volume. He also introduced a virtuality of space through the light reflected in the surface of the bronze, which is contrasted with the rough stone of the pedestal.

tance of their own, creating a contrast between their rough surfaces and the delicacy of the birds and muses, before doing away with them altogether in the manner of the African sculptors.

He was also a very talented photographer. The photographs he took of his friends, of animals and, above all, of his sculptures are works of art in their own right, and constitute an invaluable source of information on his aesthetic values and life in his studio in Impasse Ronsin in Paris.

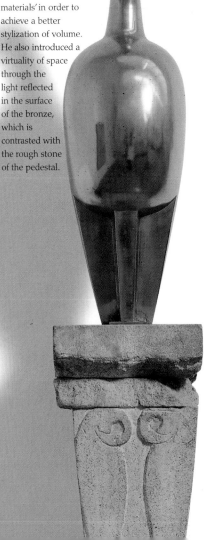

REVOLUTIONS THROUGH FORM

Through their restructuring of form, the Cubists, Futurists, Suprematists and Constructivists took the achievements of the revolution through colour of the movements that preceded them a stage further. Going beyond their individual genius and inspiration, they introduced the concept of the avant-garde in order to proclaim the brilliance of their vision more effectively. Foreshadowing abstraction, these avant-garde artists took account of the 20th-century trend towards the development of complex systems that refer neither to natural forms nor to the play of emotions, and sought, independently of any sense of transcendence, to liberate themselves from the aesthetic of previous centuries in order to define a new one: humanity confronting its own creations.

Cubism

There were three main phases in the evolution of Cubism. The first, influenced by Cézanne, lasted from 1907 to 1909; the second, known as Analytical Cubism, from 1910 to 1912; and the third, Synthetic Cubism, from 1913 to 1914. Orphism and Vorticism, two direct derivatives of Cubism, began to emerge in 1912. Most of the Cubists had gone through a Fauvist phase. Georges Braque (1882-1963) was one such artist, and it is from a critical comment made by Matisse in front of his painting *Houses at L'Estaque* (Kunstmuseum, Bern) – presented to, but refused by, the Salon d'Automne of 1908 – that it was 'made up of little cubes', that the term 'Cubism' was coined, before being popularized by the critic Louis Vauxcelles. The definition of Cubism as a movement, however, postdates Pablo Picasso's (1881-1973) initial researches, begun in 1907, by some considerable time. His painting *Les Demoiselles d'Avignon* (MOMA, New York), dating from 1907 but never completed, is considered to be the first Cubist work. This is an anti-establishment parody of *The Turkish Bath* by Ingres (1859-63, Musée du Louvre, Paris) and Matisse's *Joie de Vivre* (1905-6, The Barnes Foundation, Merion). The original title was supposed to evoke a brothel scene, but the one finally used was chosen by poet and critic André Salmon. This painting testifies both to Picasso's lengthy research into the purification of form and elimination of descriptive and sentimental detail and to his desire to develop further Cézanne's lesson on conveying space through the superimposition of planes and dispensing with chiaroscuro and the anthropomorphic

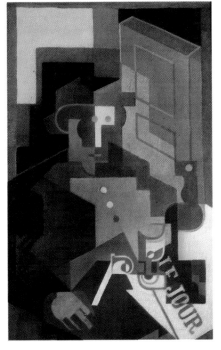

Juan Gris, *Le Tourangeau,* 1918 (MNAM, Centre Pompidou, Paris). This portrait, painted in Touraine during the summer of 1918, follows the rules of Synthetic Cubism. Juan Gris has abandoned the bright colours of 1913–14, however, substituting these with the sober palette of Analytical Cubism. Having reflected on the techniques of Cézanne, whose portraits fascinated him, prior to interpreting them in his own personal way, he declared that 'Cézanne makes a bottle into a cylinder, […] while I make a cylinder into a bottle'.

REVOLUTIONS THROUGH FORM

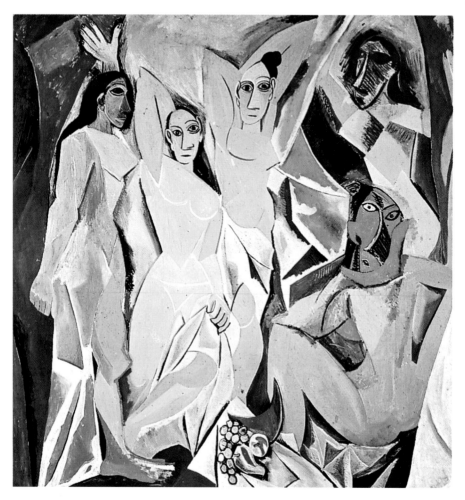

Pablo Picasso, *Les Demoiselles d'Avignon,* 1907 (MOMA, New York). Revolutionary in part because of the rift it represented between nature and art, this first Cubist painting by Picasso also reveals the artist's fascination with the portraits of Cézanne and African masks. It provides a good illustration of the poet Apollinaire's definition of Cubist paintings as being made up 'of elements taken not from the reality of vision, but from the reality of conception'.

illusion of depth (as a transposition of natural human vision). Cézanne's principle was to 'render nature through the sphere, the cylinder and the cone'. This painting also anticipated Picasso's fascination with African art, as revealed in the elliptical treatment of the figures, their frontal portrayal and the mask-like quality of their faces. In the manner of Cézanne's rigid portraiture, Picasso has prioritized structural considerations to the detriment of the individual character of the figures.

While Cubism developed exclusively in France between 1907 and 1914, it had wider repercussions, which went beyond the purely pictor-ial, throughout the whole world, including Russia and the United States. Abstract art, the most significant of the 20th century's artistic revolutions, took its inspiration almost exclusively from Cubism. The Armory Show, held in New York in 1913, focused on French art, including Cézanne, Cubism, Dadaism and works by the Duchamp brothers, among them Marcel's *Nude Descending a Staircase* (1912, Philadelphia Museum of Art), which provoked outrage.

RUTH DELAUNAY KUPKA DE VLAMINCK RUSSIAN AVANT-GARDE MARINETTI VALDUTTON SEVERINI NEO IMPRESSIONISM PICASSO NAIVE ART MODIGLIANI VORTICISM ART DELU GAUD
METZINGER PICABIA DELAUNAY MALEVICH MALEVICH MULTERS SUPREMATISM CUP SPACE ICONISM NAIVE SACRED ART EDU RIVERA ORUD DE SIGNEROS VAN DER SPRING MONDRIAN VAN AS
DHL ROUSSEAU LEGER GLEIZES DE CHIRICO HENRI MATISSE EXPRESSIONISM NEW LINK MODU NEW OBJECTIVITY DE STIJL MADAISM DUDAISM MP PLASTIC DE CHIRICO MERZ SCHOLL MAN RAY
RC KANDINSKY LARIONOV INTERNATIONAL MODERN EXPRESSIONISM DERAIN BOCCIONI THE BLUE RIDER MARC KANDINSKY LARIONOV INTERNATIONAL MODERN EXPRESSIONISM DERAIN

The formal repertoire of Cubism's reductive visual language includes the breaking down of forms into multiple polyhedrons based on asymmetric patterns or series, the merging of different planes, the dominance of right angles and diagonals, the use of contradictory rhythms and a narrowing of the range of colours and themes used. Through still lifes, portraits featuring identical accessories, pipes, guitars, games of chess – a passion shared by Louis Marcoussis and Juan Gris (1887–1927) – and draughtboards, all removed from any naturalist context, Cubism evoked an independent mental universe from which – other than in the work of Gris – all sources of outside light are excluded. The Cubists took up Cézanne's remark about art representing a harmony that runs parallel to nature, and separated the manner of representation from the natural appearance of the object by rejecting the illusionism inherited from Renaissance painting. In order to assert the independence of the work of art from nature, they established predetermined structures that were then animated through the introduction of the principles of dynamism and simultaneous viewpoints. In their book *Du Cubisme* (1911, 'On Cubism'), Gleizes and Metzinger asserted that 'the only error in art is imitation'. Man is alone and must confront the new universe that surrounds him with the fact of his existence. Cubist works suggested disturbing and ambiguous associations to which the Surrealists would later bring a dreamlike quality.

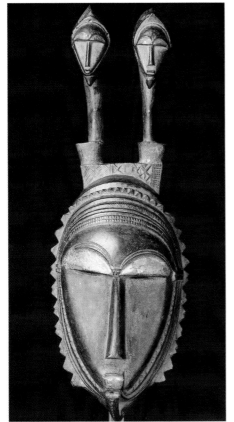

Mask with two heads from the Ivory Coast (Musée d'Art d'Afrique et d'Océanie, Paris).

Metzinger distanced himself from any form of decadent spiritualism: 'We condemn any tendency towards fanciful occultism.' Painting became an art 'determined by the formal laws of the object', an 'instrument of knowledge', a scientific activity, no longer merely 'aesthetic material allowing us to display our irritability with certain things or spectacles'. It was no longer theory but reality that governed perception. Cubism retained a link between subject and object, which would be dismantled by later abstraction. The beauty of the portraits and compositions dating from the period of Analytical Cubism stems from the very extensive formal rigour behind the organization of their geometrical facets, from the unity of their different elements, which is a function of the conflict between them, and from the sobriety of the transparent grey, beige and brown monochrome tones, all of which seem to emanate from a purely abstract poetic order.

REVOLUTIONS THROUGH FORM

Georges Braque,
The Portuguese, 1911
(Kunstmuseum, Basel).
This painting dates
from Cubism's purest
phase, known as
Analytical Cubism. The
subject's basic physical
features can still be
made out, but, taken as
a whole, the painting
displays a remarkable
homogeneity resulting
from the breaking up
of the figures and the
background into
geometrical elements
painted in brown and
grey hues. Braque
introduced stencilled
letters and numbers for
the first time in this
painting. These signs
were not meant to be
significant in terms of
meaning, but rather in
terms of shape. The
artist continued to
experiment in this field
with his *papiers collés*
(paper collages)
of 1912.

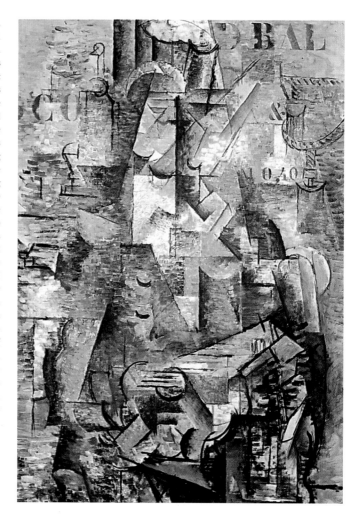

The beginning of the 20th century was a period in which, more than
ever before, artistic theories were influenced by the scientific discoveries
of the day. In 1923, Juan Gris declared: 'Pictorial mathematics lead me
to representative physics.' Careful to leave the reproduction of real life to
photographers, the Cubists explored the discoveries of theoretical
physics, particularly Einstein's theory of relativity, which revealed the
space-time dimension through the linking of matter with energy, thus
altering man's place in the universe. As explained by Gleizes – who refers
also to the theorems of Riemann – and by Apollinaire, the movement's
exegete, Cubist artists liked to think of their pictures as representing an
assertion of space over volume and as an attempt to represent the fourth
dimension, which as an interpretation of Cubism is certainly more
metaphorical than scientific. To have taken their inspiration from the
theory of relativity, the Cubists would, above all, have to have rejected
the principle of simultaneous viewpoints, which they did not, in any case,

Pablo Picasso

La Vie, 1903 (The Cleveland Museum of Art, Cleveland). This allegory from Picasso's Blue period, which reveals a strong Spanish expressionist influence, deals with the themes of melancholy and problematic motherhood. The play of picture-within-picture prefigures the artist's later thoughts on perception and the limitations of art during his Cubist period.

With his exceptional vision and inexhaustible powers of invention combined with incredible calligraphic talent, Pablo Picasso, a painter of true genius, was responsible more than any other artist for reinvigorating the figurative language of the 20th century. Picasso's work was a detailed investigation into the ambiguity of representation.

1881. Birth of Pablo Picasso in Malaga, Spain.

1901. Having arrived in Paris in 1900, he works until 1904 on expressionist pictures in which the predominant mood is one of melancholy. This constitutes his Blue period, followed between 1905 and 1906 by his Rose period.

1907. Picasso paints *Les Demoiselles*

d'Avignon, thereby earning himself the reputation as the precursor of Cubism. He defines its formal structure – which serves him as a framework for reflection throughout his life. His Bateau-Lavoir studio becomes the venue for impassioned debates with his friends Gertrude Stein, Juan Gris, Louis Marcoussis, Max Jacob and André Salmon.

1914. His sculpture *Absinthe Glass* (MNAM, Paris) is effectively the first ready-made, and marks the start of a long meditation on transparency, a theme taken up by other sculptors such as Naum Gabo and Antoine Pevsner.

1915. Picasso moves towards a form of realism, featuring variations on the Cubist theme still, which comes to the fore in 1919 in London, where he meets up with Derain, who is in the throes of a return to classical sources. He revolutionizes the Ballets Russes with his almost instinctive calligraphy and the introduction of mythological figures such as the Minotaur.

1916. World War I, during which he remains in Paris, leaves Picasso with Gris and Jacob as his sole companions. He is deeply affected by the death of Apollinaire in 1918.

1920. His modernist reinterpretation of ancient Greek and Roman styles through colossal, sculptural, static, timeless and melancholic figures, realized using a sober palette of ochre and grey, distinguishes his work from the linear platitudes of the return to order. His interest in the dynamic energy of line, however, would remain a constant feature of his work.

1923. He tries his hand at precious portraits in the style of Ingres, such as the *Harlequin* series (MNAM, Paris), which are characterized by a certain moving beauty. This period of neoclassicism, neo-Cubist illusionism and worldliness – 'the time of the duchesses', according to Jacob – does not last long. Picasso's life and work would constitute a fierce and uncompromising affirmation of the freedom of political, artistic and personal expression, and a constant struggle against convention.

1925. His work undergoes a transformation, intensified in 1928 by the growing influence of Surrealism, which allows him to develop further his own thoughts on the double meaning of images.

His original style, involving playing with signifier and signified, and the imitation of imitation, notably in his wallpaper collages, would

Picasso

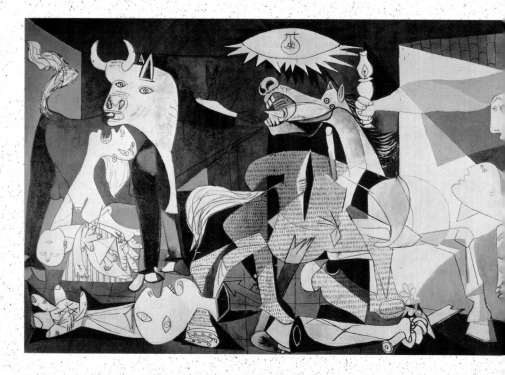

subsequently centre on the dislocation of the human form, seen simultaneously from different angles, the heterogeneity of space and the stridency and vivacity of his colours. Picasso's work, however, would never evolve to full abstraction.

1930. Mythological subjects, such as the horse, the Minotaur and the weeping woman, become Picasso's most common themes. He makes two last journeys to Spain before his passionate temperament enters a period of intense personal crisis.

1937. Picasso completes his masterpiece *Guernica,* a commemoration of the martyred Basque town.

1940. In Paris, where he remains during the occupation, he paints a number of dramatic works in a range of muted colours, such as *L'Aubade* (1942, MNAM, Paris) and *The Charnel House* (1945, private collection), in which the disturbing and distorted human figure is set within a sinister framework of interiors whose very domestic banality seems to portend great danger.

Picasso's works, which so shocked the public, merely anticipated the agonizing reality of the upheavals of the first half of the 20th century. He highlighted the new function of art,

which no longer aspires to the ideal or ethereal but is deeply implicated in real life, like the existential philosophy of Sartre's play *Les Mains Sales.*

1944. Picasso joins the Communist party and decides not to return to his homeland, Spain, as long as the dictator Franco remains in power, a promise he keeps until his death.

1945. He moves to the south of France and produces a large number of works, all of them inspired either by the human form and executed in the Cubist manner, or else by a new contemplation of nature. He takes up sculpture and ceramics again and invents assembled sculpture.

1965. Picasso achieves a unique fusion between the principles of Cubism and the rediscovered sensual lyricism of the human body, taking his inspiration from the work of Delacroix, Manet, Velázquez and Poussin.

In 1968, he parodies the idealized art of Raphael, whom he depicts in the company of La Fornarina in a series of drawings designed to evoke the voluptuousness of love and 'that which surpasses it: art' (D Cordellier, *Raphael* [exhibition catalogue], Grand Palais, Paris 1983).

1973. Before his death in Mougins in

resistance, on Monday 26 April 1937, a market day. More than 1,500 were killed in the total destruction of the town. The apocalyptic spectacle presented by *Guernica* foreshadowed the long night that was to follow. Picasso declared that 'painting is an instrument of war for attacking, and defending oneself against, the enemy'. And that 'The war in Spain represents an attack on the people and on liberty by the forces of reaction. My whole life as an artist has been a continual struggle against reaction and the death of art. The panel I am working on, which I shall call *Guernica*, expresses my unequivocal horror of the military caste that has plunged Spain into an ocean of pain and death.' This monumental work, in which human figures and animals meet in their hour of death, is dominated by the tortured faces of women, the bull, a symbol of unbridled brutality, and the horse, a symbol of the people, while the dove, symbolizing freedom, is mortally wounded. In keeping with Cubist principles, the space, based on triangular planes, is heterogeneous owing to the tension between orthogonal and diagonal lines, but the linear extension of the dislocated bodies and the distress of the faces convey an Expressionist permanence through Picasso's own style. Commissioned from Picasso for the pavilion of the Spanish Republic at the Universal Exhibition of 1937 in Paris, Guernica was returned to Spain in 1981 following the death of Franco.

Guernica, 1937 (Museo Nacional Reina Sofía, Madrid). When the Basque country was encircled by General Mola's 'circle of fire' during the Spanish civil war, the chief of staff sent by Germany, Von Richthofen, decided in agreement with the pro-Franco forces to launch operation 'Guernica'. The Luftwaffe bombed the small Basque town, a centre of Republican

April, Picasso completes a large number of engravings, drawings and paintings, including a series of self-portraits with a searching gaze.
September 1981. Having previously been housed in the Museum of Modern Art in New York, *Guernica* is taken to Spain following the death of Franco. Picasso had requested that his painting not be sent home to Spain until the restoration of the Republic. The fulfilment of this wish was taken as a sign that democracy had returned.

Raymond Duchamp-Villon, *Seated Woman*, 1914 (MNAM, Centre Pompidou, Paris). Taking his inspiration from an artist's anatomical model, Duchamp-Villon, a member of the Section d'Or and brother of Marcel Duchamp and Jacques Villon, succeeded in creating a sculpture whose elegant lines stem from the suppression of any superfluous detail and from its polished surface. The same year, he took this reduction of form even further in his *Large Horse* (MNAM, Paris), a synthesis of animal and machine.

realize properly, as objects are fragmented rather than seen from different perspectives.

It is impossible to reconcile pictorial space with the physical concept of the spatial field. Claims of a cryptic relationship between Cubism and the theory of relativity are thus misplaced, as Einstein himself asserted: 'This new artistic language has nothing to do with the theory of relativity.' It had far more in common with the logic of Hilbert and Brouwer and the works of Russian physicist P D Ouspensky (1878-1947): *A New Model of the Universe* (1905-1910-1916), *The Fourth Dimension* (1909) and *Tertium Organum* (1911), which enjoyed great popularity among both the Russian Futurists and the Cubists.

The founding of the Section d'Or in 1912, by brothers Raymond Duchamp-Villon (1876–1918), Marcel Duchamp (1887–1968) and Jacques Villon (1875–1963), with Francis Picabia (1879–1953), Roger de La Fresnaye (1885–1925), Frantisek Kupka (1871–1957), Louis Marcoussis (1878–1941) and Alexander Archipenko (1887–1964), led to a reinvigoration of Cubism. Taking their inspiration from the rules of perspective and the concept of the golden section described in Leonardo da Vinci's *Treatise on Painting* (1490), the artists of this group based their works on a form of pyramidal composition with a double viewpoint realized through the converging of diagonals. They also substituted a range of vivid tones for the dark palette of Analytical Cubism. These artists took their inspiration from African and Oceanian art, the latest discoveries on the structure of matter, Brownian motion and research into the nature of movement conducted by Étienne-Jules Marey and Eadweard Muybridge using time-lapse photography. Marcel Duchamp attempted to reproduce these principles in his *Nude Descending a Staircase* of 1912. It was in reaction to this movement towards abstraction that Picasso, Braque and Gris invented their technique of *papiers collés*, which highlighted the contradiction between the surface of the canvas and the illusionistic portrayal of depth, which strips reality of its ephemeral and secondary prettiness. In order to underscore the immediacy of materials, Gris even went as far as inserting a fragment of mirror into his work *Le Lavabo* (1912, private collection, Paris).

Jacques Villon,
The Adventure, 1935
(MNAM, Centre
Pompidou, Paris).
Despite the demise of
Cubism as a movement
in 1914, this work
proves that the
'adventure' was not
over. Having been
influenced earlier by
Cézanne, Villon joined
the Section d'Or group
in 1912. His treatment
of form is based on
scientific theories. Here
he again combines
compositional precision
with purity and
transparency of colour.

Unlike Fauvism, Cubism made some brilliant contributions to the development of sculpture. Raymond Duchamp-Villon polished the surface of his human or animal figures in order to eliminate descriptive detail and create a mechanical abstraction of form. The archaistic stylization of Archipenko's sculptures, such as *Draped Woman* (1911, MNAM, Paris), adds a certain depth to the formal repertoire of Cubism. He created the first sculpto-paintings, a genre that continued to develop throughout the 20th century. Otto Gutfreund (1889–1927) and Ossip Zadkine (1890–1967) enriched Cubism by integrating Expressionist elements and the evocation of movement or music into their figures. The Cubists led a rather hermetic existence and even in the most civilized surroundings, such as the Armory Show, attracted general opprobrium, outrage and the mockery of both public and critics. Only Gleizes and Metzinger felt the need to justify themselves.

Cubism, however, was actually following a path parallel to the way culture in general was developing at the beginning of the century. To the

REVOLUTIONS THROUGH FORM

Robert Delaunay, *Champ-de-Mars, The Red Tower,* 1911 (The Art Institute, Chicago). The Eiffel Tower, a symbol of modernity, was a source of inspiration for many painters (Signac, Chagall, Nicolas de Stäel) and writers (Blaise Cendrars, Apollinaire). One of the first Cubist painters, Robert Delaunay, who had begun to produce a series of paintings *City* in 1910, presents here a simultaneous view of the Eiffel Tower that is in fact a distortion. It is for this reason that critics categorized this series of paintings as his 'destructive period'. The breaking down of the space into multiple facets recreates the feeling of soaring emotion and giddiness generated by the real tower, as part of a poetic vision.

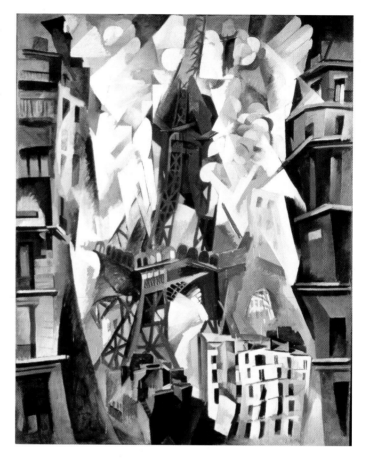

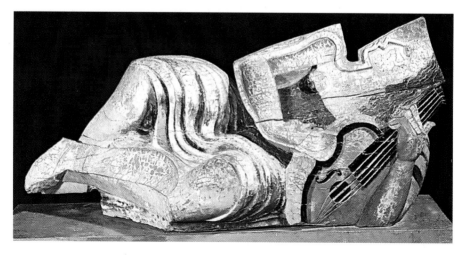

PICASSO NAIVE ART MODIGLIANI VORTICISM ART DECO GAUDIER-BRZESKA FUTURISM GRIS SOUTINE ZADKINE PARIS SCHOOL ROUSSEAU KOKOSCHKA MUNCH MAGIC REALISM MALE VOROZCO SIQUEIROS VAN DONGEN DE MORGAN NAN ARP PICABIA SURREALISM BLUE RIDER SEVERINI THE BLUE RIDER MARC KANDINSKY LARIONOV INTERNATIONAL VORTICISM MODERN EXPLI MARC ETH DERAIN BOCCIONI DE CHIRICO MARX ERNST NEVINSON SEURAT WARHOL DALI LOW MAGRITTE EXPRESSIONISM ERA AND ZORI SADEROS VAN DONGEN NEVAZO SROL ROUSSEAU KOKOSCHKA MUNCH MAGIC REALISM MALLET SEVERINI WILLIAM WOLTL NEW OBJECTIVITY DE SOTH MAGRITTE BOCCIONI DUCHAMP PICABIA OR CHIRICO MERZ SCHWITTERS DER MARC KANDINSKY LARIONOV INTERNATIONAL MODERN EXPRESSIONISM DERAIN BOCCIONI THE BLUE RIDER MARC KANDINSKY LARIONOV INTERNATIONAL MODERN EXPRESSIONISM DER

Marcel Duchamp,
*Nude Descending a
Staircase, No. II,* 1912
(Philadelphia Museum
of Art). Duchamp
provoked the greatest
controversy of New
York's Armory Show of
1913 with this nude,
the very sober and
carefully structured
deconstruction of
whose movements was
inspired by the
experiments of Marey
and Muybridge
with time-lapse
photography.

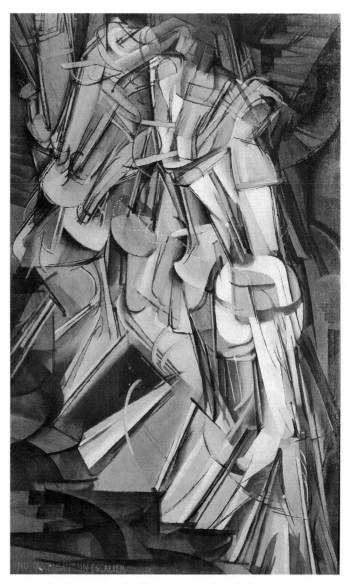

Bottom, left:
Ossip Zadkine,
Odalisque, 1936 (Musée
Réattu, Arles). The
recumbent form of this
odalisque contrasts
with the verticality of
the artist's Cubist
works from the period
1914–18. It has been
constructed using large
geometrical sections
based on the principle
of simultaneity, and
Zadkine has combined
the coarse and heavy
character of its
materials with the
spirituality of its musi-
cal theme, a dominant
one in his work.

extent that it represented a liberation from formal classical structures, it could be compared with the musical experiments of Stravinsky and Schoenberg and the literary experimentation of Mallarmé (1842–98), E E Cummings (1894–1962), James Joyce (1882–1941) and Gertrude Stein (1874–1946). The movement was interrupted by World War I, in which nearly all those artists not forced into exile fought. Apollinaire and Braque underwent surgery for serious head wounds, Raymond Duchamp-Villon, Roger La Fresnaye and Amédée de la Patellière (1890–1932) died prematurely from serious injuries sustained during the War, Jacques Villon, Puy and Dunoyer de Segonzac served in camouflage units, and the Czechs Kupka and Gutfreund, who had volunteered, served, as did Blaise Cendrars, in the Artois.

REVOLUTIONS THROUGH FORM

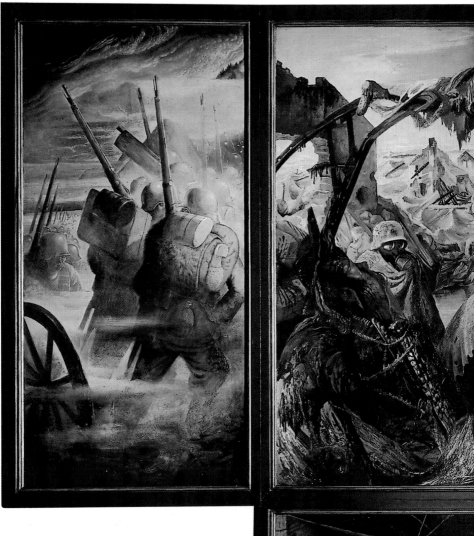

Otto Dix, *War*, 1929–32 (Staatskunst-sammlungen, Dresden). Otto Dix is known to have taken a copy of the New Testament and Nietzsche's *Die Fröhliche Wissenschaft* ('The Gay Science') with him to World War I, in which he served as a private on both the French and Russian fronts, sustaining wounds on two occasions. Despite the atrocious conditions, he managed to execute over 600 sketches. In order to enrich the Expressionism of his style, he returned to the sources of German painting in 1921, turning to the traditional altarpiece (like that in *Isenheim* by Grunewald) for his masterpiece War, a triptych featuring a

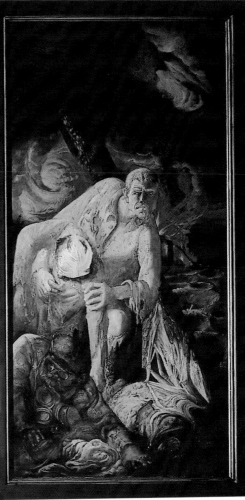

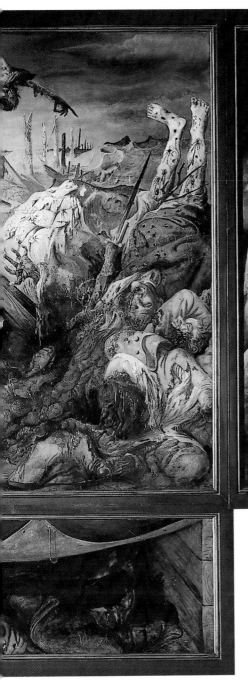

delicate glaze. As in the work of Altdorfer, the intense light, cold colours and bold composition give these scenes of war, in which the soldiers seem to be departing the human realm and hurtling towards some unknown abyss, a tragic and apocalyptic character. Dix has depicted himself rescuing another soldier in the right-hand panel. The realist style bordering on scientific objectivity of the lower panel, which depicts the corpses of soldiers, was directly inspired by Hans Holbein's *The Body of the Dead Christ in the Tomb* (1521, Öffentliche Kunstsammlung, Basel), considered to be the first profane representation of Christ in Western art.

REVOLUTIONS THROUGH FORM

After the War, the crisis in figurative values paradoxically provided a favourable context for brilliant developments in the work of Picasso, Braque and Kandinsky, and Cubism survived until 1936. Malevich, influenced briefly by Synthetic Cubism, set out on his own path towards Suprematism. Only those artists attached most closely to the principles of Cubism experienced a deterioration in the quality of their work.

Vorticism

The lectures given in London between 1910 and 1914 by F T Marinetti (1876–1944), leader of the Italian Futurists, in his 'verbal terrorism' style caused a sensation among British avant-garde Cubist painters. In March 1914, Wyndham Lewis (1882–1957), Christopher R W Nevinson (1889–1946), Cuthbert Hamilton (1884–1959) and Edward Wadsworth (1889–1949) founded the Rebel Art Centre. With the exception of Nevinson, however, they rejected the Futurist manifesto in June of the same year, criticizing the Futurists' fondness for machines, which they considered puerile, and retaining only their concept of the work of art as a source and form of energy.

Poet Ezra Pound (1885–1972), who put up a notice in the Rebel Art Centre announcing the 'end of the Christian era', was to become the champion of a new movement numbering no more than a few members. He baptized it 'Vorticism', a term coined from the Latin *vortex*. Vorticist works were characterized by a transformation of the formal language of Cubism through the addition of bent and broken radiating lines. Spreading out from the vortex at the centre of a composition, the gyratory force of the spiral creates a whirlwind effect analogous to the violent currents of history. The Vorticist manifesto was published in June 1914 in the first issue of *Blast*, the movement's official journal, and the Vorticists were soon joined by sculptors Jacob Epstein (1880–1959) and Henri Gaudier-Brzeska (1891–1915).

But the Vorticist movement, a far less coherent and robust movement than Cubism, was destroyed by the War. In June 1915, Gaudier-Brzeska – who had declared that 'War is the great cure. It kills arrogance, self-satisfaction and pride in the individual' – was killed in combat, as was the philosopher T E Hulme, one of the movement's founders, in 1917. Pound alone kept the Vorticist flame burning by publishing a book on Gaudier-

Henri Gaudier-Brzeska, *Seated Woman*, 1914 (Musée des Beaux-Arts, Orléans). The French sculptor Gaudier-Brzeska settled in London in 1911 and became a member of the Vorticist movement. An admirer of Rodin, Brancusi, Archipenko and, above all, the primitive art of Oceania, he created the highly personal style that can be seen in his studies of organic human and animal forms. The hieratic, totemic quality of this figure, the tension of its volumes and the treatment of its surfaces in flat geometric planes anticipate Henry Moore's research in 1922 into the simplification of form.

Brzeska (containing many errors) in 1916 and editing a collection of
Hulme's poems, while after the War, Lewis and Nevinson turned back to
realism.

Futurism

Futurism crystallized the efforts of Italian artists to shake off Italy's
political and cultural apathy at the beginning of the 20th century and,
given their country's obsession with its past, to attempt to rediscover the
dynamism it had experienced in the middle of the 19th century during
its struggle for independence.

The Futurists attacked established values and proposed new pro-
grammes designed to rally Italy to the cause of a progressive Europe,
based on a 'healthy' verbal and cultural aggressiveness. This involved the
eulogizing of cities, the machine age and the era of speed, and the rac-
ing car was henceforth to be considered 'more beautiful than the Nike of

Umberto Boccioni,
*Unique Forms of
Continuity in Space*,
1913 (CIMAC, Palazzo
Reale, Milan). The most
accomplished works of
Italian Futurism
appeared in 1912 and
1913. The notion,
represented here, of
spatial sculpture, in
which movement is
conveyed by the
stretching of volumes,
was later taken up by
Archipenko, Naum
Gabo, the Russian
Futurists (providing
direct inspiration for
Tatlin's *Monument*) and
later Henry Moore. A
number of casts of this
bronze exist, one of the
best of which is in the
Tate Modern
in London.

Samothrace'. Essentially nationalist, Futurism went through two historical phases. The first lasted from 1909 to 1916, the year in which Umberto Boccioni (1882–1916), the main inspiration behind the movement, died; and the second from 1918 to 1944, during which time Filippo Tommaso Marinetti (1876–1944), the movement's theoretician, tried in vain to have Futurism adopted as the official art of Italy.

Marinetti's *Futurist Manifesto*, published in *Le Figaro* in February 1909, was translated into Russian shortly afterwards, and in 1910 Boccioni declaimed the *Manifesto of Futurist Painters*, co-written by him and Luigi Russolo (1885–1947), Carlo Carrà (1881–1966), Gino Severini (1883–1966) and Giacomo Balla (1871–1958), in Turin's Chiarella theatre. As well as their aesthetic theories, it was also the oratorical skills and grandiloquence of the Futurists, whose speeches were often accompanied by 'bruitism' – concerts involving a wide range of instruments that anticipated what later became known as concrete music – that attracted many artists. But their nationalist, interventionist and later

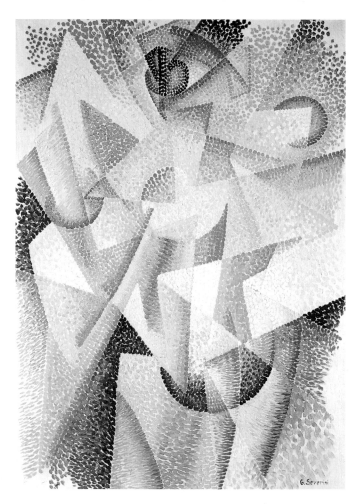

Gino Severini, *Dynamism of Light Form in Space*, c.1912 (Galleria Nazionale d'Arte Moderna, Rome). Although 'exiled' in Paris from 1906, Gino Severini joined the Italian Futurist movement in 1910 and organized an unproductive meeting between the Futurists and Cubists Picasso, Gris and Braque the following year. In this abstract work, composed of pointillist touches of colour in the manner of Seurat, he has achieved a plastic equilibrium between light and movement. The touches of colour are arranged in triangles and seem to radiate from circular planes. This fusion of shapes and sensations, a joyous homage to modern technology, plays on the phenomenon of retinal persistence.

MIT PICASSO NAIVE ART MODIGLIANI VORTICISM ART DECO GAUDIER-BRZESKA FUTURISM GRIS SOUTINE ZADKINE PARIS SCHOOL ROUSSEAU KONISCHOA MUNCH MAGIC REALISM KRAI. OROZCO SIQUEIROS VAN DOESBURG MONDRIAN NEO-PLASTICISM BAUHAUS BLUE RIDER BOCCIONI THE EXPRESSIDER'S MARC KANDINSKY LARIONOV INTERNATION AL MODERN EXPRESS SM RUTHLESS NAIVE ART DE CHIRICO VERO SCHWITTERS AL GARDE MARINETTI MORE SIGN SEVERINE SM COLD EXPRESSION IN PICASSO DYE SIQUEIROS VAN DOESBURG MODERN NEO-PLA RIDE BZESKI FUTURCSMA FUTURISM IT FUTURISM IL FUTURISTE STEVENS MALEVICH ROUND NEO-OBJECTIVITE DE CHICHI DEL ADIA OF DER CHIMNEZ SCHOOL ITAS MARC KANDINSKY LARIONOV INTERNATIONAL MODERN EXPRESSIONISM DERAIN BOCCIONI THE BLUE RIDER MARC KANDINSKY LARIONOV INTERNATIONAL MODERN EXPRESSIONISM SI

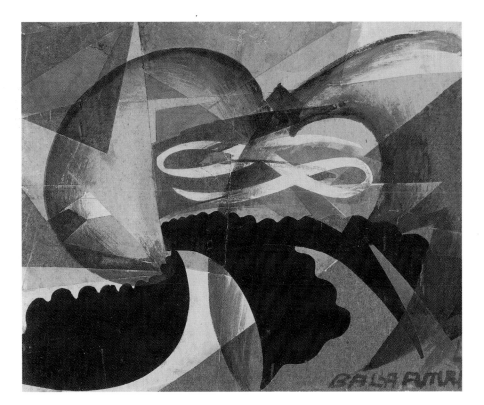

Giacomo Balla,
Patriotic Demonstration,
c.1915 (Jucker
Collection, Milan).
This synthesis of lines
of force, designed to
encourage Italian
patriots to enlist for
World War I, is typical
of the ideological line
taken by the first phase
of Italian Futurism,
which saw itself as
'action art', and is
similar in this respect
to Carrà's *Patriotic
Celebration* and
Severini's *Cannons
in Action.*

fascist positions and support for the War earned them mistrust and harsh criticism from others, such as Modigliani and de Chirico.

Marinetti travelled constantly around Europe, and even as far as Russia, giving lectures in his 'verbal terrorism' style. His programme covered not only all the artistic disciplines, but also the lives of the artists themselves, who were expected to be daring and provocative: 'Beauty is born of struggle.'

The Futurists, Boccioni in particular, were inspired by Nietzsche and Henri Bergson's analysis of the unity of different moments of perception and movement. The Futurist style is based on the principles of interpenetrating planes and simultaneity, and in this respect is similar to Cubism. However, Futurist art used, in addition, a variety of methods to draw the viewer into the centre of the work, which could be a painting, a poem or a play, as Futurism above all else saw itself as 'action art'. These included repeated forms that suggested a kinetic depiction of time and speed based on the phenomenon of retinal persistence; orthogonal or diagonal shafts of vivid colour reminiscent of the eddies of air caused by the speed of machines; and the acoustic dimension. Severini portrayed the movements of a crowd using a divisionist technique similar to that of Seurat, but brought to life through the use of radiant colours.

The research conducted by Marey and Muybridge into the nature of movement and Röntgen's discovery of X-rays also played a part in

Futurism, though to a lesser extent than in Cubism: the Futurists were not seeking to represent the fourth dimension, merely to give an impression of rhythm, and determined the lines of force of the objects depicted according to their personal point of view, not according to some pre-established structure.

Having spent 1910 and 1911 trying to borrow its techniques, at their exhibition in Paris in 1912 the Italian Futurists began to attack Cubism, which was spreading rapidly at the time, regarding it as a covert form of academism striving for purely aesthetic values. Paradoxically, given the forcefulness of their message, their influence would prove less important than that of the Cubists, except in Russia, and remained no more than an alternative aesthetic rather than an enduring artistic revolution. For their part, the Cubists, in particular Picasso and the Cubist exegete Apollinaire, criticized the Futurists for having produced superficial art. The only real influence the Futurists had was on Russian Futurism (see page 56), Vorticism (see page 50), Der Blaue Reiter (The Blue Rider group, see page 70) after 1912 and later Joseph Stella in the United States.

Because they felt a blind optimism and had not interiorized their aesthetic ideas, they threw themselves into World War I and disillusionment inevitably followed. Boccioni was killed in action in 1916, as was the architect Sant'Elia, whose Futurist aesthetic was later claimed by Mussolini as the official national art. These tragic events and the strong individuality of the Futurist artists slowed the movement's momentum in 1918, despite Marinetti's efforts to ensure its survival. Severini left for Paris and took refuge in an art characterized by the return to order, before turning to abstraction and, like Carlo Carrà, joining the Valori Plastici movement. The success of the Russian Revolution injected Futurism's second phase with a certain illusory and temporary dynamism, before its complete aesthetic and, more importantly, ideological collapse when Marinetti openly embraced fascism.

The only innovation of Futurism that remained relevant after World War I was aeropainting, which, because it was ideologically innocuous, was accepted by the Italian, Greek and German regimes as the art form most representative of Italy, in spite of the richness of the work of independent artists such as de Chirico. The end of the movement coincided with the beginning of World War II, which no longer admitted any ambiguities, and the death of Marinetti in 1944.

The Russian avant-garde

The artistic avant-garde that grew up in Russia at the same time as the revolutions of 1905 and 1907 offers a number of paradoxes that reveal much about the extent of the experimentation conducted during this period. Dominated initially by it, the Russian avant-garde was in turn to

PICASSO NAIVE ART MODIGLIANI CUBICISM ART DECO CALDER BRZESKA FUTURISM GRIS SOUTINE ZADKINE PARIS SCHOOL ROUSSEAU KOKOSCHKA MUNCH MAGIC REALISM MATISSE
MOROZOV ŠNEJKANOV KANDINSKY MUNCH SERVAN NAIVE PLASTIC SURREALISM VALLOTTI RIDER ERIC ACTION THE EXPRESSION NABIS KANDINSKY LARIONOV INTERNATIONAL MODERN EXPRESS
ART ROUSSEAU PARIS DE KIRCHNER MAZ SCHMIDT SCHWITTERS SUPREMATISM DES IMPRESSIONISM NEW SECURITIES EDUCATIONS ARKA THE BLAUE DER ADRIAN NAIVE LARIONOV
DUCK KANDINSKY LARIONOV INTERNATIONAL MODERN EXPRESSIONISM DERAIN BOCCIONI THE BLUE RIDER MARC KANDINSKY LARIONOV INTERNATIONAL MODERN EXPRESSIONISM DER

have a significant influence on European art, and formed the basis for some of the most important artistic movements of the 20th century, such as Constructivism, Dadaism and Surrealism. It even caused Italian Futurism to change direction in its latter stages.

For the first time in history, the Russian avant-garde questioned art's ideal function as catharsis. Its artists declared that the aim of art was no longer to provide humankind with a means of rediscovering a threatened harmony, the essence of human existence, but by becoming involved in political conflicts to reflect and anticipate, at the risk of exposing major ruptures, the irreversible upheavals that were occurring at the beginning of the 20th century.

Influenced predominantly by Cézanne, but also by the Italian Futurists, the Cubists, the Fauves, Matisse and Picasso, whose works they had been able to see either in Paris or else in the collections of Ivan Morozov and Sergei Shchukin in Moscow, they assimilated what they could from them and then liberated themselves from their influence, asserting their own individuality in a series of major exhibitions. These exhibitions prompted them to publish manifestos, which in certain cases had been written in

Valentin Serov,
Brave Little Soldiers!
Where is Your Glory
Now?, 1905 (State
Russian Museum, St
Petersburg). In this
painting Serov records
the repression of the
1905 revolution in a
restrained yet
expressive manner.

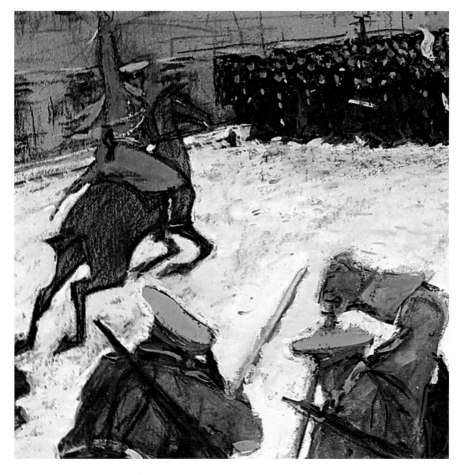

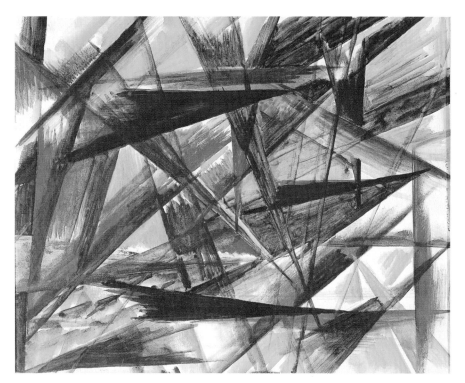

Mikhail Larionov,
Red Rayonism, 1911
(collection of Mrs
Larionov). In this
abstract work executed
in parallel with *Blue
Rayonism,* Larionov has
retained the formal
principles of Italian
Futurism but has
eliminated its social
and ideological
message.

secret years before, and to make theoretical and political choices that led them into action.

Around 1905, the aestheticism and mannerism of the wholly Russian World of Art movement – represented notably by Chagall's teacher Bakst (1886–1924) – started to attract more and more criticism, and in 1909 a Russian primitive style represented by Natalia Goncharova (1881–1962) and Mikhail Larionov (1881–1964) began to develop. This movement was still inspired by European painters such as Cézanne, Gauguin and the Fauves, but also, and more importantly, by icon painting and *lubok* (a style of popular Russian art). When they returned to Russia from Paris, where they had been designing costumes and sets for the celebrated ballets of Diaghilev in 1906, Goncharova and Larionov brought the latest ideas back with them.

Gleizes and Metzinger's book *Du Cubisme* ('On Cubism') and Cézanne's *Écrits* served as the Russian avant-garde's main written sources of reference between 1910 and 1914. Marinetti's *Futurist Manifesto* was translated and published in the Russian press shortly after its original publication in 1909. Because of its social dimension and rejection of the Renaissance legacy, the Russian painters of the day – who were mostly from humble or peasant backgrounds – were attracted far more strongly to Futurism than they were to Cubism, which represented a purely plastic revolution. Russian Futurism differed greatly from Italian Futurism, however, in its lack of respect for social conventions, its

Kasimir Malevich

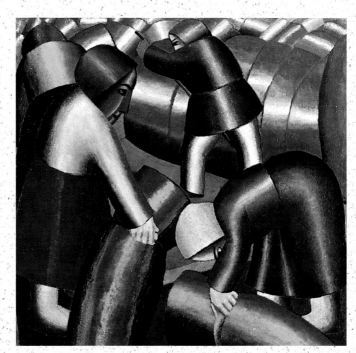

Taking in the Rye, 1912 (Stedelijk Museum, Amsterdam). In this painting, one of many Malevich dedicated to the world of work, space, deprived of perspective, is treated in keeping with the rules of Russianized Cubo-Futurism in semi-circular volumes of contrasting colours. Unlike in the works of Italian Futurism, the figures are assimilated into the same plane as the metallic-looking sheafs with no apparent emotional element. Modern man masters and surpasses the machine by integrating himself with it. Malevich depicts this statically, with none of the dizzying movement suggested by Italian Futurism. Malevich believed that man had to 'snatch the world out of the grasp of nature in order to construct a new world of which he would be master'.

1878. Birth of Kasimir Severinovich Malevich in Kiev.

1895. After studying at the Academy of Fine Arts in Kiev, Malevich meets Larionov and Goncharova, who exert a decisive influence on his early work.

1912. Malevich's style of painting is still strongly influenced by Western art: Fauvism, and subsequently Cubism and Futurism. Malevich contributes to the Donkey's Tail and Blue Rider exhibitions.

1913. For the next two years, Malevich produces alogical works inspired by Cubist papiers collés and the Zaoum poetry of Khlebnikov, Kruchenykh and Mayakovsky. Given the task of designing the set and costumes for Matiuchin's opera *Victory Over the Sun*, he exhibits his first Suprematist work, *Black Square on a White Ground*, as one of the backdrops, thus marking the start of his move towards pure abstraction.

1915. Participation in the Tramway V exhibition in Petrograd. Following a quarrel with Tatlin, he publishes with Jean Pougny his *Suprematist Manifesto* and then *From Cubism and Futurism to Suprematism*.

1918. An enthusiastic supporter of the Russian Revolution, which fires his imagination, he is appointed to a teaching post at Moscow's first National School of Applied Art, and then at the Vitebsk art academy, where he replaces Chagall.

1919. One hundred and fifty-three of Malevich's works are shown in his first solo exhibition in Moscow. Creation of his first *Architectones* on paper.

1923. His first *Planites* were probably created this year.

1927. Malevich travels to Germany and meets members of the Bauhaus in Dessau — who remain closed to his views — in order to prepare for the publication of his book *Die Gegenstandslose Welt* ('The Non-Objective World'). A retrospective of his work is organized in Berlin, but he is forced to rush back to the Soviet Union and 30 of his works remain behind in Germany. Most of them are later bought by the Stedelijk Museum in Amsterdam and the Museum of Modern Art in New York.

1930. Malevich loses favour with the authorities and is briefly imprisoned. He seems to have abandoned Suprematism for landscapes and portraits.

1935. Dies in St Petersburg, where he is buried in a coffin he has decorated with Suprematist motifs.

Natalia Goncharova, stage design for *Le Coq d'Or*, Ballets Russes, 1914 (Bibliothèque de l'Opéra, Paris). In 1914, the opera-ballet *Le Coq d'Or* (also known by its English title, *The Golden Cock*), staged by Diaghilev's Ballets Russes, fascinated Paris and in particular H G Wells, who declared himself 'stunned'. In response to a second invitation from Diaghilev, Goncharova travelled to Paris in the company of Larionov and breathed new life into *lubok*, or Russian popular art. The influence of lubok can be seen in this near-monochrome panel dominated by reds, which features naïve draughtsmanship and elaborate decoration with no specific focal point.

rejection of metaphysics, its adherence to Marxist ideology and its poetic vision of the machine, all of which are evident in the works of Larionov and especially Malevich. During this period, in which the foundations of Russian society were being completely undermined, the divisions between different art forms were also starting to disintegrate.

The Knave of Diamonds exhibition, held in Moscow in 1910, unveiled and defined a Russian artistic movement that sought to free itself from Western influences. This was the first time the public had been shown works by Kasimir Malevich (1878–1935), who would replace Goncharova and Larionov at the head of the avant-garde in the 1920s. Painted between 1905 and 1908, these paintings resembled the work of Cézanne, Derain, Van Gogh, Vuillard and Bonnard in terms of their construction, but Malevich soon freed himself from these influences and later produced scenes of peasant life in the manner of Larionov and Goncharova, whose palette, formal design and even titles he adopted. In 1909, continuing with his experimentation, he started combining the chromatic boldness of the Fauves with the spirit of commitment of the Brücke group. Malevich's heavy-looking figures with enormous hands and feet, placed in a space structured around elliptical sections, gave his representations of the world of work a symbolic meaning. Like most of the Russian avant-garde, Malevich was politically committed: he had taken a keen interest in the 1905 revolution and subscribed to the views of the Bolshevik regime.

The Target exhibition, held in Moscow in 1913, gave Larionov an opportunity to exhibit the first of his Rayonist works, *The Glass* (1909, Guggenheim Museum, New York). He also published his *Rayonist*

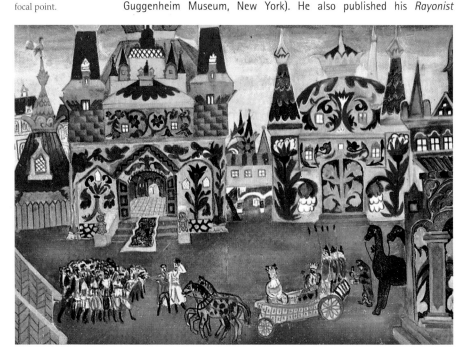

MY PICASSO NAIVE ART MODIGLIANI VORTICISM ART DECO GAUDIER-BRZESKA FUTURISM GRIS SOUTINE ZADKINE PARIS NEW JID ROUSSEAU NOLDE NIKA MUNCH MAGIC REALISM MAX NORDZCO SIGHEROS VAN DUISBURG MONDRIAN NEO PLASTICISM MARC CHAGALL BLUE RIDER RIDER BOCCION I THE BLUE RIDER MARC KANDINSKY LARIONOV INTER VIADUK VS MODERN EXPRES ANTI BUHAMEL JACQUIE DE CHIRILO MEZZO CLANGTION SUPPREBUSLER DER MONTES BONESY NEUES SACHLICHKEIT EDITION HA BROZON SIQUEROS VAN TOESPORT MEMODERN EXP NOLDE ROUSSEAU LAROSCOUN INTERNATIONAL MODERN EXPRESSIONISM DERAIN BOCCIONI THE BLUE RIDER MARC KANDINSKY LARIONOV INTERNATIONAL MODERN EXPRESSIONISM DER

Léon Bakst, *Nijinsky in L'Apres-midi d'un Faune,* a ballet with music by Debussy, 1912 (Bibliothèque Nationale, Paris). Bakst, founder of the Russian World of Art movement and Chagall's teacher, was strongly influenced by European art of the late 19th century, Impressionism and Art Deco. Bakst was commissioned by Diaghilev to design sets for a number of his ballets, including *Daphnis et Chloé,* and this watercolour shows the dancer Nijinsky in the costume of a faun as he appeared in the première in May 1912. The mannerism of both form and colour attracted loud criticism from the Russian avant-garde, however.

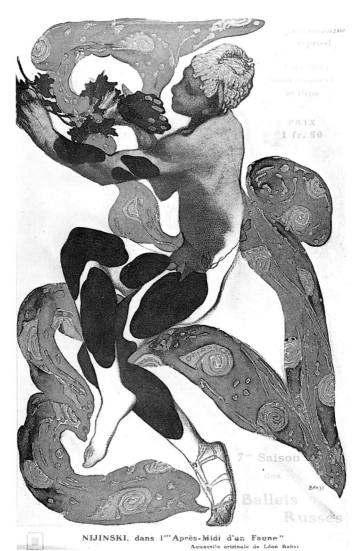

NIJINSKI, dans l'"Après-Midi d'un Faune"
Aquarelle originale de Léon Bakst.

Manifesto, written in 1911 and signed by eleven artists, including Goncharova. Mayakovsky defined Rayonism as a Cubist interpretation of Impressionism. Larionov referred to neither of these, but instead to contemporary discoveries in the field of light, and to the fourth dimension, which had become a subject of interest to painters and sculptors following Einstein's elaboration of his theory of relativity in 1905.

Despite being short-lived (from 1911 to 1914) and having a small number of followers, Rayonism exerted an important influence on European art by helping to pave the way for abstraction, and because of its theoretical basis, which led to Suprematism and subsequently Constructivism. Larionov's *Rayonist Manifesto* was translated into Italian for the exhibition 'Radiantismo'.

On 11 March 1912, the exhibition of the Donkey's Tail group witnessed

THROUGH FORM REVO FAUVISM MAGRI CHT BOLCURM LAMIER DELAUNAY MIPKA DE VLAMINCK RUSSIAN AVANT-GARDE MARINETTI VALLOTTON SEVERINI NEU HROUGH FORM REVOLUTIONS SUPERVITY KIRCHNL DONSEU ROUSSEAU GRIS AA GLEIZES DUTH LE GRA CHIRICO METZEN GRATES LE CORBUSIER DES PIÑHE KOHNISTUNG R SKARUEKSER THROUGH FORM REVOLUTIONS KANDINSKY LAURENS LARIONOU PICASSO SIGNAC VAN DOES BURG MUNCH BRUCKE GAUGUIN LEGER BRAQUE
THROUGH FORM REVOLUTIONS DELAUNE ZADKINE PABLST LOOK KANDINSKY GONCHAKOVA MARINI MAUL SEVERINI MALI REBUSSTEN CYBARUM CHAGALL VAN DHUE GROSZ
IONS THROUGH FORM REVOLUTIONS SEVERAT NEL CHKERT DIX RIVERA OROZCO SIOUEROS VAN DOESBURG MONDRIAN DED CLASTICISM MAGHALL BLUE RIDER BOCCIONI ZAUN
RM REVOLUTIONS THROUGH

REVOLUTIONS THROUGH FORM

the formation of an independent Russian school that included Goncharova, Larionov, Tatlin, Malevich and Chagall. Like the artists of Der Blaue Reiter (The Blue Rider) group (see page 70) based in Munich, they took their inspiration from popular and children's art. This exhibition was ridiculed by both public and press and Larionov called Kandinsky, who had settled in Munich, a 'decadent Municher'. In 1914, World War I forced Russia to withdraw into herself. Unlike most Western countries, Russia experienced a period of intense artistic activity. The War, which brought about the dissolution of Western Europe's artistic centres, brought together Russian artists, including Kandinsky, Pevsner and Gabo, in Moscow and Petrograd, and they all assumed artistic positions with regard to the social realities of the day.

In 1914, Larionov and Goncharova, who were again in Paris painting sets for Diaghilev's ballets, returned to Russia. Larionov organized the

Vladimir Tatlin, model for the Monument to the Third International (copy), 1919 (A Shchusev Museum of Architechture, Moscow). In 1919, Tatlin was commissioned to design a monument to the Third International. He conceived a leaning double-skewed spiral construction, which expressed the dynamism of the revolutionary situation of the day. Of the three models designed by Tatlin for the tower, only the one in Moscow's Museum of Architecture has survived. By basing it on a structure inspired by the Futurist structures of Boccioni, Tatlin was aiming to achieve a fusion between the different functions of sculpture and architecture. The tower was meant to contain slowly rotating glass workrooms in the form of (from the bottom up) a cube, a pyramid, a cylinder and a hemisphere, but progressed no further than the planning stage. It can be seen as an early warning sign of the fate that awaited many Futurist artistic projects: degeneration into utopia.

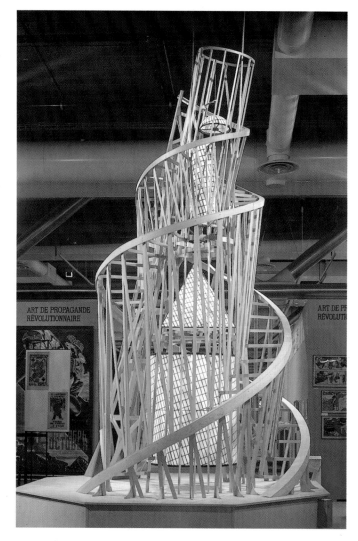

ISM PICASSO NAIVE ART MODIGLIANI VORTICISM ART DECO GAUDIER-BRZESKA FUTURISM GRIS SOUTINE ZADKINE PARIS SCHOOL ROUSSEAU KLIMT OSCHA MUNCH MAGIC REALISM MA FLOR DZZO STRINDBERG DUISBURG MERIDIAN NEW PLASTICISM BRAQUOIS BLUE RIDER BOCCION IFUTURISM ABC KANDINSKY LARIONOVINTER VINOLI MUNCH MODERN OUEVEI ISM TRIRHAM PICABIA DE CHIRICO MERZ SCHWITTERS DADAISM SURREALISM NEUE SACHLICHKEIT DIX RIVERA DADZZO SCHARDS VAN DESPORGMODERNISM NA SYI ARCE ROUSSEAU LIROGCURA INTERNATIONAL MODERN EXPRESSIONISM DEWAIN BOCCIONI THE BLUE RIDER MARC KANDINSKY LARIONOV INTERNATIONAL MODERN EXPRESSIONISM DE

Mikhail Larionov, *Portrait of Tatlin*, 1911 (MNAM, Centre Pompidou, Paris). This portrait of Tatlin, who was Larionov's student, is a remarkable synthesis of Rayonism, Futurism and traditional Russian art, and also incorporates a number of Cubist and 'alogical' resonances in its use of inscriptions and the word *balda*, or 'crazy'. The hieratic gravity of the face suggests the art of the icon.

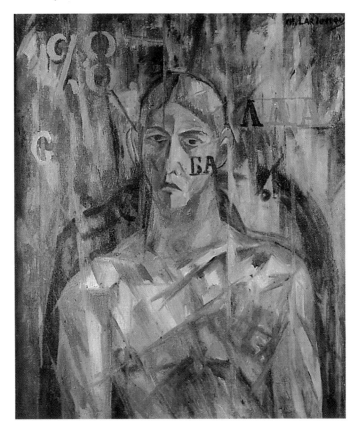

No. 4 exhibition in 1914 and contributed to Year 1915, which featured the works of Kandinsky and Goncharova. After this he left his native country for good, with Goncharova, to join Diaghilev in Switzerland.

During this period, poetry became more and more closely connected with painting and shared the same spirit: a rejection of reality that prefigured Dadaism; a lucid and disabused verdict by artists on their role in a decadent and frustrating society; and a nonsensical realism found in paintings such as Malevich's alogical picture *An Englishman in Moscow* (1914, Stedelijk Museum, Amsterdam) and Filonov's *People-fish* (1915, private collection), as well as in the poetry of Khlebnikov and Kruchenykh. During these effervescent times, new types of theatre grew up and led to the creation of masks, costumes and automata. A number of artists, such as Mayakovsky, left for the front in order to entertain the troops and carry out propaganda work.

Alongside Cubist works by Malevich, Popova and Pougny, the Futurist Tramway V exhibition, held in Petrograd in February 1915, also revealed the first *Counter-Reliefs* by the founder of Constructivism, Vladimir Tatlin (1885–1953), which were inspired by Picasso's relief paintings and executed at the same time as Paris-based Archipenko's *Counter-Volumes*. Unlike Malevich, Tatlin, having done away with the figurative, sought to

deepen the representation of real space rather than invent a new pictorial language. His slogan 'Real materials in a real space' led him to examine the qualities of the various raw materials he wished to use as an architect would, a process that allowed him to juxtapose cardboard, copper, iron and glass. Space became the constitutive element of his first abstract sculptures.

In his desire to integrate them with reality, he freed his reliefs from the frame and started to call them *Counter-Reliefs*. He suspended them in corners and played beams of light over them, accentuating the dynamic intersection of their planes.

In December 1915, Tatlin came to blows with Malevich in the manner of their peasant ancestors over the exhibition entitled 0.10, Final Futurist Exhibition. He accused Malevich of amateurism and prohibited the inclusion of his 36 Suprematist paintings in the exhibition, which was only for professionals. The problem was resolved by hanging the works of Malevich and his followers in another room. Malevich responded,

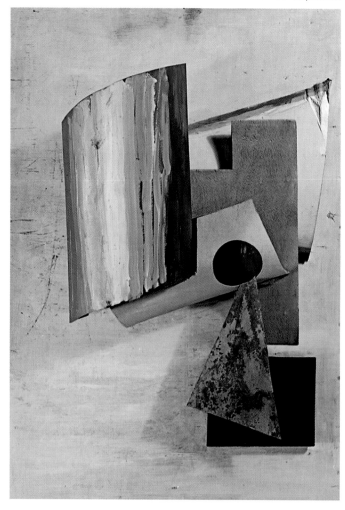

Jean Pougny, *Sculpture-Montage*, 1915 (MNAM, Paris). After a stay in Paris in 1910, during which he discovered Fauvism and Cubism, Pougny created around 30 *Compositions*, which consisted of basic geometrical elements (rectangles, triangles and circles) cut out of everyday materials and either painted or left in their raw state. What differentiates them from the Dadaist works to which they are often compared is the plastic effect produced by their rigorous spareness.

Kasimir Malevich, *Suprematist Composition*, 1914–18 (Stedelijk Museum, Amsterdam). This composition belongs to what Malevich himself termed Suprematism's coloured phase. Its bright colours represent a 'regression' in relation to the black and white lifelessness of the first Suprematist paintings. Fascinated, as was Mayakovsky, by aviation and the cosmological discoveries of the day, Malevich was exploring the third dimension in art, which he conveyed through asymmetry and the absence of a focal point.

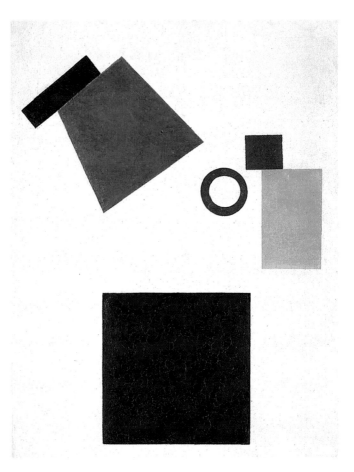

however, by publishing with Pougny his *Suprematist Manifesto*, which described Suprematism as the 'supreme state of painting'. He traced its origins back to the sets he designed for Kruchenykh's Futurist opera *Victory over the Sun* (1913), in which one of the backdrops featured a black and white square. Malevich later identified three phases in Suprematism: black, coloured and white. In 1914 he introduced what he called a 'regression' into paintings such as *Suprematist Composition* (MOMA, New York) and *Dynamic Suprematism* (1916, collection of Dr Hammer, New York). This involved setting coloured geometrical shapes in a white field within which they appear to fly, as if within some cosmic order.

The themes of flight and the cosmos that were already present in the paintings he completed in 1914 (*The Aviator*, State Russian Museum, St Petersburg) were developed throughout his work. Fascinated, as was Mayakovsky, by aviation and the discoveries of the cosmos, Malevich explored the third dimension in art, conveying it through asymmetry and the absence of focal point, and favouring dynamic movement based on the diagonal.

REVOLUTIONS THROUGH FORM

It was also in 1914 that Marinetti gave a series of lectures in Russia. Larionov, Mayakovsky, Burliuk and Kamensky, who subscribed to the revolutionary view of Futurism, detected in his speeches a dangerous subordination of art to a misguided political line and responded with violent diatribes against him. Malevich alone set aside his own political differences with Marinetti and took up his defence with passion.

Pougny started creating his *Compositions* (MNAM, Paris), constructions made of geometrical elements cut out of the most mundane objects following a visit to Paris in 1910, during which he discovered the Fauvist and Cubist movements. Their simplicity and rigorous spareness create a plastic effect that differentiates them from Dadaist works, to which they are often compared. Unlike the works of Tatlin and Rodchenko, Pougny's compositions were fixed to painted backgrounds. A friend of Khlebnikov and Mayakovsky, Pougny was a follower of Constructivism and Lettrism, and was also inspired by Cubist papiers collés in works such as *Hairdresser* (1915, MNAM, Paris), which he renders absurd through the inclusion of letters. Pougny left Russia for Berlin in 1920, before settling for good in Paris in 1923.

Invited to the exhibition entitled The Store in 1916, Alexander Rodchenko (1891–1956) met Tatlin and Malevich and fell under the influence of each of them in turn. In 1916, he founded the movement called Constructivism with Tatlin and worked with him the following year on the decoration of the Picturesque Café, later renamed the Red Cockerel, a Moscow café-theatre and meeting place of the bohemian intelligentsia. A teacher at Vkhutemas (the State Art Workshops) between 1920 and 1930, Rodchenko concentrated on meditations on space in a series of *Spatial Constructions* before moving towards Productivism. Rodchenko produced stage sets, magazine illustrations, typography and photomontages that testify to the richness of his plastic and formal experimentation.

The Russian Revolution was victorious in October 1917. A future free of bourgeois conventions opened up at last where the dreams of the Futurist artists could be realized, a future founded on industrialization and a spirit of community. The Russian Futurists took an active role in the artistic reorganization of their country. Their aim was to bring art out of the museums onto the street, to deconsecrate it. They were given four years: the period of 'heroic communism'. They decorated the streets, organized mass spectacles and wrote heroic revolutionary plays.

In 1918, Lenin proposed raising monuments to the heroes of the Revolution, including Courbet and Cézanne. Tatlin was elected president of the Moscow artists' union and, to celebrate the first anniversary of the October Revolution, he participated in a dangerously successful reconstruction of the storming of the Winter Palace while Mayakovsky conducted symphonies of factory sirens.

In January 1919, Russian art reached its peak in the form of the Tenth

SM PICASSO NAIVE ART MODIGLIANI ORPHISM ART DECO GAUDIER-BRZESKA FUTURISM GRIS SOUTINE ZADKINE PARIS SCHOOL ROUSSEAU KOKOSCHKA MUNCH MATISSE MAT OLOROZCO SIGNORELLI VAN DUESBURG MONDRIAN NEUE SACHLICHKEIT BAUHAUS KLEE BEIDER BOCCIONI THE FATHE STOCK STAEL KANDINSKY LARIONOV INTERNATIONAL MODERN EXPRESSIONISM DE MAI JNSET DUFHSME MORRIS DE CHIRICO MELA SCHLATHESS SUPREMATISM DE MAYAS SKULAE FAUVISME SLAUGHTER ART BRUT RIVERA OROZCO SEURAT SEVANS DE SRONN SOO ADRIAN NEO FRE MARC KANDINSKY LARIONOV INTERNATIONAL MODERN EXPRESSIONISM DERAIN BOCCIONI THE BLUE RIDER MARC KANDINSKY LARIONOV INTERNATIONAL MODERN EXPRESSIONISM DER

State Exhibition: Abstraction and Suprematism dedicated to 'the art of the laboratory'. Malevich exhibited his series of white on white paintings including *White Square on White Background* (MOMA, New York) made up of two barely differentiated whites, an evocation of infinity. For his part, Rodchenko, who claimed his work was 'founded on nothingness', showed his painting *Black on Black*, and created Non-Objectivism. This exhibition brought together members of the avant-garde still working in Russia for the very last time, including Popova, Stepanova, Vesnin and Rozanova.

Malevich had arrived at a style of painting dominated by pure feeling in a space in which contours and colours were erased. He was exploring art's third dimension – he would later draw attention to the futility of the Cubists' attempts to portray the fourth dimension – which led him to an overwhelming fascination with the absolute and the cosmos. At the 16th official exhibition, entitled From Impressionism to Suprematism, held in December 1919 and dedicated to Malevich, the artist announced the death of the Suprematist movement. In 1919 he left Moscow for Vitebsk, while Kandinsky went to Munich and Pevsner to Oslo.

Constructivism and industrial art triumphed, and artists abandoned pure speculation in order to place themselves at the service of society. In the following years, Malevich devoted himself to writing a remarkable theoretical work on a similar subject to *From Cubism and Futurism to Suprematism* (1916). This was called *Die Gegenstandslose Welt* ('The Non-Objective World') and was published by the Bauhaus in 1927. He attempted to apply his Suprematist ideas to industrial design, but made no compromises, which meant that his cups and teapots were far from

Kasimir Malevich, *Red Cavalry, Galloping,* 1918–30 (State Russian Museum, St Petersburg). A keen supporter of the Revolution, here Malevich has realized a simultaneously epic and minimalist vision of the victorious Red Cavalry. The horizontal stripes, an unusual compositional feature in Malevich's work, emphasize the immensity of the sky and earth, which is sublimated through strength of colour and the imagination.

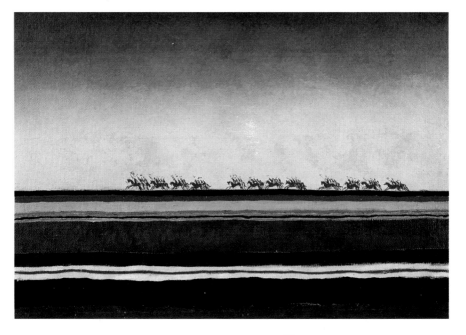

functional. From 1919, in Vitebsk, he drew designs for suspended cities and declared that 'Suprematism was transferring its centre of gravity to architecture' and that 'modern art is neither pictorial nor imitative, it is above all architectural'. He became interested in Rudolf Carnap's theories on formal space, both intuitive and figurative (R1, R2, R3), published in 1922, and subsequently in Le Corbusier's manifesto *Towards a New Architecture* (1923).

Malevich's first *Planites* appeared in 1923. These were blueprints for flying vessels, geometric constructions of cubes and blocks. In 1924, he submitted a design for the monument to Lenin, in which Lenin was represented by a cube! The proposal was rejected. This was followed in 1926 by his *Architectones*, architectural systems of rigorous formal beauty, which conveyed Malevich's admiration for Greek architecture and which would inspire Bauhaus and Chicago School architects. It was at this time that, for reasons he never explained, Malevich ended his experimentation, refusing, unlike the Constructivists, to serve the future of technology. Instead, he turned back to figurative art, to portraits and landscapes. Until his death in 1935, he lived in some disgrace, having been arrested and then swiftly released in 1930.

The IZO, the plastic arts section of the People's Education Commissariat, consisting notably of Kandinsky, Punin, Altman, Rozanova and the poet Brik, allowed Russia to become the first country to exhibit abstract works as official art, rejecting the art of the past as irrelevant to present-day artistic creation.

But in 1920, Rodchenko published his *Programme of the Constructivist Group*, which subordinated art to a utilitarian purpose in the name of what he termed 'objectivism'. Like Tatlin, he thereafter devoted himself exclusively to the applied arts and photography.

In accordance with their ideals, which developed rapidly into a utopia, Tatlin and Rodchenko wanted to transform work into art and art into work, and Tatlin even became an engineer in a metalworking factory. Revealing a private fascination for aviation, he constructed a flying machine named the Letatlin in 1930, and exhibited it in Moscow in 1932. 1921 saw the triumph of the Bolshevik regime (despite the famine that ravaged the Volga region and the revolt in Kronstadt), a return to relative order and, crucially, the emergence of the NEP (New Economic Policy) devised by Lenin. The failure of attempts at reorganization made by Lunacharsky and the Narkompros (People's Education Commissariat) is explained by the insufficient means at their disposal and the growing influence of the Proletkult. This organization, led by Bogdanov and whose aim was the creation of a proletarian culture, was, however, severely criticized by Lenin in a speech given in 1920. The stirring, heroic years had disappeared with the emergence of the new bourgeoisie of the NEP, giving rise to numerous caricatures.

PICASSO NAIVE ART MODIGLIANI VORTICISM ART DECO GAUDIER-BRZESKA FUTURISM GRIS SOUTINE ZADKINE PARIS SCHOOL ROUSSEAU KOKOSCHKA MUNCH MAGIC REALISM MAL
RODIN SIGNEURS VAN DOESBURG MONDRIAN NEO-PLASTICISM BAUHAUS MAILLOLDER BUECKIN THE BLUE RIDER MARC KANDINSKY LARIONOV INTERNATIONAL MODERN EXPRESSI
MODIGLIANI ROSSEAU DE CHIRICO MARC EXPRESSIONISM FAUVE SAVIGNY FEININGER BRUCKE MARCO WORLD DIE SPHINX DE DERAIN NEO-EXP
KIRC KANDINSKY LARIONOV INTERNATIONAL MODERN EXPRESSIONISM DERAIN BOCCIONI THE BLUE RIDER MARC KANDINSKY LARIONOV INTERNATIONAL MODERN EXPRESSIONISM

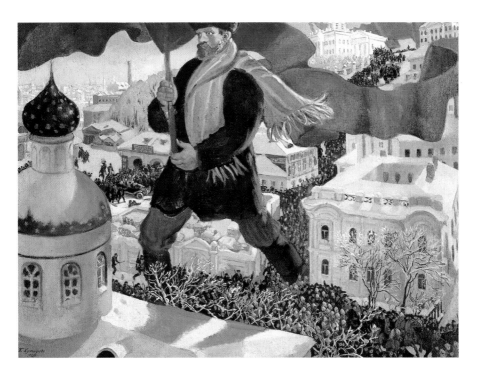

Boris Kustodiev,
The Bolshevik, 1920
(Museum of the Army
of the Soviet Union,
Moscow). Bearing the
red flag, which flutters
in the breeze, the
Bolshevik advances
resolutely, crushing all
obstacles in his way,
including the church.
Kustodiev (1878–1927)
wanted to depict the
1917 Revolution in all
its greatness. The
saturated, decorative
colours evoke the
traditional Russian
style of *lubok.*

In August 1920, Antoine Pevsner (1886–1962) and his brother Naum Gabo (1890–1977) declared in their *Realist Manifesto* that they were rejecting Cubism and Futurism in order to investigate the 'true laws of life', but their concept of art required total independence from the state, forcing them to leave the Soviet Union in 1922, at the same time as Gorky. In Europe, they joined the Abstraction-Création movement. Their version of Constructivism met with official recognition from Moholy-Nagy at the Bauhaus and El Lissitzky in Russia. They condemned the 'darkness of abstraction' while retaining its theoretical principles and, even more confusingly, revolted against bourgeois studio art and Tatlin's Suprematism and Utilitarianism. 'That which we call reality is a chain of images created by man', announced Gabo. In defining a strictly personal way forward, the Constructivists were interested in the machine for its dynamism and rhythm alone – unlike the Futurists, for whom it repre-sented an idealized way of life – and, like Picasso, sought to develop the purely formal principles of transparency and depth in their sculptures. The Productivists would question this belief, asserting that 'art is just a lie that only serves to camouflage man's impotence'. In 1923, Chagall returned to Paris for good, following serious disagreement with Malevich and El Lissitzky. At Inkhuk, the Institute of Artistic Culture founded in May 1920, Kandinsky attempted to systematize Suprematism, Tatlin's 'culture of materials' and his own ideas into a pedagogical method. But Inkhuk's Constructivists, in favour of greater rationality in artistic cul-ture, categorically rejected his programme, and in 1921 Kandinsky left

REVOLUTIONS THROUGH FORM

the Soviet Union to take up a teaching post at the Bauhaus. A new pro-gramme was devised after his departure, helping to reinforce the division between the 'laboratory art' and 'industrial art'.

Rodchenko joined the 'industrial art' movement, represented by Tatlin, Stepanova, Exter, Vesnin and Popova, who exhibited under the label 'lab-oratory art' for the last time at the 5 x 5 = 25 exhibition in 1921. Constructivism was redefined by Tatlin and Rodchenko at this time as a theory 'aimed at integrating art with life'. Art was demythologized, muse-ums reduced to archives and style replaced by technique based on three principles: architectonics, execution and construction. Rodchenko, who never managed to free himself from the abstraction of his early days, devoted himself, along with Mayakovsky, to the design of propaganda. His designs were essentially geometric, and his furniture, unlike Tatlin's, was a response to his interest in pure abstraction rather than to the demands of the materials or to the aspirations of the new man.

Prior to developing in the West with Gabo and Pevsner, Constructivism had found its true expression in the Soviet Union only in the theatre and in the propaganda posters of El Lissitzky (1890–1941). An engineer, Professor of Architecture at the Vitebsk School of Art in 1919, brilliant theoretician, designer of the Lenin Tribune and creator of what he called 'Proun' (abstract compositions based on axonometry), he disseminated the Suprematist and Constructivist theories abroad, and after his return was one of the rare avant-garde artists to remain in the Soviet Union up to his death, devoting himself to decoration, design and architectural projects.

Alexander Rodchenko, *Photomontage,* 1920 (Museum of the Revolution, Moscow). In order to 'integrate art more effectively with life', Rodchenko applied Constructivist theories to new artistic techniques such as photomontage.

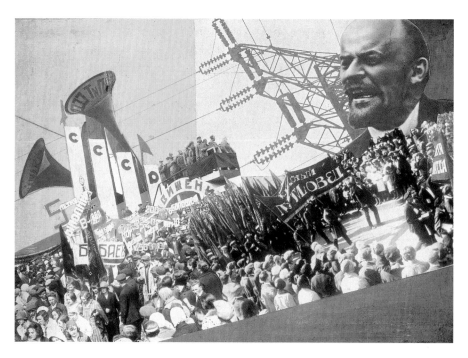

In 1922, Stalin was named Secretary-General of the Soviet Communist Party. The Association of Artists of the Russian Revolution, founded in May, declared itself against Futurism and the avant-garde and in favour of realism. Paradoxically, this enabled the Proletkult movement so decried by Lenin to gain influence. Khlebnikov died the same year, and Lenin in 1924. According to Trotsky, imagination was 'put on hold' in 1928. Mayakovsky, who had devoted the final years of his life to propaganda tours, committed suicide on 14 April 1930. In 1934, Idanov imposed Socialist Realism at the First Congress of Soviet Writers. Henceforth, this would be the sole official form of art.

The reign of the imagination was over. It had led Soviet artists to their very limits amid the passionate effervescence of the Revolution and defined the fundamental theories of 20th-century art.

THE BIRTH OF ABSTRACTION

In his book *Abstraktion und Einfühlung* ('Abstraction and Empathy') of 1908, German philosopher and art historian Wilhelm Worringer (1885–1965) described a 'primordial instinct that tends towards pure abstraction as the only possibility of peace amid all the confusion and obscurity of this world full of imagery, and that creates geometrical abstraction out of itself through instinctive need'. Abstraction, the most significant achievement of all the 20th-century artistic revolutions, dominated the artistic effervescence that occurred during the decade 1910-20 and spread throughout Europe and the United States.

The 19th-century theory of art for art's sake and the subsequent academism of the signified – or subject – had already been thrown out by the Impressionists. Art was only able to survive and renew itself through constantly breaking the rules of plastic language and through the use of formal units that have no significance in objective reality.

Between 1910 and 1920, Munich, in Germany, became one of the main meeting places for members of the artistic avant-garde, who may occasionally have rubbed shoulders with a certain failed painter who had become a housepainter – frequently unemployed – by the name of Adolf Hitler. He had twice been turned away from the Academy of Fine Arts in Vienna in 1905, having failed the entrance exam because of a lack of original inspiration. Indeed, the paintings he presented, just like his later works, were pale imitations of Rudolf von Alt's (1812-1905) architectural scenes, which were popular in Austria at the time. This disappointment was dramatic in that, having become an advocate of war, it made him turn to politics. Once he became Reichsführer, Hitler adopted a highly aggressive stance towards the artists of the Bauhaus (see page 74), an institution that symbolized the Weimar Republic.

Der Blaue Reiter (The Blue Rider)

Wassily Kandinsky (1866–1944) left his native Russia in 1896. He settled in Munich, where he came to be considered as the inspiration behind the Expressionist movement, and in 1901 founded the Phalanx group, whose main purpose was to exhibit the work of Monet and the Neo-Impressionists. He crystallized the aspirations towards abstraction that had appeared simultaneously in Russia, with Malevich, and in Europe (notably Italy) with Alberto Magnelli (1888–1971). This is apparent even in the still figurative works he completed during the first decade of the century, such as *The Cow* (1910, Städische Galerie, Munich). In 1909, Kandinsky founded the Neue Künstlervereinigung München (New Association of Munich artists) with Alexis von Jawlensky, Gabriele Münter, Franz Marc and Frenchmen Henri Le Fauconnier and Pierre Girieud. Kandinsky completed his painting entitled *First Abstract*

EXPRESSION NEU NIEKE SACH PLASTICISM MINER ARE AMPHISICA WE MORAL DW ART IKE SK MORTHERN IRKEDES FUNDAMENTAL'S KULP PUY KANDINI I CHE I BLUE RIDER FAV KANDINSKY EXPRESSION SVE NEW LE MILLE HERTUDO RIVERA DE ROCCO OCI CHRIS YA HELO SIVE SIVE DE M AND UCI BLUE DANE ZO CONS I ERDE MUM MILLY INI THE EXPRESSINI NEU IMPRESSINI CATIONAL MULTER LEADS RUD TNS WERH NEW WARREL PAINT DIE BRUCKE KIRCH UCHE MUNC PRON ARD THIRD OANCHIZ SCHVILTER SI ORECHISNI E FURDRICE HEL BLUE REIER FAV A OROZCO SIGUEROS VAN DUESBURG MONDRIAN NEO PLASTICISMBAUHAUS BLUE RIDER BOCCIONI THE BLUE RIDER MARC KANDINSKY LARIONOV INTERNATIONAL MODERN EXPRESSI

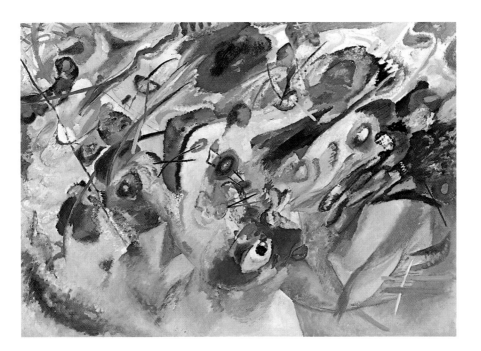

Wassily Kandinsky, *Study for Composition VII (version 2)*, 1913 (Städtische Galerie im Lenbachhaus, Munich). This work evokes Kandinsky's first calling: music. He strove to create equivalencies between lines, colours and music. The composer Arnold Schoenberg, also a teacher at the Bauhaus later on, saw this as being analogous to the twelve-tone system. One of the rare abstract painters not to have undergone a Cubist phase, Kandinsky had no interest at all in representing objects.

Watercolour (MNAM, Paris) in 1910 – a year after Francis Picabia (1879–1953) painted the very first abstract watercolour, *Rubber* (MNAM, Paris). He went on to publish his theories in his book *Über das Geistige in der Kunst* ('Concerning the Spiritual in Art'), which describes the importance of working towards an abstraction of forms determined by the concept of interior necessity and intuition.

His rejection of academism caused a split at the heart of the group in 1911. Kandinsky, followed by Le Fauconnier, Gabriele Münter and, most importantly, Franz Marc, formed Der Blaue Reiter (The Blue Rider) group, a name he came up with in conversation with Marc, who, like himself, was fond of both the colour blue and horses. Their strong friendship would continue to grow over the coming years.

Kandinsky gave his paintings non-referential titles – *Impressions, Improvisations, Compositions* – and distinguished them one from another using a simple chronological numbering system. He challenged the limits of representation by choosing oval formats, like the Cubists, or white borders, shifting the focus of the composition towards the outside. By developing a compositional idea based on a double system of graphic elements (black lines and coloured shapes) that are independent of one another (in contrast to Matisse), he changed the relationship between figure and background, which for centuries had been based on linear perspective – as defined by Alberti in the 15th century – and the subordination of colour to line. However, he avoided the danger of producing decorative art, a widespread fear among abstract painters of this

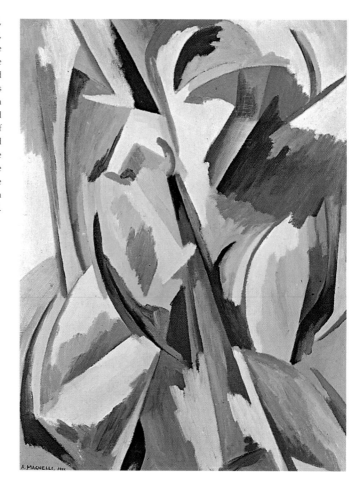

Alberto Magnelli, *Lyrical Explosion No. 8,* 1918 (MNAM, Centre Pompidou, Paris). The end of the War inspired Magnelli to produce his *Lyrical Explosions,* a series of sophisticated abstracts made up of sections of ellipses and characterized by the Futurist style, despite the painter's deliberate independence from that movement.

period, through the strict analysis of lines. His first love, music, particularly dodecaphonic music, was an important theme throughout his life, and he strove to create equivalencies between pictorial and musical elements through the repetition or weightlessness of cosmic or biomorphic shapes and motifs.

In 1912, Kandinsky published *The Blaue Reiter Almanac,* written in conjunction with Franz Marc. Their system of bright, non-naturalistic colours resembled that used by the artists of the Brücke group, although unlike them, Kandinsky and Marc retained a certain confidence in the future of art, conveyed through lyricism and a surge of empathy (Einfühlung) towards nature, which for Kandinsky was represented by the inner man and for Marc by animals and the natural world. While Kandinsky liberated his forms from the pull of gravity and prepared the way for Art Informel, Franz Marc, (1880–1916) remained rooted in the terrestrial world. Following a Neo-Impressionist period from 1908 to 1912, Marc devoted most of his work to animals: roe deer, cats and, above all, horses, all of which he depicted with great tenderness. Prefiguring

IMPRESSIONISM NEUE SACHLICHKEIT FAUVISM RIVERA HEUZI COMPLETION VON HUG JAWLENSKY MINIATURISM ANTI-CLASSIC EXPRESSIONISM BLAUE REITER PICHLING UTRILLO DELAUNAY THE BLUE RIDER NEO-IMPRESSIONISM ALBERT MARQUET BLAUE REITER SCHOOL STADLER HOLTZ DIE BRUCKE CARRÀ KLEE KIRCHNER CHIRICO MERZ SCHWITTERS SYMBOLISM EXPRESSIONISM BLAUE REITER PAUL KLEE NOLDE LIEBERMANN EXPRESSIONISM LITERATURE BRÜCKE KANDINSKY MÜNCH JARRY NAZI ARP ROUSSEAU DUFY POST-IMPRESSIONISM NABIS GAUGIN ORPHISM KIRCHNER EXPRESSIONISM DE LA FRESNAYE
OROZCO SIGUEROS VAN DOESBURG MONDRIAN NEO-PLASTICISMBAUHAUS BLUE RIDER BOCCIONI THE BLUE RIDER MARC KANDINSKY LARIONOV INTERNATIONAL MODERN EXPRESSION

Mondrian in his series of *Trees* – and in the face of intense mockery that led to periods of severe depression – Marc created highly poetic master-pieces, abstract despite their figurative references, such as *Blue Horse* (1911, Städtische Galerie im Lenbachhaus, Munich), which would become the movement's emblem, *Blue Horses* (1911, Walker Art Center, Minneapolis) and *Small Yellow Horses* (1912, Staatsgalerie, Stuttgart).

His original and metaphorical palette – with blue symbolizing virility, red passion and yellow gentleness – governed the pictorial space of these works, which remains homogeneous, while the painter's very real anxieties were sublimated into his aesthetic ideals. Marc's extensive knowledge of animals, which he observed at length, enabled him to go beyond simple appearances and convey the very essence of nature. In 1912, after he and his friend August Macke (1887–1914) met Robert Delaunay in Paris, Marc started to tone down the figurative elements in favour of a more analytical style. In terms of their treatment of space, using crystalline colours of great purity, his paintings have much in common with Orphism and Rayonism. They convey a premonitory anxiety about the coming conflict, all the more powerful for the fact that it was latent and focused on the innocence of animals. World War I caused the Blue Rider group to disperse and destroyed some of the most brilliant artistic minds of the day. Marc was killed at Verdun in 1916 and his friend August Macke died on the Champagne front in 1914. His last works, abstract drawings made in his wartime sketchbook, offer a glimpse of what one of the greatest painters of the 20th century might have achieved.

Kandinsky decided to return to Russia, where he stayed until 1921. Despite a retrospective dedicated to him in Moscow in 1920, and his nomination to the highest teaching posts, he was not able to integrate with the more radical trends of the Revolution and found himself

Franz Marc, *Small Yellow Horses*, 1912 (Staatsgalerie, Stuttgart). In all his work, Marc expressed a love for animals, ideal beings that embodied his yearning for the beautiful, the pure and the true. In this powerful metaphor, yellow horses – the yellow signifying gentleness – symbolize wisdom and the freedom of the inner being, and are set in contrast to a careworn landscape with a black sky, shown in cosmic motion with blurred houses. The horses' bent heads and their emphatic curves accentuate the internalization of their innocence and sensuality. As early as 1912, Kandinsky expressed his foreboding in a letter to Marc that war was imminent.

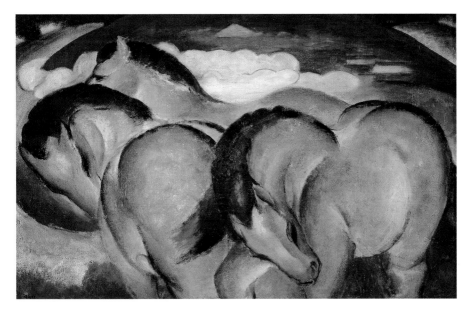

THE BIRTH OF ABSTRACTION

Laszlo Moholy-Nagy,
A. XXI, 1925
(Landesmuseum,
Münster). Hungarian
Moholy-Nagy was
Constructivism's most
faithful representative
at the Bauhaus. This
abstract composition of
austere purity, based
on a subtle use of
colour, dates from the
second phase of
Constructivism, which
started in 1920.

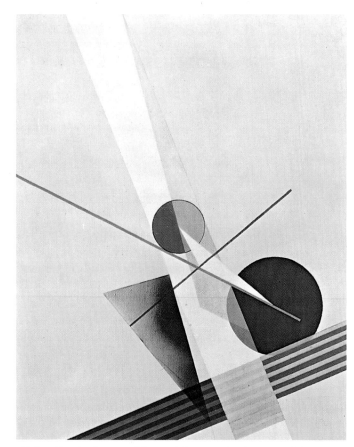

sidelined by the Constructivists and Suprematists because of his individ-
ualism and loyalty to an introspective form of art.

In 1921, Kandinsky left Russia for good, accepting an invitation to
teach mural decoration at the Bauhaus, the school of architecture and
applied arts founded in Weimar in 1919 by architect Walter Gropius
(1883–1969), who was celebrated for his functional architecture.

The Bauhaus

The aim of the Bauhaus, inherited from William Morris, founder of the
Arts and Crafts Movement, was to reconcile art and applied art while
acknowledging the utility and functional rigour of the machine.
Kandinsky, who occupied a non-teaching post, formed friendships with
other Bauhaus teachers such as Johannes Itten (1888–1967), who con-
ducted his research into the colour circle there between 1919 and 1923,
and Swiss painter Paul Klee (1879–1940), who from 1920 to 1929 taught
theory on the Vorkurs (preliminary course) and subsequently weaving and
painting on glass. Both Kandinsky and Klee considered abstraction – and

Wassily Kandinsky

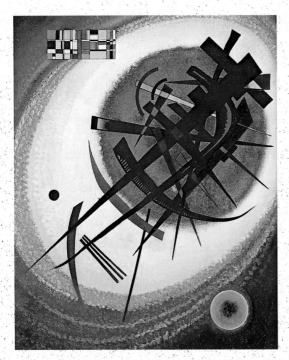

In the Bright Oval, 1925 (Thyssen-Bornemisza Collection, Madrid). In 1925, Kandinsky was teaching at the Bauhaus in Dessau. In this off-centre space, the Bauhaus-style geometric shapes in the left of the picture conflict with the animated oriental-style signs that combine in joyous rhythm with various free abstract elements. Through work like this, Kandinsky was paving the way for Art Informel. The colour range used to purely abstract effect here is darker, still leaving room for the brighter colours that would become dominant again in 1930.

1866. Birth of Wassily Kandinsky in Moscow.

1893. After studying law, Kandinsky becomes interested in music and painting and researches the popular art of northern Russia.

1895. The Impressionist exhibition held in Moscow comes as a revelation to him.

1896. Kandinsky decides to devote himself to painting and settles in Munich, a major artistic centre at the time.

1901. His first works derive from Neo-Impressionism and Jugendstil. He founds the Phalanx movement.

1909. After meeting Jawlensky and the Fauves in Paris, Kandinsky adopts a palette of pure colours and creates the Neue Künstlervereinigung München.

1910. He writes his famous text *Über das Geistige in der Kunst* ('Concerning the Spiritual in Art'), in which he analyses the formal constituents of pictures in order to isolate their particular spiritual resonance, as with music and dance: 'form, even abstract or geometric, possesses its own inner life'. He insists on the need for painters to free themselves from nature as 'their most solid base,

positive science, has been taken away and the prospect is opening before them now of the dissolution of matter [...] we are not far away from pure composition'. He completes his first abstract watercolour.

1911. A split opens up at the heart of the Neue Künstlervereinigung München. Kandinsky founds the Blue Rider with Franz Marc. Impressed by scientific advances such as the discovery of the atom, he suspends the different elements of his paintings in arbitrary levitation, as if belonging to a cosmic order.

1912. Publication, with Franz Marc, of *The Blue Rider Almanac*. Meets Robert Delaunay in Paris and is influenced by Orphism. Kandinsky turns once more to mystical themes, which he treats in a non-religious manner.

1913. Publication of a volume of poetry entitled *Klänge* ('Sounds'), followed by *Rückblicke* ('Looking Back').

1914. Following the Blue Rider exhibition in Berlin, Kandinsky is impelled by World War I to return to Moscow. In spite of his theoretical support for the Russian Revolution and his appointment to leading teaching posts at the IZO, the Academy of Fine Arts and Inkhuk, he has serious differences of opinion with the Constructivists and decides to return to Germany, leaving the USSR for good.

1922. Invited by architect Walter Gropius to teach theory and mural decoration at the Weimar Bauhaus, he works on his book *Punkt und Linie zur Fläche* ('From Point and Line to Plane'), published in 1926.

1932. Broken up by the Nazis, the Bauhaus continues to operate in Berlin as a private institution.

1933. His work is condemned as 'degenerate art' by the Nazis. The Bauhaus is closed down completely. Kandinsky moves to France, taking French nationality in 1939.

1944. Final exhibition, with César Domela and Nicolas de Staël, at the Jeanne Bucher gallery in Paris. Dies in Neuilly-sur-Seine on 13 December.

Oskar Schlemmer, *Staircase of Women*, 1925, (Kunstmuseum, Basel). This painting belongs to Schlemmer's series of Galeriebilder (gallery paintings), which were preceded by preparatory studies and executed while the artist was a teacher at the Bauhaus in Dessau. The emphasis on figurative structures and the schematic rendering of the contours of the figures, which are identical to mannequins, also reveal his talent as a sculptor.

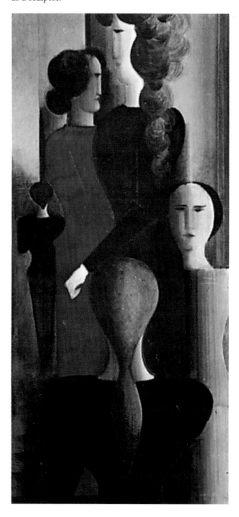

similarly a dynamism of vision, symbolized, as in Fernand Léger's work, by the arrow – to be an essential process in making art. They also shared the same confidence in the future and the hope that art would one day replace religion: 'Art is the parable of creation.' Klee published his main theories in 1925 in his book *Pädagogisches Skizzenbuch* (Pedagogical Sketchbook) while Kandinsky's appeared in 1926 in his *Punkt und Linie zur Fläche* ('From Point and Line to Plane'), inspired partly by Goethe's theories about colour.

Kandinsky's paintings of this period evoke his interest in science, in particular the science of the atom and discoveries in optics and psychology. His work began to feature a growing formal freedom and a deliberate lack of balance, which played on the opposition between the right and left parts of the picture and the lower (symbolizing materiality) and upper (symbolizing spirituality). But Kandinsky and Klee encountered the same disagreements at the Bauhaus as had existed in Russia between the supporters of pure art and the Constructivists, represented at the Bauhaus notably by the Hungarian Laszlo Moholy-Nagy (1895–1946), the sculptor Oskar Schlemmer (1888–1943) and the American Lyonel Feininger (1871–1956).

Enjoying much in common with the Blue Rider group in its early days, the Bauhaus gradually moved further and further in the direction of functionalism and the geometrization of form. After the fall of the Weimar Republic, the Bauhaus came increasingly under threat after 1924, and a reduction in its funding forced it to produce more commercial works. In 1925, in an atmosphere of extreme tension, the Bauhaus was forced to relocate from Weimar to Dessau and then from Dessau to Berlin. Gropius resigned in 1928 and was replaced by Ludwig Mies van der Rohe (1886–1969), but when Hitler came to power in 1933 he in turn was forced to resign. The Bauhaus was closed down and turned into a school for Nazi officers. The works of Kandinsky (57 of which were seized), Klee and Feininger were condemned as 'degenerate art'. Klee moved to Düsseldorf and then Switzerland, and the ageing Kandinsky to Paris, where he continued to paint abstract works of timeless beauty right up to his death. Lyonel Feininger, Josef Albers, Walter Gropius and Mies van der Rohe all

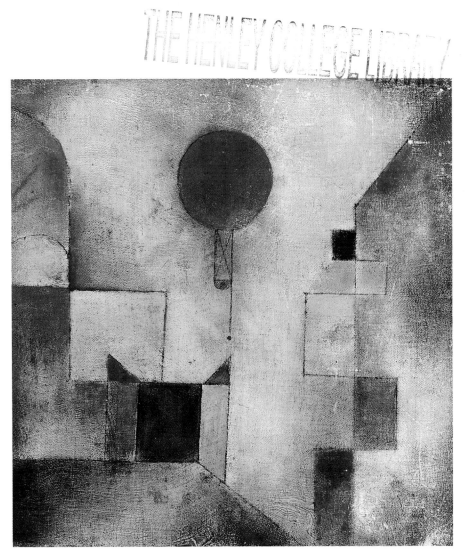

Paul Klee, *Red Balloon,* 1922 (The Solomon R Guggenheim Museum, New York). Paul Klee painted this imaginary world while a teacher at the Bauhaus. He remained independent of the Constructivist tendency at the Bauhaus, but was close to Kandinsky in his vital and dynamic conception of painting, which he considered to be related to music. These principles can be seen here in the ascent of the balloon and the vivacity of the colours.

emigrated to the United States, as did Moholy-Nagy, who founded the New Bauhaus there.

Neo-Plasticism

In 1913, the various impulses towards abstraction that had emerged at the beginning of the 20th century converged on, and achieved rational expression in, the work of Piet Mondrian (1872–1944), which had been influenced by academism, divisionism, Fauvism, Expressionism and even Cubism. His own personal style was typified by a lack of realism in terms of colour and the restriction of subject matter in his series of *Trees,* notably *The Blue Tree* (1908, Gemeentemuseum, The Hague) and *Red Tree* (1908, Gemeentemuseum, The Hague). Mondrian's research, conducted mostly alone, despite his trips to Paris, led him to create his first abstract paintings in 1913, and by 1917 he had excluded all representational elements from his work. Despite the interruption of World War I, during

Vilmos Huszar, *Composition* (cover for the periodical De Stijl), 1916 (Gemeentemuseum, The Hague). A Hungarian painter who emigrated to the Netherlands in 1905, Huszar subscribed to the views of Neo-Plasticism and in 1917 became one of the founders of the De Stijl movement and periodical.

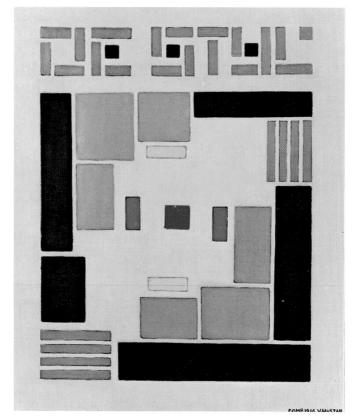

which he remained in his native Holland, Mondrian founded the periodical *De Stijl* ('The Style') with painter and writer Theo van Doesburg (1883–1931) in October 1917, contributing long theoretical essays, including 'Natural Reality' and 'Abstract Reality'. The two artists were joined by painters Bart van der Leck, Vilmos Huszar, Georges Vantongerloo and architects Oud, Wils, Van't Hoff and later Rietveld, but they never constituted a group as such; style was the only quality that united them. It is surprising to note that certain prominent members of De Stijl (the name adopted by this group of individuals), such as Mondrian and Rietveld, never actually met. Rietveld designed his famous red and blue armchair (see page 82), inspired by Japanese art and the furniture of William Godwin, prior to joining De Stijl, and Oud designed the Café de Unie in Rotterdam after having left the group.

During this period, Mondrian also painted a series of compositions featuring 'plus' and 'minus' signs in black and white. November 1918 saw the publication of the *First Manifesto of the Neo-Plasticist Movement*, written by van Doesburg and Vantongerloo (1886–1965), which appeared simultaneously in English, French and German translation. Following this, a pamphlet written by Mondrian entitled *Neo-Plasticism* was published in 1920 by the Effort Moderne gallery in Paris. The

elaboration of Neo-Plasticism, whose rules were strictly articulated, had taken seven years. Any notion of subjectivity and, therefore, dynamism, of movement or of depth, was condemned. Although painters might still be moved by nature, which remained the point of departure for their works, the rules of Neo-Plasticism as formulated by Mondrian demanded the use of rigorously abstract and geometrical forms based on orthogonal lines and the smooth application of pure, flat colour without impasto – above all the primaries yellow, blue and red – allied to neutralizing blacks, whites and greys. Mondrian claimed to have discovered the right angle in the natural world of the Netherlands, a horizontal landscape inhabited by vertical people, in the intersection of the line of the horizon or the sea with the imaginary vertical that meets the moon, signifying calm (*Vouloir* review, no. 25, 1927).

In contrast to the Cubists, Mondrian was seeking to destroy volume, in keeping with the first principle of Neo-Plasticism: 'The plastic means should be the plane and rectangular prism in primary colours (red, blue, yellow) and in non-colours (white, black and grey). In architecture, empty space counts as non-colour while matter counts as colour.' From 1922, the grey and blue backgrounds in Mondrian's paintings started to become white in order to underline the two-dimensionality of the planes. The purpose of all these rules was to create an equilibrium among the plastic means employed in the painting, which was to be based not on symmetry, but – as with Kandinsky, already visible in his painting *The Cow* of 1917 – on principles of non-laterality and non-stability, with the

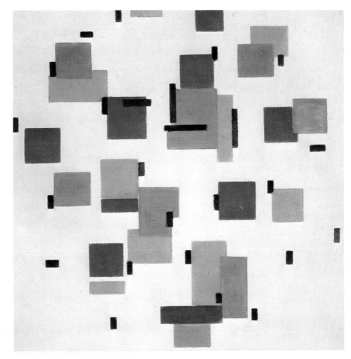

Piet Mondrian, *Composition in Blue,* 1917 (Rijksmuseum Kröller-Müller, Otterlo). After completing his series of paintings with 'plus' and 'minus' signs, Mondrian began to paint subtly coloured squares and segments positioned freely against a white background in a style similar to that of Bart van der Leck.

THE BIRTH OF ABSTRACTION THE BIRT
OF ABSTRACTION THE BIRTH OF ABST
THE BIRTH OF ABSTRACTION THE BIRT
OF ABSTRACTION THE BIRTH OF ABST
ACTION THE BIRTH OF ABSTRACTION
F ABSTRACTION THE BIRTH OF
RACTION THE BIRTH OF ABST

THE BIRTH OF ABSTRACTION

Theo van Doesburg,
Counter-Composition,
1924 (Stedelijk
Museum, Amsterdam).
By rotating his
composition by 45°,
van Doesburg
introduced the idea of
movement, a concept
strongly condemned by
Mondrian (hence its
title). In his decoration
of the Aubette café
and dance hall in
Strasbourg in 1927–28
he was to transgress
even more of
Neo-Plasticism's rules.

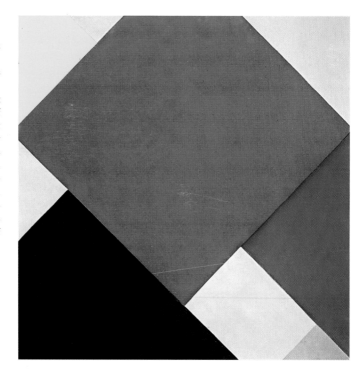

mind alone recreating an equivalent equilibrium. Not only is Neo-Plasticism an aesthetic expression of our subjective feelings, it is also a direct expression of the universal in us. This equilibrium, almost Japanese in character, between vertical and horizontal lines and between colour and non-colour allows for the creation of a new form of beauty, one that is not dependent upon the beauty of nature.

The abstract ideal is realized externally, in life, raising questions about the frame, which is either painted and therefore integrated into the work itself or flush with the canvas to avoid a tunnelling of vision. This also explains Mondrian's interest in architectural chromoplasticism, which had to be mathematical and abstract, and interior decoration – of the painter's studio in particular, starting with the stunningly designed studio he occupied in the rue du Départ in Paris until 1936. In 1930, van Doesburg also decorated his studio in Meudon in a remarkable fashion.

According to Neo-Plasticist theory, buildings had to be constructed of orthogonal planes with the aim of creating a balanced spatial relationship and in order to become pure manifestations of that which is immutable: the right angle. This new order would engender a 'new man', who would not hesitate to exploit the machine in order to be able to devote himself to intellectual pursuits. Neo-Plasticism, therefore, had social implications. From architecture, this new concept of the plastic would pass into life itself, into inter-human relationships, and once the equilibrium of these relationships was established, art would no longer

occupy any place in life. It would simply disappear, along with painting, and the artist would be demythologized.

But Vantongerloo had already started to challenge Mondrian's ideas by using mathematical formulae in his relief compositions. Rejecting decoration and everything that was contrary to the concept of total art, Mondrian stopped contributing to *De Stijl* in 1924. The periodical continued until 1928. One further edition was published, however, in 1932, in posthumous tribute to van Doesburg, who had challenged the preeminence of the right angle in his *Elementarist Manifesto* of 1926 and founded the review *Concrete Art* with painters Jean Hélion and Leon Tutundjian in 1929.

Van Doesburg and César Domela (1900–1992) broke the Neo-Plasticist rule of orthogonal rigour even more fundamentally by giving non-colours a significant role and rotating their compositions, thereby – with the resulting diagonals – introducing a sense of dynamism and thus subjectivity. Mondrian had strongly condemned this: 'The naturalistic and frivolous character of the slanting line is undeniable. What's more, this unbalanced form of expression is not eliminated by the contrasting position of another line. While this still gives an impression of stability, the plastic expression remains one of external movement, and therefore

Theo van Doesburg, plan for a private house, 1920 (Stedelijk Museum, Amsterdam).

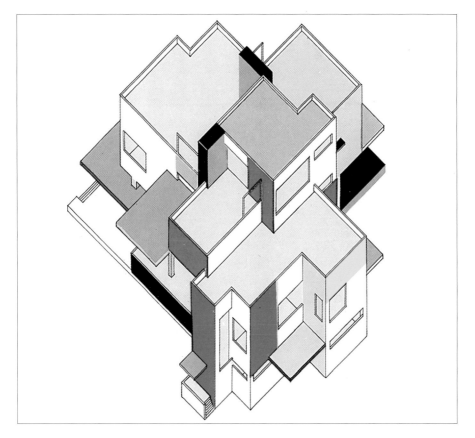

Gerrit Rietveld,
Red-Blue Chair, 1917.
Rietveld, a
cabinetmaker by
training, applied the
theories of the De Stijl
movement – pure
colours and the
projection into space of
geometric shapes – in
this famous armchair.

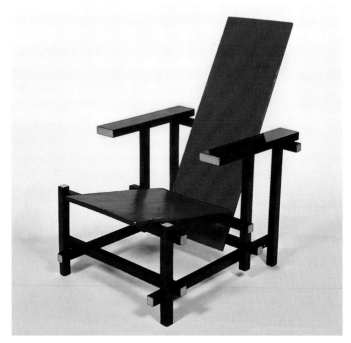

naturalness.' ('Le Home, la Rue, la Cité' ['Home–Street–City'], *Vouloir*, No. 25, 1927.)

The decoration in 1927-28 by van Doesburg, Hans Arp and Sophie Taeuber for the Aubette café and dance hall in Strasbourg was also based on the diagonal, but was not a success, resulting in its deterioration and ultimate destruction. César Domela also broke the rule of two-dimensionality by introducing the third dimension into his work, as did Frenchman Jean Gorin (1899–1981) and German Max Bill (1908–94). But Domela and Max Bill remained faithful to the philosophical basis of Neo-Plasticism, in other words a reflective process that moves from the internal to the external, respect for the science of proportions and economy of plastic means.

Although Mondrian pursued his ideas alone, he had a considerable influence on the Bauhaus, Mies van der Rohe and, curiously, Kurt Schwitters, the inventor of 'Merz'. In 1930, he joined the Cercle et Carré and Abstraction-Création groups and in Paris met Marinetti, Gropius, Gabo, Pevsner, Arp, Baumeister, Schwitters and Ben Nicholson. He went to London in 1938, anticipating the gravity of the international situation, and met up with Naum Gabo and Ben Nicholson, before emigrating to the United States in September 1940. There he became interested in Op Art and, banishing black from his work, created more rhythmic paintings – such as *Broadway Boogie Woogie* (1942-43, MOMA, New York) – based on lines broken up into small squares, but remained faithful at all times to the rule of orthogonality.

For his Schröder house in Utrecht of 1924, Gerrit Rietveld (1888–1964)

IMPRESSIONISM NEUE SACHLICHKEIT DER BLAUE REITER KANDISNK DIVISIONISME HOLBORN STIJL MONDRIAN AVANT-GARDE MARINETTI DADA AVANT-GARDE MARINETTI DADA IMPRESSIONISM NEUE INTERESSI
ABSTRASE DER BLAUE REITER KANDISNK DIVISIONISME HOLBORN STIJL MONDRIAN AVANT-GARDE MARINETTI DADA AVANT-GARDE MARINETTI DADA IMPRESSIONISM NEUE INTERESSI
ATION AVANT-GARDE EXPRESSIONISM VUERA DE MATISSE KANDI THE BRÜCKE SONDNIER MUNCH BONNARD GRIS CONSTRUCTI MALEVIC UNGEISSLE E BRÜNISNER DER BLAUE REITER FAU
OROZCO SIGUEROS VAN DOESBURG MONDRIAN NEO-PLASTICISMBAUHAUS BLUE RIDER BOCCIONI THE BLUE RIDER MARC KANDINSKY LARIONOV INTERNATIONAL MODERN EXPRESSI

borrowed from American architect Louis Henry Sullivan (1856–1924) the idea of increasing the interior space of buildings by positioning windows in the corners. He emphasized the vertical and horizontal planes in keeping with De Stijl's plastic approach, which was hostile to both Art Nouveau and its antithesis, functionalism. With its moveable partition walls and flexible interior space, which could be opened up completely or divided to create intimacy, this house was designed to adapt to the new informality of family or community relationships. Similar in shape to much functionalist architecture, it was supposed to reconcile social and individual concerns, like traditional Japanese houses, as prescribed by the De Stijl ethic. For Rietveld, the aim of art and architecture, which should be universal, was to temper nature by bringing it back within human norms; the construction of an entirely artificial environment would obviate the need for art. Just like Dadaism, Neo-Plasticism aimed to reject art as a form of idealism and therefore as something divorced from real life. The De Stijl architects believed that individuals should throw their energy into the reality of life.

Gerrit Rietveld,
Schröder House, 1924
(Utrecht).

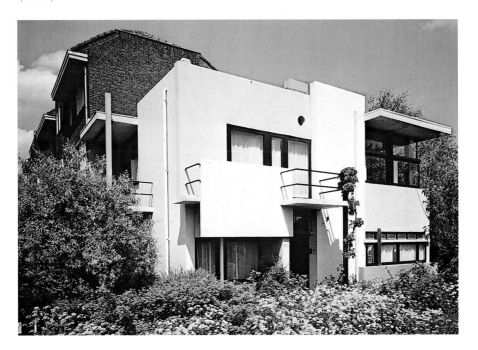

MORPHOSES OF THE UNCON-
UNCONSCIOUS THE METAMOR-
SES OF THE UNCONSCIOUS THE
IAMORPHOSES OF THE UNCONSCIOUS
UNCONSCIOUS THE METAMOR-
SES OF THE UNCONSCIOUS THE

THE METAMORPHOSES
OF THE UNCONSCIOUS

Literary in origin, the Dadaist, Merz and Surrealist movements took Giorgio de Chirico as their point of reference and, unlike Neo-Plasticism, emphasized the imagination of mankind ruled by his instinct and libidinal urges. While the Dadaists and Merz sought to suppress cultural references to the past, the Surrealists explored the depths of the unconscious and provided a diversion from the banality of daily life by exposing the relationship between the overt and latent meaning of images.

Marcel Duchamp,
Tu m' ..., 1918 (Yale University Art Gallery, New Haven, Connecticut). This complex painting is the last that Duchamp completed, and also the most aesthetic, due to the diagonal arrangement of its sequence of colour samples and the abstract draughtsmanship of the shadows and the symbols on the right of the picture. Commissioned by Katherine Dreier, it features the shadows of three ready-mades (a corkscrew, a hat-stand and a bicycle wheel), a pointing hand drawn and signed by the signwriter A Klang and, most importantly, a *trompe l'oeil* rip fastened by real safety pins. The title is assumed to be an abbreviation of 'Tu m'ennuies' (you irritate me/you bore me), but this interpretation was never confirmed by the artist.

Dadaism: through the mirror

The dismantling of art's sacred status and the challenging of the limits of representation, a process already begun by the abstract painters, reached their logical conclusion with the Dadaists, who rejected the concept of the artistic masterpiece and 'the edifying games of the parental world' (as critic Werner Spies put it) and denied all idealized and reassuring references to the past, including, notably, the illusion of perspective. World War I, the deaths of friends, the economic crisis that was starting to be felt, social poverty, unemployment and the repression of the Spartacist Revolution in January 1919 all caused a profound nihilism among German artists. At the same time, these factors resulted in an explosion of new trends within the Dadaist movement (1916–22), which developed in a remarkably parallel fashion in New York with Francis Picabia (1879–1953) and Marcel Duchamp (1887–1968), in Paris with Jean (Hans) Arp (1887–1966) and Man Ray (1887–1968), in Cologne with Max Ernst (1891–1976) and in Berlin with Raoul Hausmann (1886–1971), Hannah Höch (1889–1978), John Heartfield (1891–1968) and George Grosz (1893–1959). These trends all revolved around the historical creation of Dadaism by Romanian poet Tristan Tzara (1896–1963) in Cabaret Voltaire in Zurich on 8 February 1916. He came up with the

name by opening a dictionary at random (dada means hobbyhorse in French), and random chance was to preside over the artistic creation of the Dadaists.

A calculated coldness, numerous subversive manifestos, among them the *First Dada Manifesto*, which was published in German in 1918, and a deliberate negativity led these artists to end the debate at that time over three-dimensional Cubist illusionism and two-dimensional abstraction. In their exaggerated condemnation of all backward-looking attitudes, they rejected art's mimetic function as well as all aesthetic norms – even the most recent such as Expressionism – that related to bourgeois values, naturalism and even language, which had become a 'system of ruts' and which they reduced to a form of verbal intoxication based on aggressive onomatopoeia. The German Dadaists gathered together elements that had no meaning beyond their own materiality, 'miserable shards of a superannuated culture' in the words of Hugo Ball, a diverse collection of everyday urban debris of the most banal kind, which they arranged haphazardly in collages or assemblages sometimes held together by string. They also expressed themselves in photomontages (Hannah Höch, Man Ray and John Heartfield) and posters featuring the puzzling repetition of typographical characters.

Their activities were designed to be iconoclastic and materialist; these artists were more preoccupied with social poverty than with aesthetic speculations, and exposed the break with representation already apparent, though obscured by formalism, in the works of the Cubists and Futurists. In an attempt to destroy the commercial value of the 'work of art', Marcel Duchamp, who offered a meditation on the transparency and opacity of art in *The Bride Stripped Bare by her Bachelors, Even* (1912, Museum of Art, Philadelphia), omitted his signature and encouraged people to complete mischievous phrases such as *Tu m'* ... ('You ... me') (1918, Yale University Art Gallery, New Haven), a provocation taken up by Picabia in *Chapeau de Paille* (1921, MNAM, Paris), which represents a

Marcel Duchamp,
With Hidden Noise,
1916, ready-made
(1964 replica, Moderna
Museet, Stockholm).
This object is a good
illustration of Dada
anti-art. A ball of string
held between two
metal plates connected
by long screws evokes
a world of secret
relationships. A
sibylline message
consisting of words
interspersed with full
stops, in Morse-code
fashion, is engraved
into each of the plates,
reinforcing the
impression of secrets,
but rendered
absurd here.

Top plate:
P.G. ECIDES.
DEBARRASSE
LE. — D. SERT. —
F.URNIS.ENT AS
HOW.V.R
COR.ESPONDS

Bottom plate:
.IR CAR.E —
LONGSEA
F.NE, — HEA., — .O.
SQUE TE.U —
S.ARP — BAR AIN

break with the strait-laced atmosphere of the exhibitions and Salons.

The first production line appeared in 1913 in the Ford factories, and the presence of the machine became both haunting and menacing. Duchamp parodied the Futurist machine aesthetic by exhibiting untreated *objets trouvés* or ready-mades, thereby discovering a brutal and ironic solution to the question of the fourth dimension. His intentionally subversive works, and even the controversial urinal entitled *Fountain*, exhibited at the Society of Independent Artists in New York in 1917, became accepted by the mainstream art world. However, he failed to protect this work entirely from the taboos relating to the value of works of art, as it was spirited away during the exhibition. He explained his ideas in the review *291* with the help of photographer Alfred Stieglitz.

This artistic inquiry into total freedom of the means of expression was mirrored in the extreme-left political opinions of the artists, above all those of the German Dadaists, who condemned the Weimar Republic as representing a renaissance of 'Teutonic barbarity'. Many were Communist Party sympathizers, believing this to be their best hope for freedom.

But in addition to the repetition of certain elements, what gives their works a conceptual structure that distinguishes them stylistically from primitive art are the artists' social and intellectual origins – philosophy in the case of Max Ernst, industrial design, architecture and photography in that of Man Ray, the Cubist circles for Duchamp, periodical publishing for Hausmann. Clearing a way for the Surrealist imagination, they emphasized the role of the unconscious in artistic creation.

RA OROZCO SIQUEIROS VAN DOESBURG MONDRIAN NEO-PLASTICISM BAUHAUS BLUE RIDER BOCCIONI THE BLUE RIDER MARC KANDINSKY LARIONOV INTERNATIONAL MODERN EXPRES MSM HULELAUN CYAN APPL CHIRICO LEGER SCHAD AVANT-GARDE MARINETTI MODERATIONS VERDE NEO-EXPRESSION SIVERA AVANT-GARDE OROZCO VAN DOESBURG MONDRIAN NEO-P HLIEF BOCCIONI IL CAN SEACH CHIRICO KOKOSCHKA PERBUSLER DER BLAUE REITER NEO-SM KEINESCHACH THE SUPO DIVERA MODERATION VERDE SVERA SMM THE MODERN ART VAN DOL RC KANDINSKY LARIONOV INTERNATIONAL MODERN EXPRESSIONISM DERAIN BOCCIONI THE BLUE RIDER MARC KANDINSKY LARIONOV INTERNATIONAL MODERN EXPRESSIONISM T

1920 saw the organization of the first and last international Dada fair (Erste Internationale Dadamesse) – where as many as 147 works were offered up to the mockery of the public, indicating the size of the movement – but also the breaking up of the Cologne branch of Dada by the authorities. However, Picabia, who was engaged in a perpetual, quixotic quest for true anti-art, and who declared 'all my life I have been smoking painting', left the Dada movement in 1921, finding it too structured and theoretical. The Dada congress that took place in Weimar in 1921, and was attended by Kurt Schwitters, Moholy-Nagy, van Doesburg and El Lissitzky, was actually the prelude to its total disintegration, as Tristan Tzara broke with the German Dadaists at the same time. At the Nazi exhibition held in 1937, the Dada works were considered the most degenerate of all. Like many other German artists, Raoul Hausmann was forced into exile in 1933. Thanks to Picabia and Tzara, Dadaism lived on in Paris in the literature and poetry of the Surrealists.

Merz

The concept of total art, launched by the proponents of Neo-Plasticism and given other overtones by the Dadaists, was developed by Kurt Schwitters (1887–1948), 'scourge of the burghers' of Hanover, in his collages, photomontages and environmental constructions, all of which are based on the Merz concept. This word came from the name of a bank, Commerzbank, one of whose leaflets he used in a collage.

Schwitters, a painter, illustrator and photographer, joined the Dadaists relatively early, in 1917, and met Arp in Berlin in 1918, with whom he maintained a close relationship all his life. However, in 1919 he started to look for a more personal way forward and published a collection of poetry entitled *Merz* that year. This was followed by *Merz* the review, which ran from 1923 to 1932. Random chance was to govern the almost organic expansion of the Merz concept, which involved no premeditation and was based on refuse – such as scraps of paper and bits of wood – that Schwitters picked up in the street during this period of industrial expansion, and which the artist claimed to assemble following unconscious instinct alone. Merz ended up encompassing and defining Schwitters's own personality.

In 1924, he dedicated one of his collages to the 'Prince of Siberia', Kandinsky, whose works from the Blue Rider period strongly influenced him. But Schwitters was later to criticize the aesthetic theories published by Kandinsky, then a teacher at the Bauhaus, in his book *Punkt und Linie zur Fläche* (1926, 'From Point and Line to Plane'). Schwitters considered the Bauhaus, as did van Doesburg and the Constructivists, to be a parody of modern ideas that had to be rejected. He attended the Dada

congress in Weimar in 1922 and made a trip with van Doesburg to the Netherlands in order to promulgate Dadaist ideas.

Schwitters provoked the opposition of the Dadaists, however, who considered that someone who owned an apartment building and had a private income was necessarily bourgeois. Furthermore, unlike the Dadaists, he wanted to remain within the context of established aesthetic categories, and although he did break various taboos, he tempered the role of chance through a search for rhythm and geometric equilibrium, evident in the way he arranged the waste materials he used and in his subtle use of colour.

He was forced into exile from Germany in 1937 and lived in Norway before settling in England in 1940, where he continued to work on increasingly abstract Merzbilder and eventually died in obscurity. Nevertheless, the Kestner Gesellschaft, based in Hanover, devoted a major retrospective to him in 1956 and his work went on to exert a major influence on Arte Povera, Pop Art and the New Realists.

Kurt Schwitters, Collage. This Merz picture was conceived according to the principle of random chance and mockery using discarded materials, a technique borrowed from the Dadaists, who collected 'miserable shards of a superannuated culture in order to create a new one' (Hugo Ball). But paradoxically, it offered a new aesthetic cohesion that placed it within the category of artistic creation.

The 'convulsive beauty' of Surrealism

Surrealism, which was born out of the Dada movement, emerged in a

Giorgio de Chirico

Metaphysical Interior, 1917 (Von der Heydt Museum, Wuppertal). From his wartime refuge of Ferrara, where he remained between 1915 and 1918, de Chirico defined the principles of Pittura Metafisica with Carlo Carrà in 1917. This work, with its apparently confused and curious composition, is actually highly structured around architectural fragments and geometric elements, suggesting a meditation on perspective, depth, reflection and the real and imaginary. De Chirico was a major influence on the Surrealists.

1888. Birth of Giorgio de Chirico in Volos, Greece, to Italian parents.

1906–9. In Munich, de Chirico studies the philosophy of Nietzsche and admires the works of Böcklin, which have a decisive influence on his style, as can be seen in his painting *Battle of the Hoplites and the Centaurs* (private collection, Italy).

1911–14. In Paris, he makes the acquaintance of Picasso and Apollinaire. His painting is characterized by a precise and dreamlike realism based on a static illusionism and peopled by mannequins or 'disturbing muses'. He uses appearances as mirrors of the unconscious.

1917. He makes friends with Carlo Carrà, who joins him in Ferrara. Together they establish a style they call Pittura Metafisica (Metaphysical Painting).

1918. The Valori Plastici movement emerges, grouping together the most important Italian artists, including Giorgio de Chirico and Giorgio Morandi, who experience a return to order that is almost universal throughout Europe.

1919. Giorgio de Chirico claims to have suddenly seen the light vis-à-vis classical art in front of Titian's *Sacred and Profound Love* (1515 or 1516) in the Villa Borghese in Rome. He pens his text 'The Return to the Craft', published in *Valori Plastici* Nos. I, XI and XII, in which he criticizes both Futurism and the 'great colourist phobias that are enflaming Europe' and concludes with his famous declaration: 'Pictor classicus sum.' He returns to Metaphysical Painting and demonstrates an obsessive precision with form and imagery, to which he has recourse solely for their interrogative power; he also becomes more and more influenced by Nietzsche.

1924. Giorgio de Chirico exhibits in Paris. The Surrealists are attracted by the sense of foreboding and the 'symbols of the unconscious' they see in his work, and seek to claim him as one of their own. This marks the beginning of a long controversy.

1928. André Breton condemns de Chirico's post-1917 work, which he describes in his book *Surrealism and Painting*, as having fallen into 'the rut of technical preoccupations'. Jean Cocteau writes an essay on him entitled 'Le Mystère Laïc'.

1938. De Chirico lays claim to realism. He includes numerous references to Courbet in his work and paints portraits and self-portraits in which the influence of Rubens is evident.

1950. His self-portraits and paintings of horses are permeated with classical and archaeological references.

1960. De Chirico is overcome by weariness, exacerbated by the appearance of numerous fakes that he denounces in vain, accused of trying to disclaim works from his Metaphysical period, until finally being proved correct in 1977.

1968. De Chirico devotes himself to theatre design, portraits and realist still lifes and also completes precious sculptures in patinated and polished metal.

1978. Giorgio de Chirico dies in Rome.

victorious France during the roaring twenties. As early as 1919, poets André Breton (1896–1966), Louis Aragon (1897–1982) and Philippe Soupault (1897–1990) experimented with automatic writing, founded the Dada review *Littérature* and published poems and manifestos in periodicals such as *391* and *Unique, Eunuque, Jésus-Christ Rastaquouère* (c.1920), of which Francis Picabia was the heroic instigator.

But not everyone could be a Dadaist. Tristan Tzara broke with the German Dadaists in the name of Dada nihilism at the Weimar congress in 1922 and then fell out with Breton at the International Congress for Determination and Modern Defence held in Paris. Dadaism, however, had opened up new possibilities and a new period of lucidity for Breton. Through the elimination of stereotyped images, he sought to convey the reality of dream and desire. His meeting with Freud in 1921 and the revelation of African and Oceanian art allowed him to enrich the nihilism of

Max Ernst, *The Blessed Virgin Chastising the Infant Jesus before Three Witnesses, André Breton, Paul Éluard and the Artist*, 1926 (collection of Mme Jean Krebs, Brussels). The iconoclastic separation between the Virgin as 'the virtual vessel of God' (Guy Rosolato) and Mary, mother of the infant Jesus (with whom Ernst identified himself in a number of paintings), is typical of the Dada spirit, as are the evocation of pleasure in the spanking and the blasphemous Trinity, embodied here by Breton, Éluard and Ernst. However, the careful draughtsmanship, smooth finish and empty architecture, in which emphasis is placed on the triangle, clearly anticipate the Surrealist style adopted emphatically by the movement in 1928.

René Magritte

The Universe Unmasked, 1931 or 1932 (private collection). Above a barren landscape and ruined house, the sky is transformed into a set of cubes through the power of the imagination in this picture painted in nursery colours white and blue.

1898. Birth of René Magritte in Lessines, Belgium.

1916. Magritte paints his first abstract works shortly after enrolling at the Académie des Beaux-Arts in Brussels.

1919. Mesens shows him illustrations of works by de Chirico, including Love Song (1914), which come as a revelation and remain an influence on his work up until 1940.

1920. Magritte develops a style similar in spirit to Magic Realism, characterized by a meticulous, poetic realism inhabited by mannequins and men wearing hats, bizarre objects and mirror images.

1926. He joins the Société du Mystère, the Belgian Surrealist association.

1927. Magritte moves to a suburb of Paris, where he remains until 1930, and paints The Murderous Sky (MNAM, Paris).

1929. Breton admits him into the ranks of the Surrealists (at the time of the Second Surrealist Manifesto), but material difficulties force him to return to Brussels.

1934. Paints The Human Condition (private collection, Paris).

1935–40. He explores 'elective affinities', the relationships between objects. Magritte's interest in psychoanalysis becomes evident in works such as The Red Model, 1935 (MNAM, Paris) and the three versions of Therapist, 1937 (private collections in Paris, Brussels and New York).

1940–46. Magritte adopts a style similar to Neo-Impressionism in its use of lighter colours and hazy draughtsmanship.

1945. He illustrates Les Chants de Maldoror by Lautréamont and joins the Belgian Communist Party for a while.

1948. Magritte spends three months creating pastiches of Fauvist paintings, a time that Magritte himself calls his 'période vache' (his 'cow period').

1950. Cruelty and black humour come to the fore in his pastiches of masterpieces in which figures are replaced by coffins: Perspective: Manet's Balcony (Museum of Ghent) and Perspective: David's Madame Récamier (private collection, Brussels). From 1960 onwards, his work starts to exert an influence on Pop Art and conceptual art.

1967. Magritte dies in Paris.

Francis Picabia, *Woman and Face*, c.1933 (private collection). Following the liveliness of Cannes, Picabia rediscovered a certain solitude in 1933, having distanced himself from Breton and Duchamp, and entered into a sustained correspondence with Gertrude Stein, whose portrait he would paint. In 1927 he began work on his series of *Transparencies* in Spain, inspired by traditional Italian painting but also by Duchamp's exploration of the transparency of glass within the Surrealist context of preoccupation with the visible and the concealed. This transparency, which resembles *The Young Girl*, 1935 (private collection, Milan), is more accurately the superimposition, with the aim of blurring the two, of the sad face of a Madonna over a conventional portrait.

Dada works through the addition of sensual and sexual references. He declared that: 'Beauty will be convulsive or it will not be at all.'

Initially a sporadic activity indulged in by poets, Surrealism took shape as a movement with Breton's 'Manifesto of Surrealism', published on 1 December 1924 in the first issue of the periodical *La Révolution Surréaliste*, the platform of poets Robert Desnos, Louis Aragon, Paul Éluard, Pierre Reverdy, Antonin Artaud and Philippe Soupault, which had Cubist illustrations by Picasso. It led Picabia to break with Breton and launch a violent attack on him, but other painters were willing to collaborate on *La Révolution Surréaliste*, among them Miró, Ernst, de Chirico, Masson, Arp and Tanguy. The transforming language of the unconscious questioned appearances, emphasized the hidden meanings of images and helped to define a new artistic approach centered on the ability of objects to reveal truths, and on the splitting of images into multiple correspondences that transform vision. The term 'Surrealist' seems to have been first used by Apollinaire on 18 May 1917 at Erik Satie's ballet *Parade*, performed by the Ballets Russes, but André Breton provided a peremptory definition of it in his *Manifesto of Surrealism* of 1924: 'I am therefore defining [the term] once and for all: Surrealism n. pure psychic automatism by means of which an attempt is made to

express the real functioning of thought either verbally, in writing or by some other means'.

From 1924 to 1928, during the first phase of Surrealism, Picasso, Max Ernst, Miró and Masson turned to collage and a wide range of automatic writing techniques in order to give free rein to the unconscious, often under the influence of alcohol, hunger or drugs. Henri Michaux (1899–1985) was later to use mescalin to a similar end, attaining a state of hypnotic trance during which he produced works of a transcendental beauty characterized by a certain nervousness and a halting, jerky graphic quality. In 1925, Max Ernst, influenced by his reading of Leonardo da Vinci's *Treatise on Painting* and inspired in particular by the famous passage on how images may be suggested to an artist by the shape of random stains on a wall, invented the technique of 'grattage' where the painted surface is scratched. For his part, André Masson adopted a sand technique, used in ancient times by the Indians, for his compositions.

These artists thus produced unreal, abstract paintings, marginal referents of the symbolism of the unconscious, from which any notion of perspective was rigorously excluded: 'We are in the grip of a metamorphosis (of global proportions) and no longer feel any spatial security other than in the eye of the storm or inside the spiral of a gigantic maelstrom' (André Breton).

In 1925, two exhibitions of Surrealist paintings were held in Paris, featuring works by Picasso, Klee, Man Ray, Pierre Roy, André Masson and Giorgio de Chirico, and in 1928 André Breton published his book *Surrealism and Painting*, illustrated by Picasso.

The first crisis for the Surrealists occurred in 1929, over the attitude

Alberto Giacometti, *The Invisible Object*, 1934–1935 (Maeght Foundation, Saint-Paul-de-Vence). Giacometti adopted a wide variety of styles – among them polychromy and abstraction – after studying sculpture in the studio of Archipenko, and was part of the Surrealist movement between 1930 and 1935. This totem-like figure is very much in the Surrealist tradition of the strange and secret, and is an early example of the elongated lines that became a feature of Giacometti's work after 1947.

Joan Miró, *Snail, Woman, Flower, Star,* 1934 (private collection). 1934 marked the start of Miró's era of 'wild paintings', which lasted until 1938, followed in 1939 by the *Constellations*. The surface of the canvas has been invaded by strange and disturbing symbols and fragments of biological forms or of the human body (a face and an extended, wide-open hand). These are surrounded by hieroglyphs and script of a falsely reassuring, dreamlike quality lacking in any logical connections. Miró was expressing his anxiety during this period of social tension that gave rise to fascism, Nazism and above all the Spanish civil war, which greatly distressed the artist.

they should adopt vis-à-vis the exile of Leon Trotsky. In addition, the war in Morocco and the economic crisis meant that already, as Breton explains, 'the nimble minds are warning of the imminent, unavoidable return of global catastrophe'. The problem arose, within the context of the total liberation of mankind, of their political commitment. Under Breton's dictatorial rule, a sequence of expulsions followed, including those of Artaud, Masson and even Soupault, while Miró and Ernst maintained their independence. Breton underwent an about-turn in his hostility towards Marxism, which resulted in the less peremptory, more hesitant tone of his *Manifesto* of 1929, the year in which Aragon joined the Communist Party. A new generation of Surrealists emerged, including Yves Tanguy (1900–55), René Magritte (1893–1967) and Salvador Dali (1904–89). These artists all claimed to have seen the light after discovering the work of de Chirico, who, despite his sympathy for the Surrealists, was actually 'hijacked' by them rather than genuinely in tune with their views. Roberto Matta, Paul Delvaux, Hans Bellmer and Victor Brauner joined them to form one of the most dynamic artistic movements of the inter-war years.

Sculptor Alberto Giacometti (1901–66) liberated himself from the influence of the Cubist sculpture of Laurens and Lipchitz and, in keeping with Surrealist principles, broke away from the notion of fidelity to the real appearance of things. His sculpture-objects with a 'symbolic function' rejected the illusion of volume and had their origins in his speculative obsession with sex murder and particularly his admiration for African and Oceanian art.

The most famous of the Surrealist painters are those who returned to a precise iconography of the imagination presented in a theatrical setting that owed much to de Chirico, and with a flawless classical technique. It was this that inspired Dali to write his book *50 Secrets of Magic Craftsmanship* in 1947, based, like his painting, on his 'critical paranoia' method: 'A spontaneous method of irrational knowledge based on the systematic critical objectification of associations and interpretations of delirious phenomena'. In the management of his artistic activities, Dali never forgot to serve the primary goal of 'turning painting into gold', both literally and figuratively. The expulsion of Dali, or 'Avida Dollars' as he was renamed in Breton's anagram, was not long in coming, and he was forced to leave the ranks of the Surrealists in 1939. In 1940 Dali announced his 'desire to become classical' and until 1948, lived in the United States, where the commercial success of his works was equalled only by his transgression of social and pictorial taboos through provocative, feigned delirium and showy exhibitionism, which contrasted strongly with the asceticism of his working methods.

With the approach of war, there was a widespread exodus of Surrealists, notable exceptions being Magritte and Picabia, to the United States. Matta, Tanguy and Ernst left in 1939, Breton and Masson in 1941.

LORENZO SIGUEROS VAN DOESBURG MONDRIAN NEO-PLASTICISM BAUHAUS BLUE RIDER BOCCIONI THE BLUE RIDER MARC KANDINSKY LARIONOV INTERNATIONAL MODERN EXPRESSIO NEU DUTCH ATONAL NABE DE CHIRICO METZ SCHWITTERS SURREAL KANDINSKY IMPRESSIONISM ABEUS SIX EXPRESSION RIVERA DADA CONSTRUCTION DUCAN VON SPHERE MONDRIAN NEO-PLASTICIS NEU BONNARD FAUVE ORPECH BLUE ATONAL REALISM TH CORBUSIER DEGAS FAUVE MODERN FAUVISM MAJA DIE BLUE RIDER DADA UNEDO DEPORT EN ABUS DE CHIRICO CRZ SCHMI FINIST CUE MARC KANDINSKY LARIONOV INTERNATIONAL MODERN EXPRESSIONISM DERAIN BOCCIONI THE BLUE RIDER MARC KANDINSKY LARIONOV INTERNATIONAL MODERN EXPRESSIUM DERI

Miró returned to Spain in 1940, despite the Franco regime, which was to extinguish the greatest aspirations of Spain's leading artists. Surrealism emphasized the idea that human drives are the organizing force behind the world, and redefined the work of art as something that both reveals and is itself a perpetual rupture, something undefined, an instability in the face of which the illusion of art alone could provide a degree of permanence during turbulent times.

Salvador Dali

The Enigma of Desire, 1929 (collection of Oskar R Schlag, Zurich). With this metamorphic figure resembling a bird, set in a desert-like space (his favourite setting for fantasmagoria of the passions), Salvador Dali has created an association of mental images in keeping with the Surrealists' interest in the portrayal of dreams. The meticulous technique, precise draughtsmanship and heavy shadows give free rein to the imagination.

1904. Birth of Salvador Dali in Figueras, Spain.

1920. Dali tries out a wide range of styles, including Impressionism, the realism of his teacher Isidro Nonell and, under the influence of Juan Gris, Cubism.

1923. He is influenced by the Italian Metaphysical Painting of Giorgio de Chirico and Carlo Carrà. His technique becomes smooth, delicate and devoid of impasto. He declares himself highly impressed by Max Ernst's painting *Revolution by Night*, which induces him to explore the use of impulse and buried memories in creating art.

1928. Through Miró, Dali meets Breton. He develops the theme of putrefaction (*The Putrefied Donkey*), along with soft or spectral forms (*The Spectral Cow*).

1929. He meets Gala Éluard, whose first husband, Paul Éluard, described her as 'a woman whose gaze can pierce walls'. This represents a turning point in Dali's life. She would become omnipresent in his work and encourage him to return to realism. He writes *Diary of a Genius*, holds his first solo exhibition at the Goemans Gallery and joins the Surrealist movement. His art is made up not so much of poetry as of provocation and

elaborate effects.

1930. He devises his 'critical paranoia' method, 'a spontaneous method of irrational knowledge based on the systematic critical objectification of associations and interpretations of delirious phenomena'.

1937. Dali travels to Italy during the Spanish civil war. His style and technique become classical once more, in the manner of de Chirico.

1939. Breton decides to expel him from the Surrealist movement for his counter-revolutionary activities, a stance he adopts again later under the Franco regime. He meets Freud and publishes his *Declaration of the Independence of the Imagination and Man's Right to his Own Folly* in 1939.

1940. Emigrates to the United States, where he remains until 1948, and achieves considerable commercial success. He announces his desire to 'become classical' and cites Meissonier, Millet, Raphael and Vermeer as his favourite painters.

1947. Dali writes *50 Magic Secrets*. Secret no. 43, to 'turn painting into gold, both literally and figuratively' justifies the nickname 'Avida Dollars', invented for him by Breton and meant as a criticism of the commercialism underlying his development.

One Second Before Awakening from a Dream Caused by the Flight of a Bee around a Pomegranate, 1944 (Thyssen-Bornemisza collection, Madrid). In 1930, Dali invented his 'critical paranoia' method, and 'seeking to create the iconography of our inner worlds', offered up these dreamlike, hallucinatory images for the spectator to interpret as he wished. In 1941 he announced a desire to become a classical artist.

1948. Dali undergoes a 'nuclear mysticism' phase during which he paints religious subjects.

1949. He returns to Spain for good and experiments with a wide range of techniques. He paints large-format paintings in the classical style, but also makes jewellery, creates sculptures and assemblages and even used sea urchins to make paintings.

1956. Dali takes revenge on the Surrealists and members of the avant-garde with *The Cuckolds of Antiquated Modern Art,* which only creates further controversy.

1957. Dali practices Tachism in *The Apocalypse of Saint John* and kicks off the era of Boulétism with the aid of ink cartridges and bombs filled with nails.

1970. Becomes interested in the technique of holography and completes three holographic compositions in 1972.

1976. Completes a stereoscopic composition using mirrors.

1978. Millet's *The Angelus* inspires him to paint a large-format picture in a style to which he remains faithful for the rest of his life.

1989. Death of Dali in Figueras.

A 'LABORATORY OF FORM'

While on the one hand the artificial euphoria of the roaring twenties, particularly the years 1925–1929, led certain artists into a craze for decoration, and on the other, in parallel with the spread of psychoanalysis, the world of art came under siege from Surrealist imagery, the only artists to maintain stylistic continuity during the inter-war years were outstanding independent figures such as Matisse, Bonnard, Dufy, Léger, Foujita and Survage, the artists of the School of Paris and, most importantly, the abstract painters.

Piet Mondrian,
Composition with Red, Yellow and Blue, 1930 (private collection, Zurich). Mondrian's loyalty to the strictest form of Neo-Plasticism ensured abstraction's survival between the World Wars.

Abstraction: permanence with variations

During the depression, the more revolutionary of the abstract artists, a number of whom were from eastern Europe, felt the need to put aside their individual artistic differences and band together. After meeting Theo van Doesburg and Michel Seuphor, Uraguayan painter Joaquin Torres-Garcia (1874–1949) decided to abandon Synthetic figuration and found the Cercle et Carré movement with them, attracting exponents of

Ben Nicholson,
Painted Relief, 1939
(MOMA, New York).
After the realism of
his early work, Ben
Nicholson turned
towards abstraction
and took part in events
organized by the
Abstraction-Création
group in 1933
and 1934.

Neo-Plasticism (Mondrian, Gorin, Vantongerloo), Futurists (Prampolini, the musician Rossolo) and other figures as diverse as Schwitters, Arp, Kandinsky, Baumeister, Pevsner and architects Ozenfant and Le Corbusier. Just three editions of their review *Cercle et Carré* were published, containing articles by Mondrian and Seuphor (including 'Defence of an Architecture'). But the widely differing tendencies within the movement, the death of van Doesburg (who had actually been expelled from the group after founding the movement and review Concrete Art in 1930), Seuphor's illness and Torres-Garcia's return in 1932 to Uruguay (where he strove to create a South American artistic avant-garde inspired by the European trends) led to the demise of *Cercle et Carré*. It was reborn in almost identical form, however, as the Abstraction-Création movement. Abstraction-Création had initially been founded in 1931 by Vantongerloo and acquired over 400 members, including Kupka and the Cubists Valmier, Gleizes and Herbin, who kept it alive until 1936 thanks largely to publications such as *Abstraction-Création: Art Non-Figuratif*. The Abstraction-Création debates were taken up again in 1950 in the reviews of the Salon des Réalités Nouvelles.

As well as ensuring the survival of abstraction after World War II, albeit in a severely weakened state in terms of its ethical and aesthetic influence, these movements, thanks to their international scope, also facilitated the creation of a common stylistic language and strengthened the relationships between painters, sculptors and architects in Poland (with Kobro in Lodz), in Great Britain (with Ben Nicholson, Henry Moore,

Henri Matisse

1869. Birth of Henri Matisse in Cateau-Cambrésis, France.

1891. After studying law, Matisse belatedly takes up painting. He enters Gustave Moreau's studio at the École des Beaux-Arts in Paris and is exposed to the influence of Moreau, the Nabis, Cézanne and Rembrandt.

1904. Matisse spends the summer in the company of Paul Signac and produces a number of Divisionist works. His subjects are established at this early stage in *Luxe, Calme et Volupté.*

1905. His painting *The Woman with the Hat* causes an uproar at the Salon d'Automne and Matisse is regarded as the Fauves' leader.

1907. He paints *The Blue Nude* (Museum of Art, Baltimore), the first

of a long series of nudes, and travels to Italy.

1908. The academy he opens in his studio attracts numerous foreigners, in particular Germans and Scandinavians.

1909. The Russian collector Shchukin commissions *The Dance* and in 1910 *Music* (Hermitage Museum, St Petersburg).

1911. *The Blue Window* (MOMA, New York). The window motif, to which Matisse returned repeatedly throughout his life, is one of the most brilliant artistic meditations of the 20th century.

1912–13. Matisse spends the summers in Tangiers, where he is fascinated by Arab motifs, which he uses in later decorative compositions. Black, for him the 'colour of light',

The Sadness of the King, 1952 (MNAM, Paris). At the end of his life, Matisse made paper cut-outs that allowed him to 'cut into the heart of colour' and 'recalled the direct way in which sculptors carve their materials'. In 1952, Matisse was 83. The gaiety of the Blue Nudes was followed by this nostalgic and monumental work in which, depicting himself as the king (in black), he indulges in a final meditation on the great themes of his work: music, dance, life and death. In this scene, perhaps inspired by the ancient theme of Salome dancing for Herod, the strident colours and omnipresent flora seem the very antithesis of the black of death. Three human figures leaning towards the left evoke the movement of dance and the rhythm of music. These silhouettes without depth represent the culmination of Matisse's experiments with the abolition of volume, which was already in evidence in his sculpture. In this allegory, which surpasses the limitations of decorative art, Matisse has confided to us his final thoughts on his work and the voluptuousness of life, using a style radically different from that of the self-portrait of 1900, Luxe, Calme et Volupté (1904) or, equally, Joie de Vivre (1906).

plays an increasingly important role in his work, as can be seen in Piano Lesson (1916, MOMA, New York).

1914. French Window at Collioure (private collection) adopts Alberti's metaphor of art as a window that opens onto nature.

1917–18. The Violinist at the Window (MNAM, Paris) indicates that Matisse shares Duchamp's enduring interest in transparency.

1930. Matisse travels to Tahiti and New York.

1943. After undergoing a major operation during the war, he completes his first gouache cut-outs for the book Jazz, published in 1947.

1946. Matisse settles in Nice and then Vence (in the south of France).

1948. He produces three models for the stained-glass windows for the Chapel of the Rosary at Vence, and Saint Dominic for Notre-Dame-de-Toute-Grâce on the Assy plateau.

1949. Solo exhibition at the Musée National d'Art Moderne in Paris.

1952. Matisse paints a series of Blue Nudes (private collection, Paris and Basel). His gouache cut-outs reach monumental proportions with The Sadness of the King (MNAM, Paris), and for the remainder of his life he creates only cut-outs. One of the 20th century's greatest painters, Matisse's work would exert a considerable influence on abstract art during the second half of the century, particularly on Ad Reinhardt, Mark Rothko, Simon Hantaï and Claude Viallat.

1954. Matisse dies in Nice.

Barbara Hepworth, Paul Nash and Edward Wadsworth) and in the United States. During this period, a new and prestigious type of design featuring clean and elegant lines appeared on the marketplace and was shown at the Exhibition of Decorative Arts in Paris in 1925 and at the Deutscher Werkbund (1907–1933) exhibition in Stuttgart in 1927. The furniture being designed by Marcel Breuer at the Bauhaus, as well as that of Ruhlmann, Chareau, Djo-Bourgeois, 'MAM', Arbus and even Rietveld's De Stijl designs, initiated a form of mass production that threatened the individuality of creative artists: even Walter Gropius and Le Corbusier were designing chairs. In 1930, Seuphor referred to the 'structural principle of works', which he called 'an architecture' whose 'individual organization reflects the magnificent order of the universe' (*Cercle et Carré*, No. 1, 15 March 1930). More than ever before, painting had become the 'laboratory of form' to use Le Corbusier's phrase, and architects, even those who were not painters, took their inspiration from Constructivist and Neo-Plasticist theories.

Amédée Ozenfant (1886–1966) and Charles Édouard Jeanneret (1887–1965), who changed his name to 'Le Corbusier' in 1928, were the perfect embodiment of this new trend for painter-architects. In 1917, they founded Purism in an attempt to revitalize the principles of Cubism, which had degenerated into merely decorative art. They published their manifesto, *Après le Cubisme* ('After Cubism'), in 1918, and later the review *L'Esprit Nouveau*. Without excluding biomorphic curves, the

Amédée Ozenfant, *The Creation of the World*, 1929 (private collection). Ozenfant's shift from Purism to Magic Realism is evident in this imaginative composition. Its original and complex subject matter has replaced the artist's previous still lifes, whose strict architectural geometry has given way here to a poetic and playful spirit.

H BONNARD DUFY GIACOMETTI MALEVICH ORPHISM LE CORBUSIER DER BLAUE REITER FAUVISM MAGRITTE BOCCIONI DERIBLO DELAUNAY KUPKA DE VLAMINCK RUSSIAK AVANT-GAR HE ZADKINE DADA SEURAT DE ROUSSEAU KIRCHNER MUNCH MAGIC REALISM INTERNATIONAL MODERN UNIT SECESSIONIST OP ART DIVISIONISM DUFY GUERNIC ARP DE MUNCH PAINTINGS M COLLAGE VA ARNETTI VAN BEBE BIEDERMANSE EXPRESSIONISM FUTURISM MODERN EXPRESSIONISM VORTICISM OP ART DADA GAUDIER BRZESKA HIPOMITA GRIS SOUTINE ZADINE PER CHIRICO MERZ SCHWITTERS SURREALISM POST-IMPRESSIONISM NEUE SACHLICHKEIT DIX RIVERA OROZCO SIGUEROS VAN DOESBURG MONDRIAN NEO-PLASTICISM BAUHAUS ZADKINE PER

Alexander Calder, *Fishbones*, 1939, painted metal rods and wire, hanging mobile (Centre Pompidou, Paris). After visiting Mondrian in Paris in 1930, Calder decided to devote himself to abstract sculpture. He made individual elements oscillate by projecting them into space attached to rods. In 1932, Marcel Duchamp christened these kinetic works 'mobiles', which contrast with the 'stabiles' (static works) created by the artist in 1937. For his early mobiles (discs painted in pure colour), Calder took his inspiration from the constellations and the cosmos and for his later work from natural elements such as leaves or, as here, fishbones.

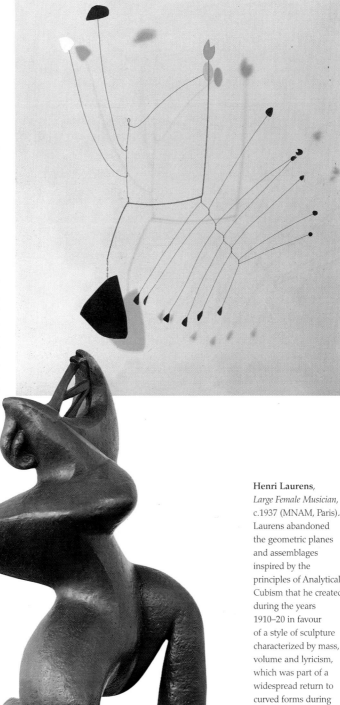

Henri Laurens, *Large Female Musician*, c.1937 (MNAM, Paris). Laurens abandoned the geometric planes and assemblages inspired by the principles of Analytical Cubism that he created during the years 1910–20 in favour of a style of sculpture characterized by mass, volume and lyricism, which was part of a widespread return to curved forms during the 1930s.

Fernand Léger

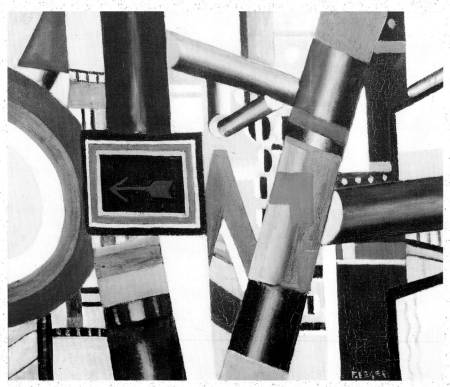

Follow the Arrow, 1919 (The Art Institute, Chicago). The theme of the arrow as a symbol of movement had already been used by Klee and Kandinsky. This simultaneous juxtaposition of mechanical parts remains homogeneous thanks to the play of diagonals and the Orphic disc set in counterpoint to the rectangle.

1881. Birth of Fernand Léger in Argentan, France.

1907. After passing through both Impressionist and Fauve phases, Léger's paintings retain the influence of Cubism and the Section d'Or.

1909. With Robert Delaunay, he leads the 'battle of free colour through contrast', in his *Contrast of Forms* paintings.

1914–18. Gassed in the trenches of Verdun during World War I, he returns with drawings of robot-soldiers and mechanical parts.

1918–20. Léger's works dating from this period belong to his 'dynamic' style. Acrobats and workers are to remain his favourite subjects. He paints *Follow the Arrow* in 1919. He isolates triangular, tubular and circular mechanical parts, which resemble the electrical prisms and Orphic discs of Robert Delaunay.

1925. Together with Ozenfant, Léger paints large murals for the decoration of the L'Esprit Nouveau pavilion at the Exhibition of Decorative Arts. Le Corbusier is influenced by his poetic approach towards mechanical objects.

1935. First major retrospective at MOMA in New York.

1940–5. Returns to the United States for the duration of the War. He is fascinated by New York.

1944. Léger paints *Figures in Space* modelled on his own *Objects in Space*. Separation of patches of colour from outline drawing.

1945. Joins the Communist Party on returning to France.

1948. Resumes a certain classicism of style in order to handle social subjects in *The Builders* (private collection, New York) and *Les Loisirs,* a work he had started in 1943 but took up again in 1948, rechristening it *Homage to Louis David.*

1949. Léger completes a number of monumental works including a mosaic for the church on the Assy plateau (1949), windows for the church at Audincourt (1951) and decorative paintings for the UN building in New York.

1952. He produces his final masterpieces *Women with a Parrot* (MAM, Paris) and in 1954 *The Great Parade* (Guggenheim Museum, New York), which depicts the circus in all its grandeur.

1955. Awarded the painting prize at the Sao Paulo Biennale. Death of Fernand Léger in Gif-sur-Yvette.

Orphism

Guillaume Apollinaire used the term 'Orphism' or 'Orphic Cubism' to describe the works shown by Robert Delaunay at the Section d'Or exhibition of 1912.

This was the reinvention of a term that had already been used by the Symbolists. It refers to the mythical figure of Orpheus, whom the poet invoked in his collection *Le Bestiaire* ('Bestiary') and in his book *Les Peintres Cubistes* (1913, 'The Cubist Painters').

According to Apollinaire, Orphism denotes a purely imaginary form of abstraction that derives from Cubism, but is rendered more lyrical by the use of pure colour applied according to the principle of simultaneous contrast or by analogies with music, as in Frantisek Kupka's 'philosophical architectures'.

Apollinaire included a diverse range of painters under the label Orphism: Kandinsky, Macke, Marc, Meidner, Münter, Freundlich, Jawlensky, the Italian Futurists and to a lesser extent Picabia, Duchamp and Léger. Only Robert and Sonia Delaunay would pursue any serious experimentation in this direction, however.

From 1912, Robert Delaunay, a member, like Kupka, of the Section d'Or, distanced himself from the rigorous severity of Cubism in his series *Simultaneous Discs and Circular Rhythms*, and in his book *Du Cubisme à l'art abstrait* (1957, 'From Cubism to Abstract Art') offered a slightly different definition of Orphism in which he included the Synchronism of American painters such as Morgan Russell and Stanton Macdonald-Wright. He traced its origins back to Seurat's Divisionism. While for Seurat the principle of simultaneous contrast only applied between the light figures and darker background, Delaunay sought to apply it to the entire canvas.

Through the opposition of pure complementary colours and that of cold and warm tones, Orphic works suggest perpetual motion and changes in light in networks of helical or circular lines organized in an irregular rhythm. The Orphic style would have a considerable influence on Paul Klee and Blue Rider painters August Macke and Franz Marc.

'Speed = Abstract art', the motto of the International Exhibition of Art and Technology of 1937, provides an accurate description of the frescoes Robert Delaunay exhibited in the Palais de l'Aéronautique et des Chemins de Fer.

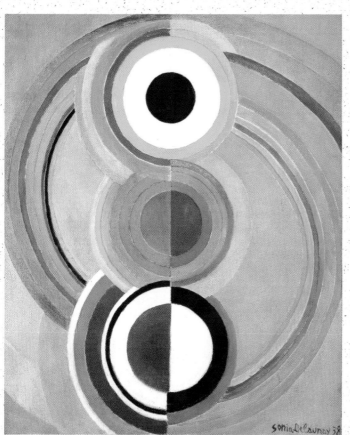

Sonia Delaunay, *Rhythm*, 1933 (MNAM, Centre Georges Pompidou, Paris). This Orphic composition painted in pure colours creates an impression of perpetual movement, the scale of which is suggested by the three asymmetric discs and the intersecting curves on either side.

A 'LABORATORY OF FORM'

Purists defined objects in terms of structure in its purest form, in a spirit of typically French rationalism, through areas of light and neutral colour, neatly demarcated as in industrial design, and similar in technique to that of mural painting.

At the end of the 1920s, Ozenfant began to move gradually towards Magic Realism and went to the United States in 1938, where he was director of the New School (Ozenfant School of Fine Arts) until 1955.

Cubism survived nevertheless, in a stylistically diluted form, in the work of Russian Léopold Survage (1879–1968) and Jacques Villon, and especially in sculpture. As with architecture, sculpture was split between two main tendencies: the first, represented by Calder, Modigliani, Gabo and Pevsner, tended towards the purification of form and a diminution of volume; the other, typified by Arp and Laurens, towards biomorphism, which was paralleled by the return of the curve in Purist architecture from the 1930s onwards, as in Le Corbusier's church at Ronchamp in western France (1952–5).

Henry Moore, *Large Reclining Figure*, 1938 (Henry Moore Foundation). In his stylized sculptures of the human figure, Moore achieved a fusion of the different principles of archaic, Surrealist, abstract and naturalist sculpture.

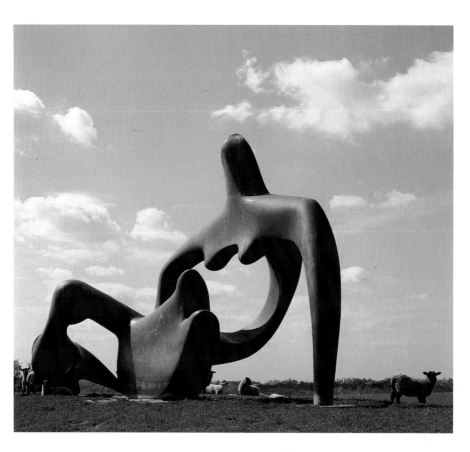

Jean (Hans) Arp, *Head*, 1927 (Galerie Natalie Seroussi, Paris). Its unidentifiable random forms, resembling biological and vegetal structures, give this work a poetic dimension tinged with humour, very much in the Dadaist spirit. Arp had been a member of the Dada movement between 1916 and 1922. The sobre composition and subtle colours also foreshadow the artist's move towards abstraction. For Arp, however, nature remained the origin of art; a belief that led him in 1930, from within the Cercle et Carré group, to oppose the rigour of Mondrian.

International Modern

Paradoxically, this approach to the formal plastic arts was only realized on an international level in architecture, where it was applied most rigorously during the 1950s and 1960s. From 1925 onwards architecture became so international in character that modernist architecture of the 1930s is now commonly referred to as the 'International Modern' style. It influenced both Mies van der Rohe's (1886–1969) purism and Le Corbusier's geometrical functionalism, and its prototype was the Bauhaus building designed by Mies van der Rohe in Dessau in 1925. The common characteristics of International Modern were unornamented geometrical surfaces, which marked a complete liberation from the Renaissance orders as defined by Vignole and Scamozzi; an emphasis on transparency using glass allied either to concrete or steel, which characterized post-war architecture; the luminosity of exterior surfaces; and the 'brutal' use of reinforced concrete. The International Modern style was supposed to bring a sense of social responsibility into the city and

INTERNATIONAL AND STYL MODERN ABSTRACTION ROUSSEAU KOKOSCHKA MUNCH MAGIC REALISM MALLET-STEVENS WILLINK WOOD NEW OBJECTIVITY DE STIJL DADAISM LUCHA
ERN ABSTRACTION AND INTER... THE BLUE RIDER MARC KANDINSKY ... VLAMINCK NAUEN DIX MODERN EXPRESSIONISM HERALD MATISSE KLEE DIE BRÜCKE
RN ABSTRACTION AND INTER GARDENERS STREGLOS KIRCHNER HECKEL ... SCHIELE NAUE LWKN WERFEL GRAEZ VOLLEROS VAN DOESBURG MONDRIAN NIETZ
DN AL MODERN ABSTRACTION... DROL ROUSSEAU KOKOSCHKA MUNCH MAGIC REALISM MALLET-STEVENS WILLINK WOOD NEW OBJECTIVITY DE STIJL DADAISM DUCHA
RACTION AND INTERNATIONAL

A 'LABORATORY OF FORM'

Le Corbusier (Charles-Édouard Jeanneret), Villa Savoye, 1929, Poissy.

create a 'new man' through the introduction of a shared egalitarian moral code. After the stone architecture of the bourgeois dwellings of previous centuries, which served primarily to affirm the social status of their occupants, the ideals of modernist architecture displayed a previously unseen aesthetic messianism and an openly expressed egalitarianism. Purism's fundamental stylistics were put to the service of social preoccupations such as urbanism, hygiene and the art of living that flowed from the new demographic and industrial imperatives. International Modern would develop with lightning speed in the United States under the influence of immigrants who joined forces with the disciples of the Chicago School, which was founded after the great fire of 1871. The main exponent of the Chicago School was Frank Lloyd Wright (1867–1959), a pupil of Louis Sullivan (1856–1924), who taught him the principle of geometric structures that made the most of simple materials but were still suited to their natural surroundings.

The principle of transparency – which had been ushered in by Sir Joseph Paxton with his Crystal Palace designed for the Great Exhibition of 1851 in London, Bruno Taut (1880–1938) with his glass pavilion at the 1914 Cologne Werkbund exhibition and Mies van der Rohe with his glass skyscraper designs of 1919 and 1920 – was taken up by Le Corbusier in his L'Esprit Nouveau pavilion at the Paris Exhibition of 1925, the large glazed panels of which lent the space a sense of rhythm and air. In it he replaced furniture with fittings integrated into the infrastructure of the building, and this model for a habitable, functional living space or *cellule* created a sensation. In 1928, Pierre Chareau, taking his inspiration from

De Stijl, created his House of Glass at 31 rue Saint-Guillaume in Paris, while Le Corbusier raised his glazed panel design to its most sophisticated expression in the Villa Savoye (1929–31) at Poissy, east of Paris, which had a box shape built on a square plot, and which exploited the contrast between its internal spiral and the geometrical rigour of its outer form, alleviated in turn by a spaciousness achieved by raising it up on stilts or pilotis.

Even the urban dwellings resembled industrial buildings with their exposed framework, cubic design and flat roofs, the latter being the only stipulation made to entrants in the 1927 Werkbund competition.

Reinforced concrete, patented in 1844, was artificial and monolithic and became the building material of choice because of the rising cost of steel (that was used just for the framework). It was cheap, durable and created a new aesthetic. It created a coarse, crude and brutal skin onto which architects played violent light – Le Corbusier's 'light cannons'. In Europe, it inspired the Brutalism of the 1950s and 1960s, as a reaction to the American architecture of glass and steel.

In France, Auguste Perret (1874–1954), who built the Théâtre des Champs-Élysées in Paris in 1913, Eugène Freyssinet (1879–1962) and Le Corbusier, assisted by his cousin Pierre Jeanneret (1896–1967), were notable for the rigour of their architecture, which was based on planes at right angles to each other. These agnostics built churches, among them Perret's Notre-Dame-du-Raincy (1922) and Le Corbusier's Notre-Dame-du-Haut at Ronchamp in western France (1952–5) and Convent of La Tourette (1952), but the very heaviness of these right-angled concrete buildings deny traditional faith. Although International Modern has

Auguste Perret, Grand staircase, Conseil Économique et Social. Formerly the Museum of Public Works, Paris 1937. Auguste Perret, one of the masters of architectural modernism, improved the technical and aesthetic qualities of concrete and left its structural framework exposed on the façades of his buildings of the 1920s and 30s. However, in 1937, like many architects, he gravitated towards neoclassicism, evident here in the building's columns, high windows and, in particular, the sweeping curves of the staircase.

A 'LABORATORY OF FORM'

Louis Sullivan and Dankmar Adler, *Wainwright Building*, 1890–1 (St Louis). This skyscraper is one of the most representative of the Chicago School, which emerged in 1871 in the wake of the great fire of 8–10 October 1871. Sullivan and Adler established the basic construction principles still used in modern skyscrapers, ie an external steel skeleton and second framework of brick or concrete. The elaborate decoration of this building was typical of Sullivan's style, which was heavily influenced by European art, but his famous dictum 'form follows function' means that he can still be classed as a functionalist.

apparently now become the dominant architectural style other, complex tendencies in existence during this period should not be neglected.

Expressionism was still very much alive in Germany during the 1930s and a number of architects took their inspiration from the contributions made by the Brücke and, more importantly, the Blue Rider movements, notably Hans Scharoun (1893–1972), Peter Behrens (1868–1940), Hans Poelzig (1869–1936) and Erich Mendelsohn (1883–1953), whose Einstein Tower in Potsdam was directly influenced by Franz Marc and Wassily Kandinsky. Mendelsohn, like Gropius, belonged to the November Group (1918–20) of left-wing Berlin intelligentsia. Their political commitment was shared by almost all the Expressionist architects, and was allied to a taste for excess, a subjective lyricism, an attachment to the real, a rejection of classicism, an appreciation of organic forms and an expressive simplicity. Even Mies van der Rohe succumbed occasionally to the influence of Expressionism – in his monument to Rosa Luxemburg and Karl Liebknecht, for example, erected in Berlin in 1926 but since destroyed – as did Walter Gropius in his monument to those killed in the March Rising (1921) and the theatre in Jena (1923).

After World War II, Expressionism played a minor role in architecture, as it had become confused with Nazi architecture in some people's minds because of its ideological and ethical ambiguities.

Despite receiving the financial support of the upper classes, historicist tendencies dwindled in importance. Because they harked back to the past, like Art Nouveau, their rigidity was seen as a threat to art, a fundamentally living phenomenon. They lost their way in futile arguments at a time when the War had abolished moral illusions and traditional art was being threatened by other new techniques. Only the Secessionist movement, led in France by Robert Mallet-Stevens (1886–1945) and a reaction to the eclecticism of the Modern Style, had any coherent and lasting influence.

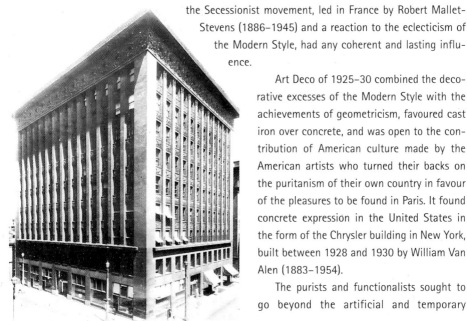

Art Deco of 1925–30 combined the decorative excesses of the Modern Style with the achievements of geometricism, favoured cast iron over concrete, and was open to the contribution of American culture made by the American artists who turned their backs on the puritanism of their own country in favour of the pleasures to be found in Paris. It found concrete expression in the United States in the form of the Chrysler building in New York, built between 1928 and 1930 by William Van Alen (1883–1954).

The purists and functionalists sought to go beyond the artificial and temporary

Otto Wagner, Villa Wagner, 1912 (Vienna). In Vienna, Wagner (1841–1918) challenged academism and established the principles of modern architecture. A member of the Vienna Secession from 1899 to 1905, he founded the Viennese School with Adolf Loos (1870–1933), Josef Hoffmann (1870–1956) and Josef Maria Olbrich (1867–1908). His work, initially historicist, developed in the direction of Art Nouveau before acquiring a greater architectural rigour akin to that of American Louis Sullivan (1856–1924). Wagner maintained the use of decorative plant motifs and a certain monumentality in his buildings: the Karlsplatz metro station (1898–99), the Post Office Savings Bank (1904–6) and the Am Steinhof Asylum chapel (1907) in Vienna. At the same time he advocated a purer, geometric style, the use of glass and steel, the flat roof and the need for aesthetics to be allied to architectural function.

euphoria of Art Nouveau, its derivatives or revivals. They achieved this through the vigour of their rhetoric, through an ethical commitment (influenced by the Freudian link between culture and the psyche), and by proclaiming the permanence of specific architectural principles, as symbolized by the 'Modulor', a scale of proportions based on the human body and developed by Le Corbusier between 1942 and 1948.

Just like the painters of the day, architects turned more and more to writing and defined their approach in numerous plans and manifestos, in which they expressed their desire to see the development of a new man in a new architecture. Avant-garde architects were able to realize their designs only under extremely difficult conditions, and their message was often poorly received. Le Corbusier did not achieve real recognition until after his death, and his ideas were not realized until 1945, often quite differently from how he had intended. After 1930, he had to sacrifice orthogonal rigour and purist luminosity in favour of biomorphic curves and concrete. The revolutionary ideas of Total Theatre, conceived in 1926 by Walter Gropius, and the Mobile Theatre of Oskar Schlemmer would only be realized in the 1960s, at the Maison de la Culture in Grenoble, for example. The Constructivist theories of German architects such as Ernst May (1886–1970) or Hannes Mayer (1889–1954) were simply distorted by the Nazis.

Ernst May and Hannes Mayer took refuge in the Soviet Union in 1930, but suffered greatly in a way that only the Productivists seemed to avoid. Rodchenko's workers' club, shown at the Paris Exhibition in 1925, proved a success, as did Konstantin Melnikov's (1890–1974) USSR Pavilion.

In Europe, the Great Depression began just as the modernists finally succeeded in uniting, through the founding of the CIAM (International Congress of Modern Architecture) by Le Corbusier and Siegfried Giedion in 1928, after having attempted to do so for ten years. The French Order of Architects, created in 1940, granted three architects without diploma (Auguste Perret, Eugène Freyssinet and Le Corbusier) the right to practise. The purist and modernist architects were not, however, above sectarianism and intolerance towards some of their disciples, such as Brazilian Oscar Niemeyer (born 1907), who was one of the most brilliant of the few architects that developed their ideas after World War II. His purist principles – transparency deriving from glass, the use of concrete and geometric forms – which he succeeded in combining to great lyrical effect with the vernacular tradition – pilotis, fountains and curved forms – were harshly criticized by Gropius and Mies van der Rohe.

More than any other country, it was Japan that assured the survival and development of these modernist tendencies, offering inspired interpretations of them based on the Japanese architectural tradition, which itself had exerted such an important influence on the Neo-Plasticism of De Stijl. In 1868, the end of the Tokugawa shogunate and the start of the Meiji era had opened up Japan to Western civilization. Architects, like

Robert Mallet-Stevens, Villa Cavrois, 1931–2. Situated at Croix, near Lille, this was the most remarkable of the private houses built by Mallet-Stevens during his brief career (1923–39). Prior to succumbing to the influence of the Vienna Secession and that of Adolf Loos, he had been one of the first exponents of International Modern. The subtle geometricism of this enormous villa with corner windows was based on the principle that the façade should reflect the interior plan. Articulated into cubes with multiple recesses, it is organized, in a subtle play of symmetry and asymmetry, around the tower, which is itself off-centre. Sold to a property developer, the house was vandalized, prior to being classified as a historical monument in 1990 and purchased by the French State in 2001.

painters, sought to learn the techniques of *Jugendstil* in Austria and Germany. In 1920 the Japanese Secession movement was formed by Sutemi Horiguchi, Makoto Takizawa, Mamoru Yamada and Kikuji Ishimoto, inspired directly by the Vienna Secession and Art Nouveau. The Bauhaus welcomed Iwao Yamawaki and Takehiko Mizutani into its ranks, while Kunio Maekawa studied under Le Corbusier. These contacts with the Bauhaus, the Deutscher Werkbund and L'Esprit Nouveau led in 1937 to the creation of the Japanese Werkbund, 'Kosaku Bunka Renmai', with Takeo Sato, Kunio Maekawa, Hideo Kishida, Yoshiro Taniguchi, Shinji Koike and Sutemi Horiguchi. This movement also received encouragement from Frank Lloyd Wright – who made a number of trips to Japan between 1916 and 1922 to build the Hotel Imperial in Tokyo, one of the few buildings to have withstood the 1923 earthquake – and later Bruno Taut, who went to Japan in 1933 in search of traditional architecture.

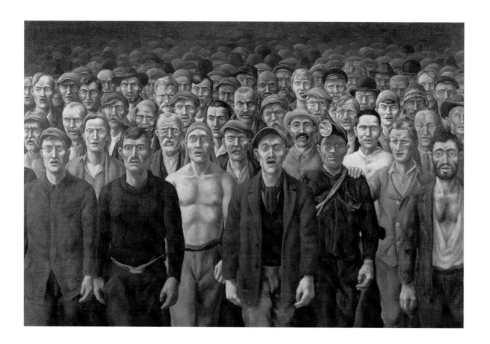

Otto Griebel, *The Internationale*, 1930 (Museum für Deutsche Geschichte, Berlin). In a realist style that retained the influence of Expressionism, shared by Marcel Gromaire and Édouard Pignon, Griebel bears witness to the economic crisis faced by Germany in the 1930s in this powerful depiction of massed ranks, which dispenses with any decorative elements. The artist has depicted himself in the front row, thus affirming his left-wing political convictions. A member of the November Group, and subsequently of the New Objectivity movement, he taught, alongside Otto Dix, at the Academy of Fine Arts in Dresden in 1927. He was arrested by the Gestapo in 1933.

The completion of post-World War I reconstruction, industrial expansion (steel production rose from 6 million tonnes in 1910 to 98 million tonnes in 1929) and exceptionally good harvests in the United States and in the monoculture-dependent tropics all contributed to a general euphoria that was shattered on 24 October 1929 by an unprecedented crash on the New York Stock Exchange, caused largely by overproduction. The free-market economy had already been hit by eight economic crises between 1857 and 1920 but they had been brought swiftly under control and their severity disguised by vibrant European reconstruction.

This slump soon reached global proportions, spread via stock markets throughout the world and reached Europe in 1931. The decline in prices and the collapse of shares led to a reduction in industrial production of 50 per cent in the United States and Germany, and, most importantly, world unemployment reached 30 million, with the United States recording twelve million and Germany six million unemployed. International trade was disrupted and governments forced to consider monetary measures and a radical transformation of their economic structures through the regulation of production. The intervention of the state marked a radical turning point for the free-market economy. Democracies were divided when faced with German, Italian and Japanese dictatorships that pursued a policy of large-scale public works, support for their arms industries and the winning of external markets by conquest. The Great Depression was one of the direct causes of World War II.

The return to order

In his 'Notes on Ingres', published in *L'Esprit Nouveau* in 1920, the French painter Roger Bissière (1886–1964) prophesied: 'We are at a stage in the history of art at which the human race, having made considerable exertions and having suffered unbelievable convulsions, feels a desire to calm itself and take stock of the treasures it has accumulated. In a word, we aspire to be a Raphael, or at least all he represents in terms of order, purity, spirituality [...] We place our hope in Ingres, the only one capable, it seems, of leading us to Raphael along a distinctly French route.'

The depression brought home to artists the brutal message that the machines they admired, and which aroused their creativity, had the

Marcel Gromaire, *The Unemployed Man*, 1936 (private collection). Gromaire evokes the harshness of social conditions following the crash of 1929 in the sober but expressive style of Synthetic Realism. Having abandoned Cubism, nevertheless still present in his treatment of the buildings, the artist uses earth colours to depict the man's facial features.

THE GREAT DEPRESSION

Grant Wood, *Stone City*, 1930 (Jocelyn Museum, Omaha, Nebraska). Following his trip to Munich in 1928, Wood returned to the United States for good and devoted himself to Regionalist subject matter. Preceded by free sketches, then drawn out and meticulously painted, the only human presence in *Stone City* is that suggested by the industrial buildings. Through its strength of composition, Grant Wood breathed new life into the primitive landscape, creating a hymn to the American countryside, in the same way that he transcended the genre of portraiture in *American Gothic*, which has become a national icon.

power to cause poverty, war and death. Sensing the enormity of these consequences, from the beginning of the 1930s they felt the need to make their message more socially expressive by means of a readjustment of form and a painterly realism.

During this period, in contrast to the most revolutionary of the American architects, European architects, including Le Corbusier, were tempering their geometric rigour with a more supple effect through the introduction of the curve. In Italy and Germany – where the growing influence of Albert Speer (1905–81) suffocated their inspiration – they opted for the easy solution of neoclassicism, thus circumventing the uncertainties of the present and guaranteeing themselves a flow of state commissions. In Italy in 1922, the year Mussolini came to power, Felice Casorati (1883–1963) and Arturo Tosi (1871–1956) founded the Novecento movement, which, like Valori Plastici, advocated a return to the past. By means of a superficial objectivity, 'flat' rationalization of forms and a choice of neutral subjects, such as still lifes, they reduced the level of commitment of both artist and spectator – a situation that suited the fascist regime, which sought to exploit the widespread poverty and lack of education. Campligli, Carrà and Sironi joined Novecento in 1929.

In France, where the avant-garde had maintained its stylistic continuity, the return to realism of painters such as André Derain, and to a lesser extent Léger and Picasso, was evident only in subtle nuances of their work. After having been a member of the Abstraction-Création movement, thanks to his friendship with Torres-Garcia, and then of Concrete

AVANT-GARDE MARINETTI VALLOTTON SEVERINI NEO-IMPRESSIONISM PICASSO NAIVE ART MODIGLIANI VORTICISM ART DECO GAUDIER-BRZESKA FUTURISM GRIS SOUTINE ZADKINE ECT BONNARD DUFY GIACOMETTI GALLEY VORPHEMUS SCHLEMMER SACHLICHKEIT EK RIVERA MAGRITTE SIQUEIROS VAN DOESBURG MONDRIAN DE LA FRESNAYE PASCIN SCHILER THE ZADKIN LEHUS GIANU MERZ VORTICISM NEUE SACHLICHKEIT DIX RIVERA OROZCO SIQUEIROS VAN DOESBURG MONDRIAN NEO-PLASTICISM BRAQUE BER TIME BLUE RIDER PICABIA CHAGALL THE BLUE RIDER MARCA AUDION MAGIC RAOUL NIMA REUNAT MODERN EXPRESSIONISM ORIENT NAVE DIE BRUCKE DUFY DUCHAMP DELAUNAY CONIC NAME ZEUX PELLICANT THE BLUE RIDER MARCA AUDION EXPRESSIONISM SENSU SACHLICHKEIT ARP RIVERA OROZCO DE CHIRICO MERZ SCHWITTERS SURREALISM POST-IMPRESSIONISM NEUE SACHLICHKEIT DIX RIVERA OROZCO SIQUEIROS VAN DOESBURG MONDRIAN NEO-PLASTICISM BRAQUE

Edward Hopper, *Nighthawks,* 1942 (The Art Institute, Chicago). Like the American Regionalists, Hopper dedicated himself to the realistic portrayal of American society and showed no interest in the European avant-garde. Less critical than that of the European realists, his art reveals the influence of photography and anticipates Pop Art, but nevertheless brings a sensitivity to its depiction of these creatures of the night.

Art, Jean Hélion (1904–87) gave up his purely formal experimentation in 1939 in order to apply the language of abstraction to the social problems of the day. Concentrating on the human figure, and especially on the theme of 'The Man with his Hat Pulled Over his Eyes', he suggested an internalization of the upheavals of civilization through work that is both rigorous and original.

In the work of Édouard Pignon (1905–1993), André Fougeron (1913–1998), Marcel Gromaire (1892–1971) and in Germany Otto Griebel (1895–1972), this return to figuration took on the aspect of social realism, of direct testimony to the poverty of the working classes. Because of the complete synthesis between the range of colours used – ochres, greys, browns, blues – and their rigid, dense, sculptural bodies, the men seem to rise from the earth.

Magic Realism

Magic Realism – a synthesis between Surrealism, the Metaphysical Painting of Giorgio de Chirico and the return to realism – emerged during the mid-1930s. Rather than a movement, it was more of a style characterized by the meticulous *trompe-l'oeil* depiction of the real, which was rendered strange by the presence of strange objects or situations. Surrealist references to sexuality, however, were excluded. Magic Realism brought to light great individual talents, such as Amédée Ozenfant, after he had moved away from Purism, Pierre Roy (1880–1950), Balthus (1908–2001), Paul Delvaux (1897–1994), Albert Carel Willink (1900–1983) and Grant Wood (1892–1942).

Although they felt the need to gather all the different avant-garde strands together into a single, unified principle, their conception of

Latin America

Diego Rivera,
From Conquest to Revolution, 1930 (Palacio de Cortes, Cuerna-vaca). Rivera's work was supposed to have broken with the European avant-garde style, but continued to display a European infl-uence enriched by elements of local naïve and tradition-al Aztec and Mayan art.

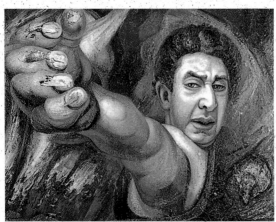

Wilfredo Lam (1902–82) and Mexican Rufino Tamayo (1899–1991); and expressionist realism, brilliantly represented by the Mexican Revolutionary School, Diego Rivera (1886–1957), Jose Clemente Orozco (1883–1949) and David Alfaro Siqueiros (1896–1974). Following the Mexican Revolution of 1910, these artists, like those of the Russian avant-garde, displayed a keen social con-science. They advocated a complete break with religious art, which had been predominant in Mexico since the 16th century, as well as a return to regional pictorial traditions and the sources of pre-Columbian art. They rejected European easel paint-ing, which they saw as bourgeois, and, from a desire to inform the public, developed the genre of the monumental historical fresco.

Cuban painter Wilfredo Lam fought in the Republican army during the Spanish civil war before joining the Surrealist group in Marseilles in 1939. He developed a politically committed art that featured earthy colours and vegetable, animal and human forms, which lent his work a totemic quality.

Following his classical training at the Academy of Fine Arts in Mexico City, Rivera travelled to Paris in 1907. He became interested in Fauvism and Synthetic Cubism, befriended Modigliani, Apollinaire and painters of the School of Paris and met Siqueiros there in 1919. In 1920 and 1921, he travelled to Germany and Italy, where he studied in depth the frescoes of Giotto, later applying some of his principles to his own compositions. In 1922 he completed his first mural, considered the first of its kind in contemporary Mexico, for the main lecture hall of Mexico City University and joined the Communist Party. His style, based on a vigorous realism, was supposed to have broken with that of the European avant-garde, but retained the influence of Cubism and Expressionism, enriched by ele-ments of both local naïve and tradi-tional Aztec and Mayan art, evident predominantly in his elimination of

While Europe was tearing itself apart and threatening the very foundations of its civilization, and its artists speculating about the end of art, South América seemed to be rising from its ashes following a period of conquest and revolution. Its vital energy fuelled a reinvigora-tion of the three great strands of contemporary art: abstraction, with Uruguayan Joaquin Torres-Garcia; Surrealism in the form of Chilean Roberto Matta (1911–2002), Cuban

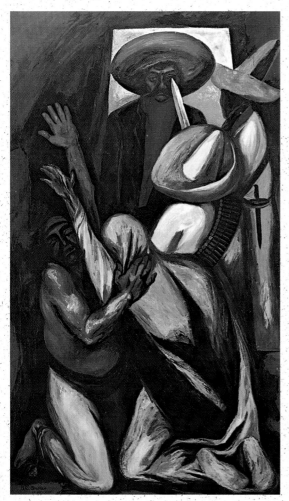

Jose Clemente Orozco, *Zapata*, 1930.(The Art Institute, Chicago). Orozco's art, characterized by revolutionary realism, is notable for its synthesis of the traditions of Aztec art with a highly structured form of Expressionism.

David Alfaro Siqueiros, *Self-Portrait (El Coronelazo)*, 1945 (Museum of Fine Arts, Mexico). The influence of Cubism and Expressionism can be seen in the dynamic violence of the artist's gesture and in the prominence given to the most expressive features of the human face in this dark-hued self-portrait by Siqueiros.

perspective. Rivera was almost exclusively interested in themes from contemporary, and particulary Mexican, history and the daily lives of the Mexican Indians.

In 1926, he completed the monumental frescoes of the National College of Agriculture at Chapingo and travelled to the Soviet Union, where he painted a vast composition for the House of the Red Army in Moscow, representing the parade for the tenth anniversary of the Russian Revolution, which he had witnessed personally.

However, the three-panel fresco dedicated to the workers of America that was commissioned from him in 1933 for the Rockefeller Center in New York and conceived in collaboration with Ben Shahn was destroyed prior to completion because of its apparent Marxist implications. Rivera decorated the building of the Mexican Department of Public Education between 1923 and 1928, the National Palace of Mexico in 1930 and 1944, and the university stadium in 1952.

Although he studied architecture at the Academy of Fine Arts in Mexico City, Orozco distinguished himself initially as a caricaturist before he, too, devoted himself to a realist revolutionary art in paintings and decorative murals dedicated to the history of Mexico and the sufferings of humanity. The originality and power of his work reside in the synthesis he achieved between a highly structured form of Expressionism and the traditions of Aztec art.

Having fought for four years in the Mexican Revolutionary Army, Siqueiros mixed in European, particularly Parisian, avant-garde circles after he, too, travelled to Europe in 1919. But in his acceptance speech upon being awarded the Prize of the Museum of Sao Paulo at the Venice Biennale in 1950 – the year Matisse was awarded First Prize – he insisted on the purely formal character of abstraction's contribution and claimed to have deliberately rejected it in order to devote himself to a heroic realist art accessible to everyone and designed to serve all revolutions and anti-colonial struggles. He painted numerous frescos in this style, including the 450m^2 *The Mexican Revolution* for the Museum of Art, Anthropology and History at the castle of Chapultepec.

Nevertheless, Cubist and Expressionist influences can be detected in his treatment of form, in his choice of dark colours such as browns and greys, in the violent dynamism of gesture and in the prominence he gave to the most expressive features of the human face. His last great achievement was to complete the Cultural Polyforum in Mexico City in January 1972.

realism was neither that of the 'reality of vision' of the 19th century nor that of the official academic art of the totalitarian regimes emerging at this time. Because of their aesthetic and philosophical knowledge (based primarily on the existential philosophy of Husserl, Nietzsche and Heidegger), they were able to avoid the much-feared 'realism of the banal'. In 1928 Giorgio de Chirico himself decided to return to the origins of the great artistic tradition, that of Arnold Böcklin, Ingres, Raphael and even Courbet.

Albert Carel Willink abandoned Cubism and pure abstraction in 1928, a critical year for his art, in which he completed his *Portrait of Madame Blijstra-van der Meulen* (private collection). After living in Berlin between 1920 and 1923, when he attended Hans Baluschek's art school, the social tension of the day made him pessimistic. In Paris in 1925, where, according to André Masson's memoirs, there reigned by contrast an atmosphere of 'extraordinary intoxication, of complete and unforgettable freedom', only Picasso's neoclassicism caught his attention. Inspired by the great Flemish masters and by Giorgio de Chirico, Willink painted portraits, landscapes and even religious themes (avoiding or deliberately eschewing any allusion to transcendence) in a realist style overlaid with fantastic elements, in which the ambiguity of gentle settings and landscapes, often featuring heavy clouds, also reveal the artist's taste for classical architecture. Based on this aesthetic of distance, his paintings constitute a profound meditation on the past and future of our civilization and on the inescapable reality of death. Willink often depicted fires in the background of his pictures, which unlike those in the paintings of Otto Dix (1891–1969), for example *Lot's Daughters* (1939, private collection, Aix-la-Chapelle), seem to be burning for no obvious reason. Examples of this can be seen in *The Preacher* (1937, Centraal Museum, Utrecht) or Simon the Stylite (1939, Gemeentemuseum, The Hague). The only one of his paintings to depict children – albeit seen from behind – is *Trafalgar Square* (1974, private collection), as Willink shared the Cubists' tragic conception of existence that relates exclusively to adults.

In the United States, the realist tradition had always been very strong, represented among others by Thomas Hart Benton (1889–1975), leader of the Regionalists, whose work was clearly influenced by naïve art and the techniques of photography. But the tradition was revitalized in the 1930s by Andrew Wyeth (born 1917), John Kane (1860–1934), Edward Hopper (1882–1967), Ben Shahn (1898–1969) and, above all, Grant Wood (1892–1942), for whom 1928, the year he travelled to Munich, was also a crucial time of change. There, Wood became acquainted with the New Objectivity movement and, most importantly, the art of Memling and the German primitives of the 15th century, whose themes he transposed in a secular context into his own work. The style of his portraits, which he painted from photographs, underwent a sudden change: line took on a greater significance and his subjects' poses,

GER LUBIN AND CONSTRUCTIVISM SUPREMATISM DE CHIRICO METAPHYSICAL PAINTING NEOPLASTICISM DADAISM SURREALISM POST-IMPRESSIONISM NEUE SACHLICHKEIT DE STIJL BAUHAUS BLAUE

DE CHIRICO MERZ SCHWITTERS SURREALISM POST-IMPRESSIONISM NEUE SACHLICHKEIT DIX RIVERA OROZCO SIGUEROS VAN DOESBURG MONDRIAN NEO-PLASTICISM BAUHAUS BLUE F

Carel Willink, *Einstein*, 1932 (collection of Mrs S Willink). Willink had been working in a realist style for four years when he painted this premonitory picture, which illustrates the spirit of Magic Realism. He has transposed an encounter between Einstein and a professor of the University of Princeton to a spot in Berlin – its Siegessäule (victory column) can be seen in the background – in front of a wooden fence that prefigures the Berlin Wall, which was not built until after World War II. The scene is treated in a realist manner, having been inspired by a photograph of Einstein's admission to Princeton, but is magical in its strange setting and in the play of real or hyperreal colours.

stripped of sentimentality, acquired the stiffness of German 15th-century portraiture. During this period of prohibition, Wood underlaid his studies of Regionalist themes, portraits and rural scenes of the Midwest such as *American Gothic* (1930, The Art Institute, Chicago), *Daughters of Revolution* (1932, Art Museum, Cincinnati) and his masterpiece *Adolescence* (1933–1940, private collection) with an overt irony targeted at American puritanism.

The New Objectivity (Die Neue Sachlichkeit)

In Germany the return to realism, which embraced former Dadaists Otto Dix and George Grosz, abstract painters and Expressionists Max Beckmann (1884–1950), Christian Schad (1894–1982), Georg Schrimpf (1889–1938), Heinrich-Maria Davringhausen (1894–1970) and Käthe Kollwitz (1867–1945), took a more satirical and Expressionist turn as a result of the social tensions that led to the most radical, including Dix, quitting the November Group. They came together in the New Objectivity movement in order to distinguish themselves from the increasingly influential neorealism of official art. In 1925, they held their first exhibition in the Kunsthalle in Mannheim under the supervision of critic Gustav Hartlaub, who defined the group and its aims. In his preface to the exhibition catalogue, he made a distinction between the New Objectivity

Ben Shahn, *Handball*, 1939 (MOMA, New York). This American painter was also an illustrator, lithographer and writer. Born in Lithuania, he emigrated to the United States with his parents in 1906. He devoted himself to social subjects, such as the Sacco-Vanzetti case in 1931 and Diego Rivera's fresco project for the Rockefeller Center in 1932. He managed to capture people and their daily lives in a schematized but realist way.

painters of the right, the classicists, and those on the left, the verists.

The humiliation and trauma felt as a result of the War had a profound effect in Germany – on both artists and the population at large. Max Beckmann served as a medical orderly for a year in Ostend, George Grosz was wounded in 1916 and Otto Dix endured atrocious conditions in the trenches, sustaining serious wounds on two occasions. They became violently anti-militarist and sought through their work to exorcize the anxieties and nightmare visions that pursued them. Rejecting both subjectivism and the abstract rationalism of the Bauhaus, they sought to turn their art into a weapon by dedicating themselves to a highly expressive and clinical portrayal of the real and dissecting the deceitful conventions and anxieties of the time, and focused on the human figure only to pour derision on it.

From Dada they retained the techniques of collage and photomontage and from the Metaphysical Painting of Giorgio de Chirico the detachment of its pseudo-classical portraiture and self-portraiture, evident primarily in the work of Christian Schad and Otto Dix (who was also greatly influenced by Dürer). Despite Emil Nolde's isolated efforts, which he later regretted, to gain official recognition of Expressionism as the art most representative of the German soul, in 1937 these ground-breaking visionaries were forbidden from exhibiting their 'degenerate art'. Most of them had already been forced into exile by 1933.

Based on the eternal themes of love and death, Dix portrayed his own experience of the seedy side of the city and the horror of war – to which

he had taken a copy of the New Testament and Nietzsche's *Die Fröhliche Wissenschaft* ('The Gay Science') – with a detailed realism that expressed in the rawest possible manner his own revulsion of violence and excluded any possibility of idealization. He was a highly skilled draughtsman who drew throughout his life, even in the atrocious conditions of the trenches. He completed over 600 pencil, charcoal and chalk sketches between 1915 and 1918, and took up these techniques again in 1920. Dix was inspired by Albrecht Dürer and his disciple Hans Baldung Grien, and admired Hans Holbein so much that he based the bottom panel of his *War* triptych (1929–32, Kunstsammlungen, Dresden) on Holbein's *The Body of the Dead Christ in the Tomb* (1521, Öffentliche Kunstsammlungen, Basel). In the manner of Holbein and Dürer, Dix excluded all traces of sentimentality from his work and played down relief in favour of line; his detailed realism, furthermore, is often tinged with a certain morbidity.

In 1925, Dix travelled to Italy, where he studied the Renaissance painters, notably Pontormo. From this time his brand of realism evolved towards Mannerism and compositional effects. He was appointed professor at the Academy of Fine Arts in Dresden in 1927, the year in which he painted *Street Battle*, and while continuing to draw nudes and sketch war scenes in order to exorcize his nightmares (as he later claimed), he also took up the ancient tradition of the retable, producing large polyptychs painted with refined glazes. This was the technique he used for the triptychs *The Big City* (1927–8), Städtische Galerie, Stuttgart), *Nocturnal Scenes* and, most notably, *War*, painted on four wooden panels between 1929 and 1932. As with Altdorfer, its cold and yet violent light takes on a dramatic intensity, endowing this depiction of war with an apocalyptic character.

Condemned by the Nazis as a 'degenerate artist', Dix was dismissed by the Dresden Academy in 1933. His works were removed from German museums and he was forbidden to exhibit. He went into exile at Hemmenhofen, on the shore of Lake Constance, where, to use his own words, he found himself 'face to face with the countryside, like a cow'. He continued to paint using glazes, and also to draw, but evolved during this period of intense crisis towards a style that featured floating, frozen landscapes of an ambiguous calm, which were devoid of any human figures and executed in cold greens and blues. These works create an impression of meditative solitude, evocative of the landscapes of Dürer and Caspar David Friedrich. Like Friedrich, Dix seems no longer to have taken mankind as his reference, but infinity, a stance later confirmed by his transcriptions of religious themes.

When World War II broke out, he was held prisoner in Colmar. Afterwards, and up to his death in 1969, he took his inspiration from religious themes, despite claiming to be an atheist. In 1960 he published 33

Otto Dix, *The Big City*, 1927–8 (Städtische Galerie, Stuttgart). With a biting irony akin to the nihilism of Nietzsche, Dix denounced the ugliness and hypocrisy of the false pleasures of the city in these nocturnal scenes featuring members of the bourgeoisie, invalids and prostitutes. The work's central panel is painted in warm colours, providing a contrast with the more sombre side panels. Dominated by reds, it depicts creatures of the night who appear to be dancing on a volcano. Their eyes do not meet and their enjoyment seems forced. The left-hand panel features a war invalid (with whom Dix identifies), who

ULRICH BONNARD DUFY GIACOMETTI MALEVICH ORPHISM LE CORBUSIER DER BLAUE REITER FAUVISM MAGRITTE BOCCIONI LIRILLO DELAUNAY KUPKA DE VLAMINCK RUSSIAN AVANT-
GARDE ZADKINE DERAIN SCHIELE KANDINSKY ROUSSEAU KOKOSCHKA MUNCH MAGIC REALISM SURREALISM SOCIAL REALISM MODERNISM OBJECTIVITY MATISSE STANLZ DUCHAMP PICABIA DE CHIRICO
NEO-PLASTICISME MARINETTI THE BLUE RIDER NATIVE EXPRESSIONISM CONSTRUCTIVISM EXPRESSIONISM MODERN SO VORTICISM ART DECO MATISSE KIRZIL DIE BRÜCKE L'ESPRIT NOUVEAU
DE CHIRICO MERZ SCHWITTERS SURREALISM POST-IMPRESSIONISM NEUE SACHLICHKEIT DIX RIVERA OROZCO SIGUEROS VAN DOESBURG MONDRIAN NEO-PLASTICISM BAUHAUS BLUE

scrutinizes the
prostitutes knowingly.
Set upon by a dog,
and with a human
form lying at his feet,
he embodies the
misery of those who,
like Dix, fought in
World War I and were
then forgotten, the
victims of capitalist
interests. In the right-
hand panel, a group
of rather flashy
women parade past
fantasy marble and
stone architecture
in a *nouveaux-riche*
style, which can also
be seen as an allusion
to female sexuality.
Abandoning the
realism of New
Objectivity, Dix took
his inspiration for the
portrayal of this
doomed world from
the painters of the
Italian Renaissance
and the noble
tradition of
the retable.

lithographs under the title *The Gospel according to St. Matthew*.

The controversy created in the 1930s by artistic personalities as diverse as Giorgio de Chirico, Otto Dix, Carel Willink and Grant Wood, by their harking back to the normative categories of realism, was accompanied by an ethical debate. They went back to the historical development of traditional forms of painting to rediscover values they believed to be sound and universal. Like the classical artists, they reinforced the idea that their era represented a transition between two changes in civilization and not an ending, a total break with the preceding centuries.

Through their figures frozen in expectation, however, they seemed to be asking questions that revealed their uncertainties. They were painters of the real, but of a real from which God had disappeared. They appropriated religious subjects while denying any allusion to transcendence. Nature, traditionally considered the work of God, was abandoned in favour of architecture (the work of mankind), urban environments or conflicts and wars.

In 1928 in *Le Mystère Laïc*, Cocteau wrote of Giorgio de Chirico that he was 'unable to convey his faith, he conveys his good faith'. These artists, witnesses to the shattering of the Christian conception of morality and the world, were searching for real values in the form of 'real poetry and real painting', in the words of Giorgio de Chirico in his memoirs. In taking their inspiration from these, however, they could only deflect the most traditional artistic categories towards a hitherto unknown system of references.

These artists refused to accept the absurdity of the human condition, which was to be the dominant theme of post-war art and literature, but the values that governed their work were essentially negative. All of them were influenced by Nietzsche, and Carel Willink took his inspiration for the book he published in 1950, *Painting at a Critical Stage*, from Albert Camus' *The Myth of Sisyphus*, retaining in particular the principle that 'there is no better way of serving art than through a negative thought'.

In seeking to solve the mystery of an elusive, ephemeral and destructive reality from which they felt excluded, and to rediscover genuine values that they knew had disappeared, these painters belonged very much to the 20th-century current of thought. They were 'problematical heroes' (Lukacs), for whom the world of essence had become irretrievably detached from the world of existence.

The work of the New Objectivity artists faltered in the face of a violent campaign against them, initiated by Germany's Minister for the Interior, Wilhelm Frick, who declared on 20 October 1933: 'Let us put a stop to the spirit of corruption! And let there be an immediate end to these ice-cold and un-German constructions that go by the name of New Objectivity.' Expressionist art was considered the product of sick minds; the Reich Chamber of Culture favouring an academic realism laden with

Two painters of the New Objectivity movement

George Grosz, *A Dream*, 1930 (private collection). This visionary work, intended as a harsh criticism of the mythology surrounding the reality of war, is executed in a style very different to that of Otto Dix's *Dream* of 1914 (Folkwang Museum, Essen). Having begun his career in Berlin as a caricaturist on the satirical periodicals *Die Aktion* and *Die Pleite*, he was injured during World War I in 1916. He returned from the war with vehemently anti-militarist views, declaring: 'Man is a beast' and joining the Communist Party in 1918. Grosz emigrated to the United States in 1933, but returned to Germany in 1959, dying the same year.

GEORGE GROSZ

1893. Birth of George Grosz in Berlin. He works initially as caricaturist on satirical reviews.

1916. Grosz is wounded in battle and develops a wholehearted hatred of jingoistic nationalism.

1918. Along with fellow artists Georg Scholz and John Heartfield, Grosz joins the Communist party. The style of his paintings is Expressionist.

1919. Grosz becomes a Dadaist.

1920. Grosz arrested for blasphemy (and again in 1923 and 1928).

1924. At his exhibition in Paris, Grosz unleashes violent attacks on French 'bourgeois' art.

1925. He rejects 'Expressionist anarchy' and adopts the views of the New Objectivity group. He denounces the artificial commercialization and democratization of art by the periodicals and galleries and abolishes all light-hearted or decorative aspects from his work.

1930. Grosz paints his visionary work *A Dream*, a stinging critique of the mythology surrounding the reality of war, in a completely different style to Otto Dix's *Dream* (1914).

1933. Grosz flees to the United States.

1937. His works are confiscated and displayed in the exhibition of degenerate art organized by the Nazis.

1946. Grosz paints several series of fantastical works influenced by his nightmares about the war.

1959. Death of George Grosz in Berlin.

MAX BECKMANN

1884. Birth of Max Beckmann in Leipzig, Germany.

1899. He studies at the Weimar Academy.

1903. Beckmann visits the Louvre in Paris and develops an interest in Gothic art.

1906. He paints a number of Expressionist works and exhibits at the Berlin Secession.

1914. Beckmann enlists for the War as a volunteer, but suffers a serious nervous breakdown from which he takes a long time to recover.

1918–19. Paints *The Night*, a depiction of post-war Germany executed in a harsh, realistic style.

1925. He joins the New Objectivity group and establishes his style: an ambiguity-laden realism.

1925–33. Beckmann takes up a teaching post at the academy in Frankfurt and makes frequent trips to Italy and Paris.

1932. His work becomes increasingly hermetic, often inspired by Gothic triptychs.

1947. Travels to the United States and settles in St Louis.

1950. Death of Max Beckmann in New York.

reassuring anachronisms, which was unlikely to provoke any great awakening of the spirit. The world of the big city and the proletariat was rejected in favour of scenes of rural life, the mythology of blood and soil, the archaistic symbol of German autonomy, and idyllic family life.

The big names in German official art would henceforth be sculptors Arno Breker (1900–1991) and Josef Thorak (1899–1952) and painters Fritz Klimsch, Oskar Martin-Amorbach (*The Sower*, 1937), Ivo Saliger (*The Judgement of Paris*, 1939), Udo Wendel, Hubert Lanzinger and Adolf Ziegler. They sculpted and painted men with neo-antique, healthy, muscular, virile bodies, and women, guarantors of the Aryan inheritance, with smooth and passive bodies.

However, by affirming the rights of the individual at the price of exile and solitude, the 'degenerate' artists – Otto Dix, George Grosz, Max Beckmann and others – created hope for the future through the possibility of establishing a link with tradition even during the apocalyptic period of 1930s and 1940s Germany.

WORLD WAR II

Whence this *'cruelty, this obedience to inexorable forces which bind us to the necessities of death'*?

Élie Faure, *Soutine.*

Dwight C. Shepler, *The Battle for Fox Green Beach, D-Day Normandy, 1944* (Naval Historical Center, Washington DC). The American artist Dwight Shepler (1905-74) witnessed fighting in the Pacific and in Normandy as a war artist and identification officer. On 5 and 6 June 1944, he observed the Allied landings from on board the USS Emmons. In this painting he expresses his personal vision of the fierce fighting by American forces to take this stretch of Omaha Beach, on which he himself landed on 11 June.

In the period from 1450 to Impressionism in the 19th century, art had developed in an organic manner, but the beginning of the 20th century witnessed a dissociation between art's two organizing principles: figurative representation and the sensibility of the artist. The emphasis on the duality of the object – a concept born out of the discoveries of modern physics – gave rise to abstraction, the greatest artistic revolution of the 20th century.

The avant-garde's aggressive and sacrilegious challenging of the value and 'charismatic ideology' of art (P Bourdieu and A Darbel, *L'Amour de l'Art*, (1969, 'Love of Art')), its denunciation of historicism but also its fear of the end of art, were surpassed by the enormity and horror of wars that dismantled all humanist stances. Nuclear energy and the atomic bombs dropped on Nagasaki and Hiroshima in August 1945 contributed to the creation, despite the return to peace that followed, of a profound trauma in the 20th-century human psyche by introducing the permanent possibility of the destruction of humanity and of planet earth. *Homo homini lupus est* (Man is a wolf to other men), Plautus' axiom taken up by Bacon, Hobbes and then Marx, saw its tragic consecration in the millions of deaths of World War II.

The artists of the first half of the 20th century, however, brought about a fundamental readjustment of representation and its limits. Nineteenth-century art criticism, covering the period 1789 to 1870, had already been influenced by the publication in 1832 of Hegel's *Aesthetics* – taken up by George Lukacs in his *Theory of the Novel* (1920) – which

WORLD WAR II

sanctioned a wider approach to the history of art based on themes studied in relation to the history of civilizations, not simply as a series of different subjects, as was the academic convention. In 1755, Johan Joachim Winckelmann had defined the artist as a 'creator of ideal form' but, via the crucial theme of the window, this interpretation was shattered in the 20th century by the complete elimination of reassuring classical illusionism, even in realist works. This process of 'passing through the mirror', this affirmation of art's autonomy, the undisputed privilege of subsequent generations, marked the passing of art's childhood. Children themselves no longer featured in the work of the avant-garde, other than in that of Picasso, or only as child-machines: this was an adult art.

The first half of the 20th century was a period of enormous contrasts in which a highly sophisticated civilization co-existed with the utmost barbarity. Hitler gained power in 1933 and the following year the Long March began in China. In 1937 the Universal Exhibition was held in Paris, while elsewhere preparations were under way for the bloodiest war in history. Culturally, the Soviet Union was withdrawing into itself, while the United States, despite its eventual entry into the conflict and thanks to its European émigré artists, maintained a dynamic cultural scene that was one of the reasons behind the massive Americanization of Europe

Joseph Cornell, Soap Bubble Set, 1936 (The Wadsworth Atheneum, Hartford, Connecticut). Associated against his wishes with Surrealism, Cornell showed the first in his long series of *Bubble Sets* at the Fantastic Art, Dada and Surrealism exhibition held at MOMA, New York, in 1936. He met Marcel Duchamp in New York and took his inspiration for the *Museum* series from Duchamp's *The Box in a Valise*. The uniformity of the exterior of the boxes contrasts with the diversity of their contents: ephemera or found objects embellished by Cornell to create his works. Although he never left the United States and led a very private life, he always felt a nostalgia for other places (hence the presence of maps in his work) and for the Europe he knew from the poetry of Baudelaire, Nerval, Rimbaud and Mallarmé. He was the most committed avant-garde artist of his day and was deeply affected by the tragic events that occurred during his lifetime, as indicated by *Black Hunter* of 1939 (private collection).

Oskar Kokoschka, *What we are Fighting for*, 1943 (Kunsthaus Zurich). Kokoschka, exiled in England since 1938, had experienced the reality of World War I, having been seriously wounded on the Russian front. This sardonic allegory, constructed around the Crucifixion, levels an accusing finger at the Church, in the figure of the bishop, and capitalism, embodied by German industrialist Schacht and British banker Montagu Norman, who are wrapped in Nazi flags under the ironic gaze of Voltaire in the foreground.

after the War. When war broke out, due in large part to the weakness of the Allies, who from 1935 allowed Hitler to flout the terms of the World War I peace treaties, the Surrealists had already emigrated to the United States, where they were welcomed by Marcel Duchamp, who had settled there in 1912. They were to exert a considerable influence over American painting through major exhibitions staged by them, such as Fantastic Art, Dada and Surrealism in 1936 at New York's Museum of Modern Art, which echoed the Surrealist Objects exhibition held in Paris. Jackson Pollock's dripping technique was directly influenced by the automatic writing methods of André Masson, who in turn was influenced by the art of the Native Americans, and Joseph Cornell adopted Duchamp's *Box in a Valise* technique for his shadow boxes, adorned with the fruits of his tireless quest for *objets trouvés*. American abstraction was also reinvigorated by the presence in New York of Mondrian, Léger, Moholy-Nagy and others, and its architecture benefited from the emigration of the greatest German architects, Gropius and Mies van der Rohe. Other artists joined the resistance, some, such as Richard Lindner, Hans Hartung and Nicolas de Staël, joined the French Foreign Legion. Olivier Debré was seriously wounded in the liberation of Paris.

The notion of culture and civilization was no longer the monopoly of Western Christian society, but shifted towards other areas, a phenomenon encouraged further by the general process of decolonization.

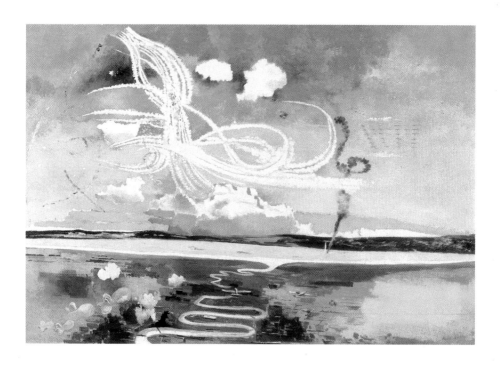

Paul Nash,
The Battle of Britain,
August to October
1940 (Imperial War
Museum, London).
During World War II,
Nash was attached to
the Royal Air Force as a
war artist before
becoming seriously ill.
Following a period of
quasi-Magic Realism,
he returned to his
Symbolist style for
paintings of the air war,
in which he drew an
analogy between
aeroplanes and birds.
The Battle of Britain
represents a bird's-eye
view of a German raid
on the Thames estuary.
The arabesques of
white smoke contrast
with the rigorous
formation of German
planes arriving
on the right.

Numerous researchers, including Claude Lévi-Strauss, explored primitive cultures and rediscovered among them a universality of the human condition that had been destroyed by conflict. For artists, it was no longer simply a question of inserting African or Oceanian influences into their work, but of assimilating the essence of these cultures in order to revitalize Western culture.

The vain denunciation of society's shams, violence and war by the avant-garde artistic movements – Dadaism, Surrealism, Futurism and abstraction – were destined to fail in the short term, but opened up the way for other fields of analysis in the history of art, such as sociology, anthropology and ethnology.

Artists' powers of creative investigation were challenged by the emergence of Communist regimes that favoured the official Social Realist line and relegated cultural revolutions to a secondary role, and also by competition from the mass media. Radio, without which the enlistment of the masses would have been impossible, and television, which first broadcast in 1936, led to a general weakening of the power of imaginary iconography, even within those movements that survived best, such as Surrealism and abstraction. Abstraction would split into a number of different tendencies after World War II: lyrical abstraction, Réalités Nouvelles, Abstraction-Figuration; and would still number in its ranks outstanding individuals such as Nicolas de Staël, Jean Fautrier, Hans Hartung, Pierre Soulages, Maurice Estève, Jackson Pollock, Mark Rothko, Willem de Kooning and Frank Stella. The process of challenging the

Olivier Debré, *Death in Dachau*, 1945, graphite and black gouache (MNAM, Centre Pompidou, Paris). After studying architecture at the École des Beaux-Arts in Paris, Olivier Debré became an exponent of pure abstraction in 1942 and used a restricted range of signs to convey his ideas concerning the essence, and here the tragedy, of war and concentration camps. His controlled gestures and use of black and white resemble oriental art. After the war, remaining true to abstraction, Debré produced lyrical paintings in increasingly large formats, painted in bright colours and often in the open air.

limits of representation would continue through the questioning of the support itself (the material on which a painting is executed) by the Support-Surface movement; through the rejection of easel painting by the exponents of Action Painting, most notably through the Art Brut of Jean Dubuffet (1901–85); and later through Yves Klein and Lucio Fontana's attempts at fixing emptiness in their monochrome canvases.

Wars have destroyed all illusions about the sophistication and foundations of Christian civilization. Traditional conventions have degenerated despite the heroic efforts of the avant-garde to adjust ethical and aesthetic values to the realities of modern life. They failed in the short term, but they made it possible for future generations to find a humanist point of reference in the apocalyptic period of 1905–45. This era of disillusionment ushered in existential doubt regarding man's freedom (Jean-Paul Sartre wrote *Being and Nothingness* in 1943), increased pessimism and the growth of the philosophy of the absurd.

The vitality and passionate energy brought by the artists of the beginning of the 20th century to the search for new means of expression faded after World War II. Furthermore, faced with the invasion of the mass media, later artists would be forced to stress the heteronomy of art – its links with other areas of life – at the risk of producing decorative and no longer purely cognitive works.

Despite the strict set of values applied by some painters, such as the Neo-Plasticists, their works did nevertheless reflect the upheavals of the nuclear age, namely the fragmentation of objects, thus introducing the notion of infinity and free interpretation.

The major works of the first half of the 20th century alluded to a

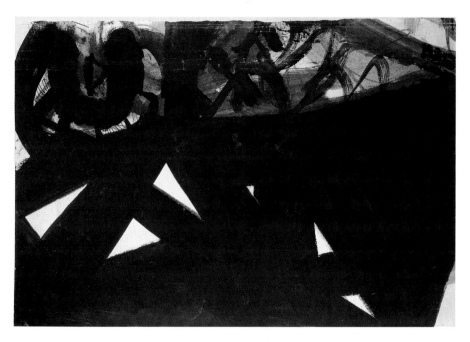

WORLD WAR II

Hans Hartung, *T. 1938.32*, 1938 (private collection; photograph © J Dubout/Galerie Daniel Gervis, Paris). Hartung fled his country of birth, Germany, in 1935 and settled in France with the help of Jean Hélion and Henri Goetz. He joined the French Foreign Legion in 1939, leaving after the Armistice and rejoining in 1943. Seriously wounded during the Belfort offensive, his right leg had to be amputated. Hartung had been a keen draughtsman since childhood, when he made *Blitzbücher* (lightning books) – collections of sketches made during evening storms. This discipline enabled him to create abstract works of extreme rigour from the start of his artistic career. In keeping with his custom, this work's title clearly indicates technique (T for *toile*, canvas), year of execution (1938) and sequence number (32). The ground is still light at this stage, in order to receive the spurts of paint that seem to extend naturally from their points of origin, but this method was subsequently reversed, the ground becoming dark or even black beneath light-coloured or white shafts of light. Hartung was something of an artistic recluse.

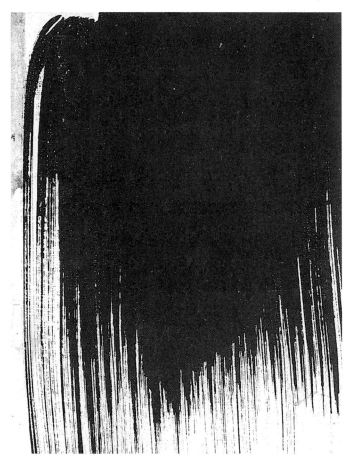

necessity to examine the problematics of art, which reflected contemporary enthusiasms and anxieties that could not be reduced to a reassuring fictional iconography. Art must remain, like the question of human existence, a confrontation with uncertainties.

Chronology

Date	Politics	Culture and science	Fine arts
1905	First Russian Revolution. Mutiny on the Potemkin.	Albert Einstein: theory of relativity. Sigmund Freud: *Three Contributions to the Sexual Theory*. Bloomsbury Group founded in London.	Salon d'Automne: the 'Fauves' den' creates a sensation. Founding of Die Brücke in Dresden. Edvard Munch: *Girls on the Bridge*, p.21.
1906	Founding of the British Labour Party. Rehabilitation of Captain Dreyfuss in France.	Magnetic North Pole discovered by Roald Amundsen. Death of Pierre Curie.	Gustav Klimt: *Portrait of Fritza* Riedler, p.19. Paul Cézanne dies.
1909	Liberal revolution in Persia; the Shah is overthrown.	Robert Peary reaches the North Pole. Syphilis successfully treated by Paul Ehrlich in Germany. Louis Blériot crosses the English Channel by plane.	Filippo Marinetti's first *Futurist Manifesto*. Pablo Picasso: *Portrait of Ambroise Vollard*, p.43. Serge Diaghilev's Ballet Russes in Paris
1911	Revolution in China, which becomes a republic. Parliament Act in Great Britain.	Albert Einstein: *On the Influence of Gravity on the Propagation of Light*. Roald Amundsen reaches the South Pole.	Birth of Der Blaue Reiter (The Blue Rider) group in Munich. Founding of the Puteaux group and the Section d'Or. Marcel Duchamp: *Nude Descending a Staircase*, p.47.
1913	Civil war in Mexico. Signature of the Treaty of London followed by Second Balkans War.	Guillaume Apollinaire: *Alcools*. Marcel Proust: *Remembrance of Things Past*. Sigmund Freud: *Totem and Taboo*. Igor Stravinsky: *The Rite of Spring*. Alain-Fournier: *Le Grand Meaulnes*.	Amory Show in New York. Beginnings of Suprematism and Rayonism in Russia.
1914	World War I.	James Joyce: Dubliners. André Gide: *The Vatican Cellars*. Exhibition of the Deutscher Werkbund in Munich, featuring Bruno Taut's glass Industrial Pavilion.	August Macke killed in action. Birth of Vorticism in Britain. Oskar Kokoschka: *The Bride of the Wind*, p.23. Kasimir Malevich: *Suprematist Composition*, p.63.
1916	Battle of Verdun. Rasputin assassinated.	James Joyce: *Portrait of the Artist as a Young Man*. Franz Kafka: *Metamorphosis*.	Death of Franz Marc at Verdun. Frank Lloyd Wright: Imperial Hotel in Tokyo.
1917	Easter Rising in Dublin. Russian Revolution and abdication of the tsar. End of World War I.	Albert Einstein: *Theory of the Universe*.	De Stijl movement founded in the Netherlands. Félix Vallotton: *The Harbour at Trégastel*, p.12.

Date	Politics	Culture and science	Fine arts
1918	Execution of Tsar Nicholas II in Russia.	Death of Claude Debussy and Guillaume Apollinaire. Oswald Spengler: *The Decline of the West.*	Dada manifesto. Amédée Ozenfant and Le Corbusier: *After Cubism.* Alberto Magnelli: *Lyrical Explosion,* p.72.
1919	Proclamation of the German republic. Treaty of Versailles. Borders in Europe and the Middle East redrawn. Creation of the League of Nations.	Publication of *The Magnetic Fields* (*Les Champs Magnétiques* – the first 'automatic writing') by André Breton and Philippe Soupault. First transatlantic flight.	First collages by Max Ernst. Bauhaus founded in Weimar. Mies van der Rohe: first skyscraper project. Fernand Léger: *Follow the Arrow,* p.104.
1920	'Blue Horizon' room in Paris. Congress of Tours.	Sir Arthur Stanley Eddington: *Time, Space and Gravitation.* First wireless.	Neo-Plasticist manifesto. Constructivist manifestos in Russia.
1921	Adolf Hitler takes over the Nazi party. Collapse of the German mark. Founding of the Chinese Communist Party.	Albert Einstein awarded the Nobel Prize for Physics. André Breton visits Sigmund Freud. Invention of the BCG vaccine. First BBC broadcast.	Purist manifesto written by Amédée Ozenfant and Le Corbusier. Félix Vallotton: *House and Reeds,* p.10.
1922	Stalin and Mussolini gain power.	James Joyce: *Ulysses.* Death of Marcel Proust.	Paul Klee: *Red Balloon,* p.77.
1923	Earthquake in Tokyo and Yokohama: 130,000 deaths. Munich Putsch led by Adolf Hitler.	Le Corbusier: *Towards a New Architecture.*	Claude Monet: *Water Lilies.* André Masson: *The Four Elements.*
1924	Beginning of the Moroccan War. Death of Lenin. Petrograd renamed Leningrad.	André Breton: *Surrealist Manifesto.* Thomas Mann: *The Magic Mountain.* Gershwin: *Rhapsody in Blue.*	Exhibition by the Novecento group inaugurated by Mussolini. Filippo Marinetti: *Futurism and Fascism.* Theo van Doesburg: *Counter-Composition,* p.80.
1929	Trotsky expelled from USSR. Wall Street Crash on 24 October ('Black Thursday') and start of the Great Depression. Lateran Accords give birth to the Vatican City.	Giorgio de Chirico: *Hebdomeros* (autobiographical tale). Jean Cocteau: *Les Enfants Terribles.* Alfred Döblin: *Berlin Alexanderplatz.* Walter Gropius: *The Sociological Bases of the Minimal Habitation.*	Museum of Modern Art founded in New York. Max Ernst: *The Woman with 100 Heads.* Salvador Dali: *The Enigma of Desire,* p.96. René Magritte: *The Use of Words.* Amédée Ozenfant: *The Creation of the World,* p.105. Le Corbusier: *Villa Savoye,* p.108.

Date	Politics	Culture and science	Fine arts
1930	Elections in Germany: the Nazi party wins an important victory.	Mies van der Rohe becomes director of the Bauhaus.	Founding of the Cercle et Carré group. Grant Wood: *Stone City*, p.116.
1931	Proclamation of the Spanish Republic following the abdication of King Alfonso XIII.	André Breton: *Free Union*. Antoine de Saint-Exupéry: *Night Flight*. Construction of the Empire State Building in New York.	Alberto Giacometti and Salvador Dali: *Symbolically Functioning Objects*. Jean (Hans) Arp: *first Papiers Déchirés ('torn papers')*. René Magritte: *The Universe Unmasked*, p.91.
1932	Germany rearms.	Aldous Huxley: *Brave New World*.	Robert Mallet-Stevens: *Villa Cavrois*, p.113. Carel Willick: *Einstein*, p.121.
1933	Adolf Hitler comes to power in Germany; Reichstag fire. End of prohibition in USA.	René Crevel: *Putting my Foot in it*. The review *Minotaur* founded. André Malraux: *La Condition Humaine*. Bauhaus closed; founding of CIAM.	Francis Picabia: *Woman and Face*, p.92. Numerous German artists emigrate to the United States: 60,000 between 1933 and 1939.
1935	Moscow trials. Birth of 'Stakhanovism'.	International Congress of Writers for the Defence of Culture. André Gide: *Les Nouvelles Nourritures*.	Kasimir Malevich dies. Alberto Giacometti: *The Invisible Object*, p.93.
1936	Spanish Civil War breaks out; assassination of poet Frederico Garcia Lorca.	Louis Aragon: *Les Beaux Quartiers*. Sergei Prokofiev: *Peter and the Wolf*. Béla Bartók: *Music for Strings, Percussion and Celeste*. First radio telescope.	Marcel Gromaire: *The Unemployed Man*, p.115. Joseph Cornell: *Soap Bubble Set*, p.130. 'Fantastic Art, Dada and Surrealism' exhibition at MOMA in New York.
1937	Guernica, a small Basque town, bombed on 26 April. Japanese invasion of China.	Universal Exhibition in Paris. André Breton: *Mad Love*. Gaston Bachelard: *Psychoanalysis of Fire*. Malraux: *L'Espoir*.	Pablo Picasso: *Guernica*, p.42. Henri Laurens: *Large Female Musician*, p.103. Auguste Perret: staircase of the Museum of Public Works in Paris, p.109.
1938	Hitler invades Austria. Oil production commences in Saudi Arabia.	Jean-Paul Sartre: *Nausea*. Pablo Neruda: *Spain in the Heart*. Meeting between Salvador Dali and Sigmund Freud.	Suicide of Ernst Ludwig Kirchner. Marcel Duchamp starts work on his *The Box in a Valise*.
1939	Franco victorious in Spain. Germany and Russia sign non-aggression pact. World War II breaks out.	John Steinbeck: *The Grapes of Wrath*. Antoine de Saint-Exupéry: *Terre des Hommes*. Sigmund Freud dies in London.	Salvador Dali expelled from the Surrealist movement. First Réalités Nouvelles exhibition in Paris. Ben Shahn: *Handball*, p.122.

Date	Politics	Culture and science	Fine arts
1940	Vichy Government installed in France. General de Gaulle appeals to the Resistance from London. Trotsky assassinated on 18 June in Mexico.	Penicillin ready for medicinal use. Ernest Hemingway: *For Whom the Bell Tolls*. Dino Buzatti: *The Desert of the Tartars*. Arthur Koestler: *Darkness at Noon*. Béla Bartók: *Mikrokosmos*. Discovery of the Lascaux cave paintings in France.	International Surrealist exhibition in Mexico City. Paul Nash: *The Battle of Britain*, p.132. Piet Mondrian and Salvador Dali emigrate to the United States. Paul Klee dies.
1941	Germany invades the USSR. Japanese attack Pearl Harbor on 7 December. The United States enters the war, which becomes a global conflict.	Siegfried Giedion: *Space, Time and Architecture*. Sergei Mikhailovich Eisenstein: *Ivan the Terrible*. Olivier Messiaen: *Quartet for the End of Time*. Discovery of plutonium by G T Seaborg and E M McMillan. First television broadcasts in the United States. Release of *Citizen Kane*.	André Breton, Max Ernst and André Masson arrive in the United States. Pablo Picasso publishes *Desire Caught by the Tail*. Death of Robert Delaunay.
1942	In France, the Germans invade the non-occupied zone. Allies land in North Africa (victory at El Alamein in Egypt).	Albert Camus: *The Outsider*, *The Myth of Sisyphus*. Louis Aragon: *Les Yeux d'Elsa*. Construction of the first nuclear reactor at the Univeristy of Chicago.	Max Ernst publishes *Surrealism and Painting*. Edward Hopper: *Nighthawks*, p.117.
1943	German surrender at the Battle of Stalingrad.	Jean-Paul Sartre: *Being and Nothingness*. Joseph Kessel: *Le Chant des Partisans*. Antoine de Saint-Exupéry: *The Little Prince*.	André Masson: *Iroquois Landscape*. Oskar Kokoschka: *What we are Fighting For*, p.131. Henri Matisse: first gouache cutouts. Chaïm Sou-tine and Oskar Schlemmer die.
1944	Normandy Landings. Paris liberated in August. Creation of the International Monetary Fund (IMF).	Jean-Paul Sartre: *Les Chemins de la Liberté*. Discovery of streptomycin by Selman Abraham Waksman.	In New York, a special issue of the review *View* is dedicated to Marcel Duchamp. Death of Wassily Kandinsky, Filippo Marinetti, Piet Mondrian and Edvard Munch.
1945	Yalta Conference. America drops atomic bombs on Hiroshima and Nagasaki. End of World War II (2 September). Signature of UN charter. Creation of UNESCO.	George Orwell: *Animal Farm*. André Derain: *L'Estaque*, p.16.	Olivier Debré: *Death in Dachau*, p.133. Piet Mondrian retrospective at MOMA in New York.

Index

Page numbers in italics refer to picture captions.

Bibliography

General and theory

Apollinaire, G, *Chroniques d'art 1902-1918*, Gallimard, Paris, 1960

Apollinaire, G, edited by Breunig, L C, *Apollinaire on Art: Essays and Reviews 1902-1918*, Thames and Hudson, London, 1972

Catalogue du collection du Musée national d'art moderne. Editions du Centre Georges-Pompidou, Paris, 1986

Chevreul, M E, *De la loi du contraste simultané des couleurs et de l'assortiment des objets colorés*, Laget, Paris, 1969

Chevreul, M E, *Principles of Harmony and Contrast of Colours, and their Applications to the Arts*, translated by Martel, C, 3rd edn, George Bell and Sons, London, 1908

Cork, R, *Art Beyond the Gallery in Early 20th Century England*, Yale University Press, New Haven and London, 1985

Frascina, F, and Harrison, C (eds), *Modern Art and Modernism*, Harper and Row, London, 1982

Gimpel, J, *Against Art and Artists*, revised edn, Polygon, 1991

Gombrich, E H, *The Story of Art*, 16th edn, Phaidon, London, 1995

Gooding, M, *Abstract Art*, Tate Publishing, London, 2001

Harrison, C and Wood, P, (eds), *Art in Theory 1900-1990*, Blackwell, Oxford, 1982

Honour, H, and Fleming, J, *World History of Art*, 3rd edn, Laurence King, 1991

Moszynska, A, *Abstract Art*, Thames and Hudson, London, 1990

Osborne, Harold (ed), *The Oxford Companion to Twentieth Century Art*, Oxford University Press, Oxford, 1981

Read, H, *Icon and Idea*, Faber and Faber, London, 1955

Read, H, *The Philosophy of Modern Art*, Faber and Faber, London, 1952

Stangos, Nikos (ed), *Concepts of Modern Art*, Thames and Hudson, London, 1994

The Tate Gallery Collections: British painting, modern painting and sculpture, Tate Gallery, London, 1984

Worringer, W, *Abstraction and Empathy - A Contribution to the Psychology of Style*, new edn, Ivan R Dee, Chicago, 1997

Cubism

Antliff, M, and Leighten, P, *Cubism and Culture*, Thames and Hudson, London, 2001

Barr, A H, *Cubism and Abstract Art*, 1936, reprint edn, published for the Museum of Modern Art by Arno Press, New York, 1966

Cox, N, *Cubism*, Phaidon, London, 2000

Dabrowski, M, *Contrasts of Form: Geometric Abstract Art 1910-1980*, Museum of Modern Art, New York, 1985

Primitivism

Cowling, E G, *On Classic Ground*, Tate Gallery, London, 1990

Cowling, E G et al, *Matisse Picasso*, Tate Publishing, London, 2002

Rhodes, C, *Primitivism and Modern Art*, Thames and Hudson, London, 1994

Post World War 1

Abadie, D et al, *Catalogue of the exhibition Salvador Dali. Rétrospective 1920-1980*, Editions du Centre Georges-Pompidou, Paris, 1980-1981

Arp, H, *Dada Painters and Poets: an Anthology*, edited by Motherwell, R, 2nd edn, Belknap Press of Harvard University Press, Cambridge, MA, 1981

Clair, J, *Considérations sur l'état des beaux-arts. Critique de la modernité.* Gallimard, Paris, 1983

Clair, J et al, *Catalogue of the exhibition les Realismes*, Editions du Centre Georges-Pompodou, Paris, 1980

De Chirico, G, *The memoirs of Giorgio de Chirico*, translated by Crosland, M, Da Capo Press, New York, 1994

Elliott, D, *New Worlds: Russian Art and Society 1900-1937*, Thames and Hudson, London, 1986

Elliott, D et al, *Art and Power: Europe under the Dictators 1930-45*, Hayward Gallery catalogue, London, 1995

Fer, B, *On Abstract Art*, Yale University Press, New Haven and London, 1997

Fer, B et al, *Realism, Rationalism, Surrealism: Art between the Wars*, Yale University Press, New Haven and London, 1993

Joedicke, J, *History of Modern Architecture*, translated by Palmes, J C, Architectural Press, London, 1961

Kandinsky, W, *Complete Writings on Art*, Faber, London, 1982

Rubin, W, *Dada, Surrealism and their Heritage*, Museum of Modern Art, New York, 1968

Willett, J, *The new sobriety, 1917-1933: Art and Politics in the Weimar Period*, Thames and Hudson, London, 1978

Photo credits

Page 1: Ph. © H Matisse estate, 1998/Artephot/Plassart - Page 2: Ph. © H Josse © Larbor © ADAGP, Paris, 1998 - Page 7: Ph. © Lauros-Giraudon/T - Page 8: Ph. © Matisse estate, 1998/Matisse Archives. Claude Duthuit collection/T - Page 10: Ph. © Titus/T - Page 11: Ph. © Lauros-Giraudon © ADAGP, Paris 1998/© Association Maurice Utrillo, Jean Fabris 1999/- Page 12: Ph. © AKG - Page 13: Ph. L Joubert © Larbor © ADAGP, Paris 1998/T - Page 14: Ph. © Wallter Drayer © Larbor © ADAGP, Paris 1998/T - Page 15: Ph. © AKG © ADAGP, Paris 1998 - Page 16: Ph. © Giraudon © ADAGP, Paris 1998/T - Page 17: Ph. Jeanbor © Larbor/ © ADAGP, Paris 1998/T - Page 18: Ph. © H Matisse estate/Artephot/Plassart - Page 19: Ph. Fotostudio Otto © Larbor/T - Page 20: Ph. R Kleinhempel © Larbor Archives - © Dr Worfgang & Ingeborg Henze-Ketterer, Wichtrach, Bern/T - Page 21: Ph. © Munch Museet, Munch Ellingsen Group/ADAGP, Paris, 1998/T - Page 22: Ph. © private collection, New York © ADAGP, Paris 1998/T - Page 23: Ph. © Colorphoto Hinz © ADAGP, Paris 1998/T. Page 25: Ph. © AKG - Page 26: Ph. L Joubert © Larbor © ADAGP, Paris 1998/T - Page 27: Ph. © Colorphoto Hinz/T - Page 29: Ph. © Archives Snark/Edimedia © ADAGP, Paris 1998/T - Page 30: Ph. © Musées de la Ville de Paris photo library/ Charles Delepelaire © ADAGP, Paris, 1998 - Page 31: Ph. © Titus/T - Page 32: Ph. J-L Charmet © Larbor © ADAGP, Paris 1998/T - Page 33: Ph. Jeanbor © Larbor Archives © ADAGP, Paris 1998/T - Page 34: © Ph. Adam Rzepka © Musée Rodin - Page 35: Ph. Jeanbor © Larbor © ADAGP Paris 1998/T - Page 36: Ph. © Tate Gallery © ADAGP Paris 1998 - Page 37: Ph. J-J Hautefeuille © Larbor © Picasso estate 1999/T - Page 38: Ph. © Giraudon © Picasso estate 1999/T - Page 39: Ph. © RMN/Labat/CFAO - Page 40: Ph. © Lauros — Giraudon © ADAGP, Paris 1998/T - Page 41: Ph. Scala, Florence © Larbor © Picasso estate 1999/T - Pages 42-43: Ph. Oroñoz © Larbor Archives © Picasso estate 1999/T - Page 43: Ph. © Giraudon © Picasso estate 1999/T - Page 44: Ph. H Josse © Larbor/T - Page 45: Ph. H Josse © Larbor © ADAGP, Paris 1998/T - Page 46 top: Ph. H Josse © Larbor © ADAGP, Paris 1998/T ; bottom: Ph. © Lauros-Giraudon © ADAGP, Paris 1998/T - Page 47: Ph. A J Wyatt © Larbor Archives © ADAGP, Paris 1998/T - Page 48-49: Ph. © Eric Lessing/Magnum © ADAGP, Paris 1998 - Page 50: © Musée des Beaux-Arts d'Orléans - Page 51: Ph. Arborio Mella © Larbor/T - Page 52: Ph. G Tomsich © Larbor © ADAGP, Paris 1998/T - Page 53: Ph. Arborio Mella © Larbor © ADAGP, Paris 1998/T - Page 55: Ph. © H Josse/T - Page 56: Ph. J-L Charmet © Larbor © ADAGP, Paris 1998/T - Page 57: Ph. © Colorphoto Hinz. - D.R./T - Page 58: Ph. Jeanbor © Larbor © ADAGP, Paris 1998/T - Page 59: Ph. Jeanbor © Larbor Archives/T - Page 60: Ph. L Joubert © Larbor - D.R./T- Page 61: Ph. L Joubert © Larbor © ADAGP, Paris 1998/T - Page 62: Ph. Luc Joubert © Larbor © ADAGP, Paris 1998/T - Page 63: Ph. © Stedelijk Museum, Amsterdam - D.R./T - Page 65: Ph. © A.P.N. - D.R./T - Page 67: Ph. © AKG - Page 68: Ph. © AKG © ADAGP, Paris 1998 - Page 71: Ph. © Joachim Blauel © ADAGP, Paris 1998/T - Page 72: Ph. L Joubert © Larbor © ADAGP, Paris 1998/T - Page 73: Ph. © AKG - Page 74: Ph. © Landesmuseum, Münster © ADAGP, Paris 1998/T - Page 75: Ph. L Joubert © Larbor Archives © ADAGP, Paris 1998/T - Page 76: Ph. © Colorphoto Hinz - D.R./T - Page 77: Ph.© Giraudon © ADAGP, Paris 1998/T - Page 78: Ph. © Gemeente Museum - D.R./T - Page 79: Ph. © Peter Willi/Top © Mondrian/Holzman Trust/ADAGP, Paris 1998/T - Pages 80 and 81: Ph. © Stedelijk Museum, Amsterdam © ADAGP, Paris 1998/T - Page 82: Ph. © Larbor Archives © ADAGP, Paris 1998 - Page 83: Ph. © Dutch Embassy © ADAGP, Paris 1998/T - Pages 84-85: Ph. © M Desjardin/Top © ADAGP, Paris 1998 - Page 86: Ph. © Moderna Museet, Stockholm © ADAGP, Paris 1998/T - Page 88: Ph. © 1900-2000 Gallery © ADAGP, Paris 1998 - Page 89: Ph. © Giraudon © ADAGP, Paris 1998/T - Page 90: Ph. L Joubert © Larbor © ADAGP, Paris 1998/T - Page 91: Ph. L Joubert © Larbor Archives © ADAGP, Paris 1998/T - Page 92: Ph. L Joubert © Larbor © ADAGP, Paris 1998/T - Page 93: Ph. Studio Mirkine © Larbor © ADAGP, Paris 1998/T - Page 95: Ph. © Maeght Gallery © ADAGP, Paris 1998/T - Page 96: Ph. L Joubert © Larbor © ADAGP, Paris 1998/T - Page 97: Ph. L Joubert © Larbor © ADAGP, Paris 1998 - Page 98: Ph. © Giraudon © Mondrian/Holzman Trust/ADAGP, Paris 1998/T - Page 99: Ph. © of the museum © ADAGP, Paris 1998/T - Page 100: Ph. Larbor Archives © H Matisse estate, 1998 - Page 102: Ph. L Joubert © Larbor Archives © ADAGP, Paris 1998/T - Page 103 top: Ph. © MNAM © ADAGP, Paris 1998 ; bottom: Ph. H Josse © Larbor © ADAGP, Paris 1998/T - Page 104: Ph. J Martin © Larbor Archives © ADAGP, Paris 1998/T - Page 105: Ph. J-L Charmet © Larbor © ADAGP, Paris 1998/T - Page 106: Ph. © The Henry Moore Foundation, Hertfordshire - Page 107: Courtesy Natalie Seroussi © ADAGP, Paris 1998 - Page 108: Ph. H de Montferrand © Larbor © by FLC - ADAGP, Paris 1998 - Page 109: Ph. L Joubert © Larbor - D.R./T - Page 110: © Courtesy Chicago Hist. Soc. - DR/T - Page 111: © ADAGP, Paris 1998 - Page 113: Ph. A Salaum © Musée des Arts décoratifs, Paris © ADAGP, Paris 1998 - Page 114: Ph. © AKG/T - Page 115: Ph. J-L Charmet © Larbor © ADAGP, Paris 1998/T - Page 116: Ph. © The Bridgeman Art Library/Artephot © ADAGP, 1998 - Page 117: Ph. © The Art Institute, Chicago - D.R./T - Page 118 top: Ph. © J-Cl Stevens - Atlas Photo © ADAGP, Paris 1998/T ; bottom: Ph. © R Roland - Ziolo © ADAGP, Paris 1998/T - Page 119: Ph. J Martin © Larbor - D.R./T - Page 121: © Sylvia Willink/T - Page 122: Ph. © MOMA, New York © ADAGP, Paris 1998/T - Pages 124-125: Ph. © AKG © ADAGP, Paris 1998 - Page 127: Ph. L Joubert © Larbor © ADAGP, Paris 1998/T - Page 129: Ph. © Imperial War Museum, London/The Bridgeman Art Library - Page 130: Gift of Henry and Walter Keney. Ph. © of the museum - D.R./T - Page 131: Ph. © of the museum © ADAGP, Paris 1998/T - Page 132: Ph. © Giraudon © ADAGP, Paris 1998/T - Page 133: Ph. © MNAM, C.G.-P, Paris © ADAGP, Paris 1998/T - Page 134: Ph. © J Dubout/Daniel Gervis Gallery, Paris © ADAGP, Paris 1998/T.